Digital Sports Photography

G. Newman Lowrance

with contributions by Andy Hayt,
Jonathan Hayt, and Kevin Terrell

Foreword by Peter Read Miller

THOMSON

COURSE TECHNOLOGY ™

Professional ■ Trade ■ Reference

A DIVISION OF COURSE TECHNOLOGY

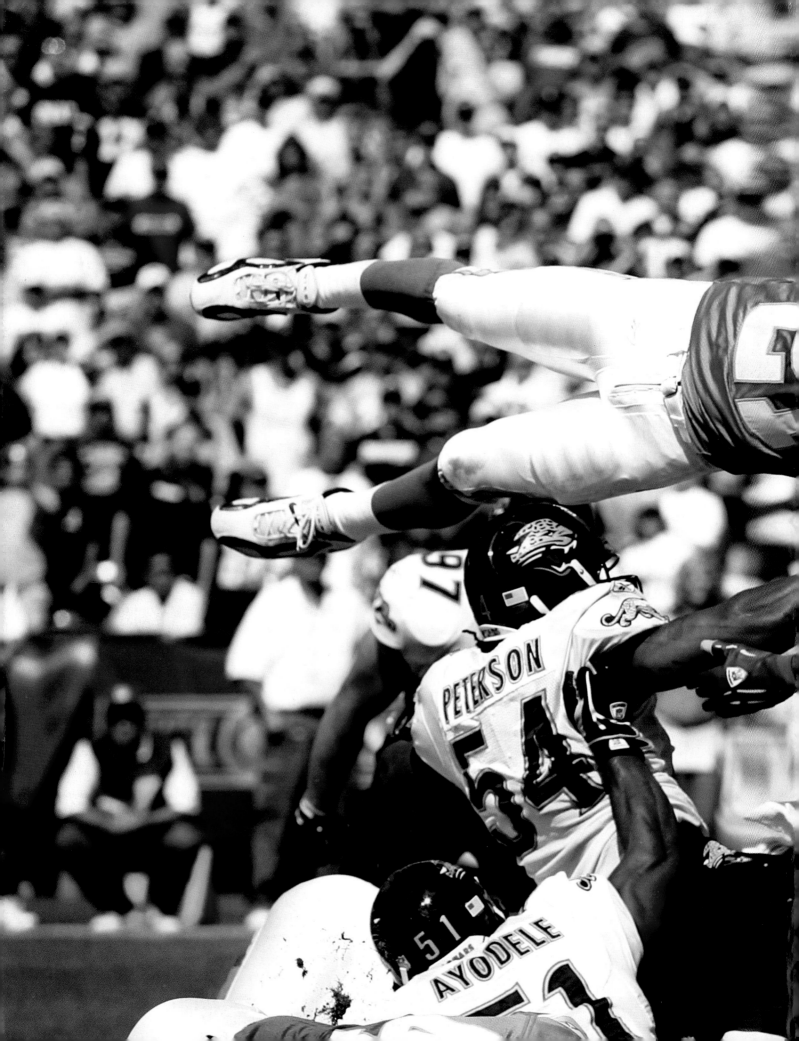

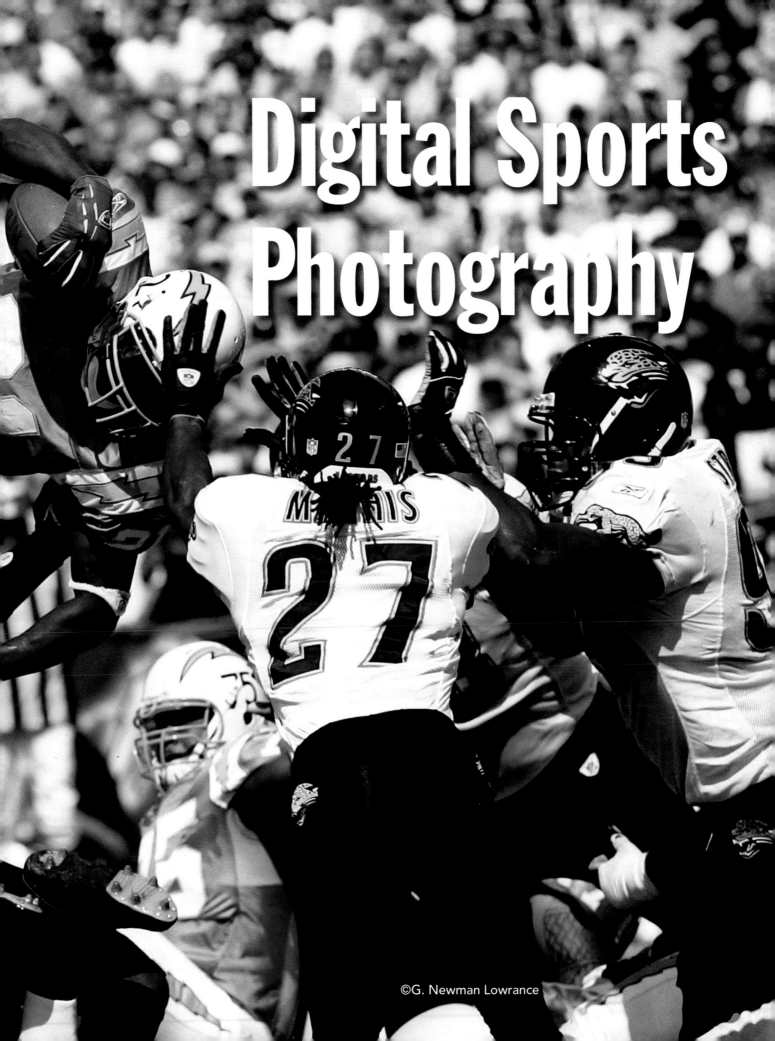

Digital Sports Photography

DIGITAL SPORTS PHOTOGRAPHY

ISBN: 1-59200-648-5

Library of Congress Catalog Card Number: 2004115265

Printed in Canada

05 06 07 08 09 TC 10 9 8 7 6 5 4 3 2 1

Publisher and General Manager of Thomson Course Technology PTR:
Stacy L. Hiquet

Associate Director of Marketing:
Sarah O'Donnell

Marketing Manager:
Heather Hurley

Marketing Coordinator:
Jordan Casey

Manager of Editorial Services:
Heather Talbot

Associate Acquisitions Editor:
Megan Belanger

Senior Editor:
Mark Garvey

Project/Copy Editor:
Karen A. Gill

Technical Reviewer:
Jonathan Hayt

PTR Editorial Services Coordinator:
Elizabeth Furbish

Interior Design and Layout:
Shawn Morningstar

Cover Designer:
Mike Tanamachi

Indexer:
Kelly Talbot

Proofreader:
Gene Redding

THOMSON
★
COURSE TECHNOLOGY
Professional ■ Trade ■ Reference

Thomson Course Technology PTR,
a division of Thomson Course Technology
25 Thomson Place
Boston, MA 02210
http://www.courseptr.com

Dedication

In memory of Larry Hastings.
May you rest in peace rooting for your Wildcats.

Foreword

I fly a lot in my job. Frequently, people sitting next to me on the plane ask me what I do for a living. When I tell them that I am a sports photographer, their response is usually something like this: "Wow, what a great job!" They're right. Sports photography really is a great job.

A sports photographer captures the graceful, the intense, the emotional, and the unexpected. Shooting sports allows you to enter that magical nether land between the intensity on the playing field and the energy of the crowd. You smell the burning shoe rubber as a basketball player makes a cut, feel the ground shake from a colossal hit on the football field, or recoil from the glass as two hockey players collide. Whether it's in front of 90,000 Rose Bowl fans or a dozen Little League parents, you still feel a wave of excitement and passion wash over you following a big score or a great play.

Usually the next question my seatmates ask is, "How do you get a job like that?" In my 40 years as a sports photographer, I've heard many individual success stories from hundreds of my colleagues. Every one is different; each person has proceeded according to his unique interests and abilities. One thing they all appreciate, however, is information on how their fellow photographers have advanced in the field and what skills and equipment they have used to make their pictures.

In this book, Newman Lowrance not only tells the story of his journey toward becoming a successful sports photographer, but he also presents a wealth of information from some of the best sports shooters and editors working today in the industry. In this book, he and his contributors cover basic and advanced topics of digital photography, discuss techniques and strategies for shooting many major sports, and include a great deal of general knowledge on sports photography that will be extremely beneficial for those who have ambitions in this field.

Whether it's covering the Olympics for *Sports Illustrated* or a local youth soccer game, shooting sports is one of the most exciting, challenging, and creative aspects of photography. Whatever your aspirations in this field are, this book will provide invaluable help and guidance.

—Peter Read Miller

Acknowledgments

To my wife Kami, who has always stood behind my photographic aspirations.

To my boys, Jordan and Austin: Hopefully, you will someday carry all my gear around when I'm too old to be running the sidelines.

To my mother and father, who have always supported and encouraged me throughout my life.

Thanks also to my fellow contributors, Andy Hayt, Jon Hayt, Kevin Terrell, and Peter Read Miller, for their valuable time, efforts, and contributions to this book.

To Paul Spinelli and all of the gang formally known as NFL Photos. All of you were a class act, and I will never forget the good times.

To Megan Belanger and Course Technology, for giving me the opportunity to write this book.

To Karen Gill, for all of her suggestions and assistance to a first-time writer.

To Shawn Morningstar, for tolerating all of my last-minute layout changes and requests.

In addition, I would like to thank all the people and organizations that have helped me get to where I am today. You know who you are.

About the Author

G. NEWMAN LOWRANCE has been a photographer for more than 16 years, with a major emphasis in sports. His images have appeared in *ESPN The Magazine*; *Sports Illustrated*; *Sports Illustrated for Kids*; *Official NFL Super Bowl* and *Pro Bowl* game magazines; NFL videos and team calendars; *NFL Insider* magazine; *The New York Times Magazine*; various covers and interior photographs for *Street & Smith's* sports annuals; *Athlon Sports* annuals; *ATS Consultants* annuals; *Human Kinetics* publications; DK publications; and Scholastic Inc. His photos have also appeared for various commercial uses such as DirecTV; *USA Today*; *Sports Weekly*; Time Warner, Inc.; and Reebok, Inc.

Newman's journey into photography started at Usdan's Center for the Arts on Long Island, New York, during high school. That background and passion for sports and photography evolved through his days in college. After leaving school and working as an engineer for the Boeing Company in Wichita, Kansas, Newman began his pursuit of sports photography by working part-time shooting high school football games for a newspaper and obtaining credentials for college and professional events. It was during this period that he learned the basics of what it means to be a professional shooter and how to capture those moments that the sporting world has to offer. His big break occurred after moving to the Los Angeles area when the major source of photography for the National Football League, NFL Photos, recognized his skills. Newman gradually worked his way up and became one of their most published photographers. Newman has since left the engineering field to become a widely used sports photographer whose photos have been printed in many national publications. He now resides in the Kansas City area.

ANDY HAYT has been a photographer for the past 35 years working primarily in sports. He has worked as a staff photographer with *The Los Angeles Times* and *Sports Illustrated*. At *Sports Illustrated*, he photographed 39 covers. He has been employed as a contract photographer for the National Basketball Association, photographing both portraits and game action. Recently, he completed a photo book for the San Diego Padres Baseball Club commemorating the building of its new ballpark, Petco Park.

JONATHAN HAYT has been a professional photographer for the past 16 years with a background in location lighting and digital photography techniques. He is a nationally known freelance sports and editorial photographer. His client list has included positions as the team photographer for the NBA's Miami Heat and the NHL's Tampa Bay Lightning. He has contracted to numerous clients including the Upper Deck Co., *ESPN The Magazine*, Reuters, and the Associated Press. Prior to this, Jon was a staff lighting technician for eight years at *Sports Illustrated*. He was responsible for all western states' arena strobe and location lighting assignments, working with *Sports Illustrated* staff and contract photographers.

Currently the NFL Business Manager with WireImage, **KEVIN TERRELL** was employed with NFL Properties, Inc. for 18 years. He served as a photo editor for six years before being promoted to managing photo editor in 1997. He has photographed numerous NFL games, including 10 Super Bowls. In addition, he wrote several articles for *NFL Game Day* and *NFL Insider Magazine*, including a physical fitness workout column with various NFL strength and conditioning coaches.

PETER READ MILLER has been a staff and contract photographer for *Sports Illustrated* for more than 25 years. His work has appeared in *Time, Life, People, Newsweek, Playboy, National Geographic*, and *The New York Times Magazine*. His other clients include Nike, Adidas, Ford, Visa, Coca-Cola, Kodak, Canon Cameras, and the National Football League.

Peter has covered 7 Olympic games, 25 Super Bowls, and 17 NBA championships. He has also covered the World Series, the Stanley Cup, the Kentucky Derby, the NCAA Men's Basketball Final Four, and the World Championship of Freestyle Wrestling in Krasnoyarsk, Siberia.

Peter has taught sports photography at the Santa Fe Photographic Workshop, Rich Clarkson's Sports Photography Workshop, and the SportsShooter Luau. He currently teaches his own sports photography workshop in Denver in conjunction with Working with Artists.

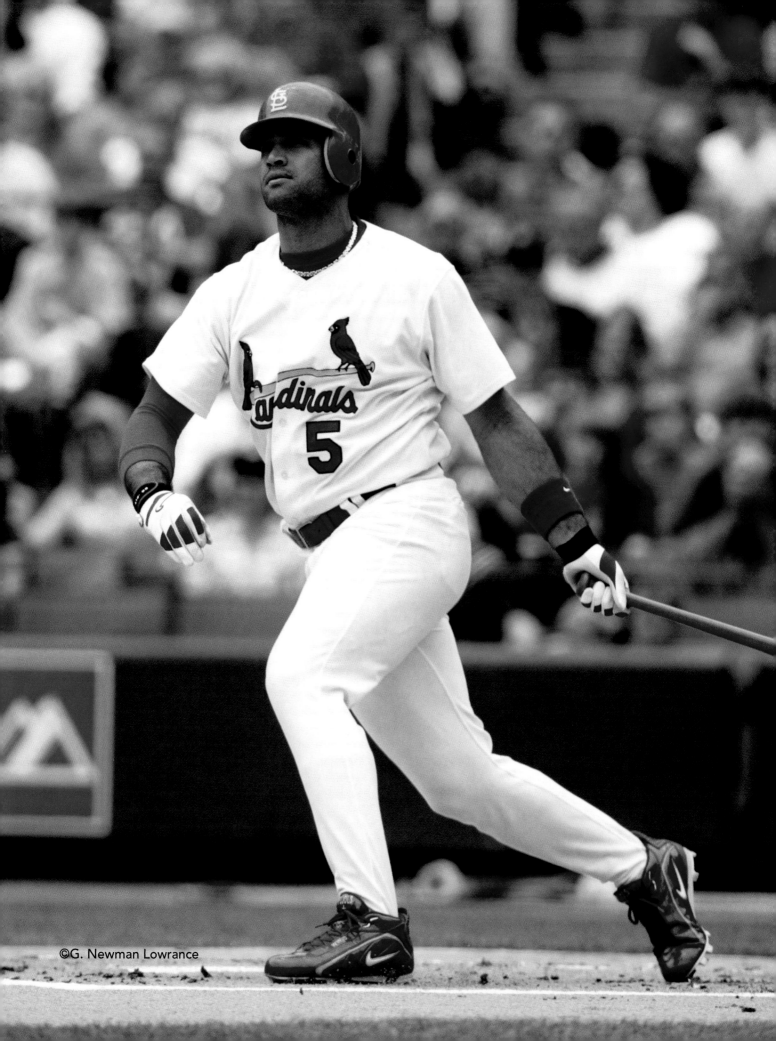

Contents at a Glance

Contents

4 **What an Editor Looks For** **63**

5 **Baseball** **83**

6 **Football** **111**

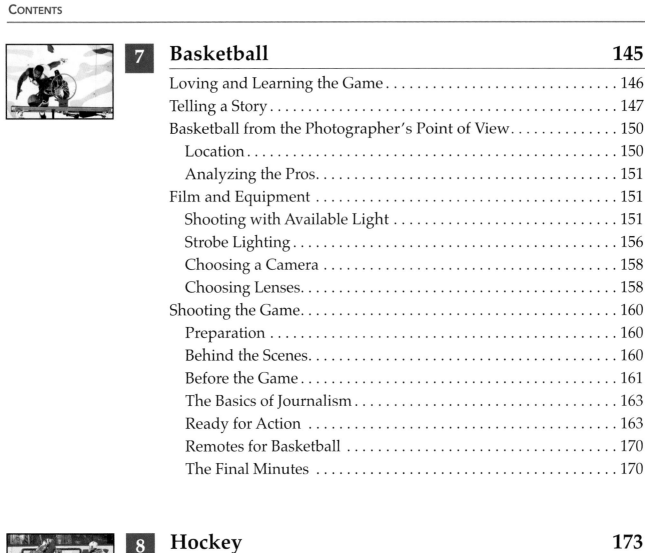

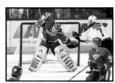

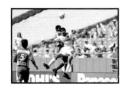

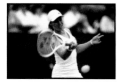

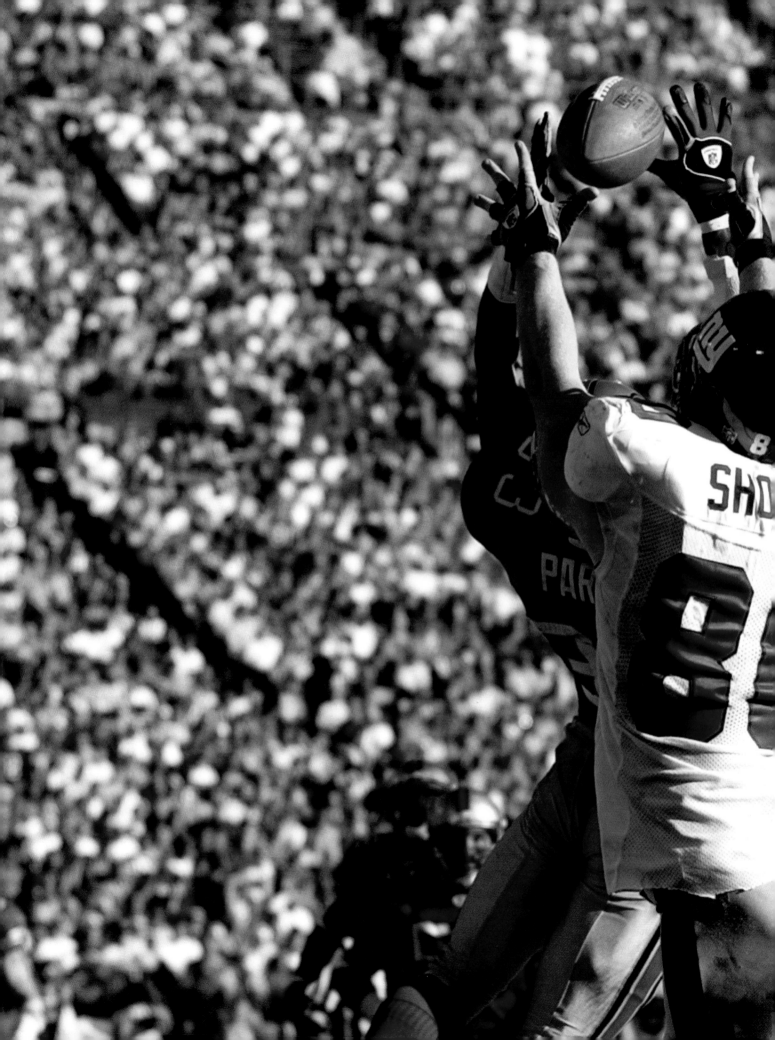

Introduction

If you are interested in learning the basics of sports photography with an emphasis on shooting with digital cameras, this book is an ideal primer for getting you started or helping you to expand your skills and techniques. My fellow contributors and I have more than 90 years of experience shooting sports, and we have used this book as a forum for passing along a wide range of knowledge gained through hard-earned practical experience. Each of us started out shooting with traditional film cameras before digital cameras were even invented, and each of us progressed in our use of the latest equipment as the highest levels of professional sports photography required us to keep pace with all the newest developments in digital photography. We have included many of our personal experiences along with our methods for shooting sports for clients who demand the highest image quality.

The book opens with my personal story and journey into the sports photography world. You'll find out what I encountered while trying to break back into photography after learning the fundamentals during my childhood and college years, and how a hobby and passion for photography eventually turned into a career.

Next, we cover the basic transformation that sports photography has undergone over the past few years as digital cameras have replaced film cameras, and how a sports photographer has changed his approach while adjusting to the digital realm. In addition, we have included discussions about the knowledge that you need to successfully work with digital imaging, including explanations about color management and camera setup to achieve images that clients can use easily. Finally, we discuss the workflow that is necessary in today's digital world.

We also focus on the various equipment options and basic concepts dealing with exposures, shutter speeds, and composition. You'll learn what it takes to capture great images while understanding these basic concepts. White balance fundamentals and color settings for digital cameras are also discussed.

Chapter 4 covers what a photo editor looks for in determining what makes a great image. Understanding what an editor is looking for benefits you as you are shooting an event and helps immensely when you try to sell your images for possible publication.

We then concentrate on six major sports individually: baseball, football, basketball, hockey, soccer, and tennis. All these sports that we cover are shot most commonly at a professional level and are highly accessible at an amateur, scholastic, and semi-professional level. We base the discussions of techniques and methods on shooting professional sports, which only helps you in understanding how to shoot the nonprofessional versions of these and other sports. We discuss photography basics, technical processes, and procedures and standards of professional comportment that apply to photographers at all levels. We help you set high standards and give you insights into how to shoot better photos, whether you are trying to break into the professional ranks or you just want to shoot sports as a hobby. A section on arena strobe lighting is included in the hockey chapter to give you a better understanding of what it takes to create light for an indoor sporting event. A useful glossary that is chock-full of photography terms wraps up the book.

Each of these chapters examines a particular sport in detail and discusses the techniques we have developed over our careers. This range of experiences is brought to you so that you can gain a comprehensive overview of sports photography in addition to specific knowledge that will help you shoot better photos. Although we realize we could have included several other sports in this book, such as volleyball, golf, boxing, auto racing, and track and field, we discovered during our research that most professional photographers learned the fundamentals of photography by shooting youth and school sports such as baseball, football, and basketball,

where it is easier to gain access for shooting experience. Besides, if you are just starting out, it might be difficult for you to obtain the proper credentials to photograph some of these other sporting events. Hopefully, after reading this book, you will have a better understanding of shooting techniques so that you can photograph practically any sport and obtain professional-quality results.

Although most of the examples in this book are based on shooting professional sports, the concepts and techniques are, for the most part, common practice regardless of what level of play you are photographing. In many ways, shooting an event below the professional level actually offers greater access and a wonderful way to learn these basic techniques that can get you to the next level if that is what you are trying to accomplish. Also, depending on whether you are a high school student, a college student taking courses in photography, a parent wanting to take great action shots of your young athlete, or a current shooter just wanting to broaden your perspective, this book offers many examples of preparation, equipment use, and key positioning aspects while at an event, in addition to numerous image examples to better explain what the photographer was trying to achieve.

Every professional sports shooter has unique opinions and methods for capturing excellent sport photographs. In this book, we share ours and hope that they will make a difference in your sports photography aspirations.

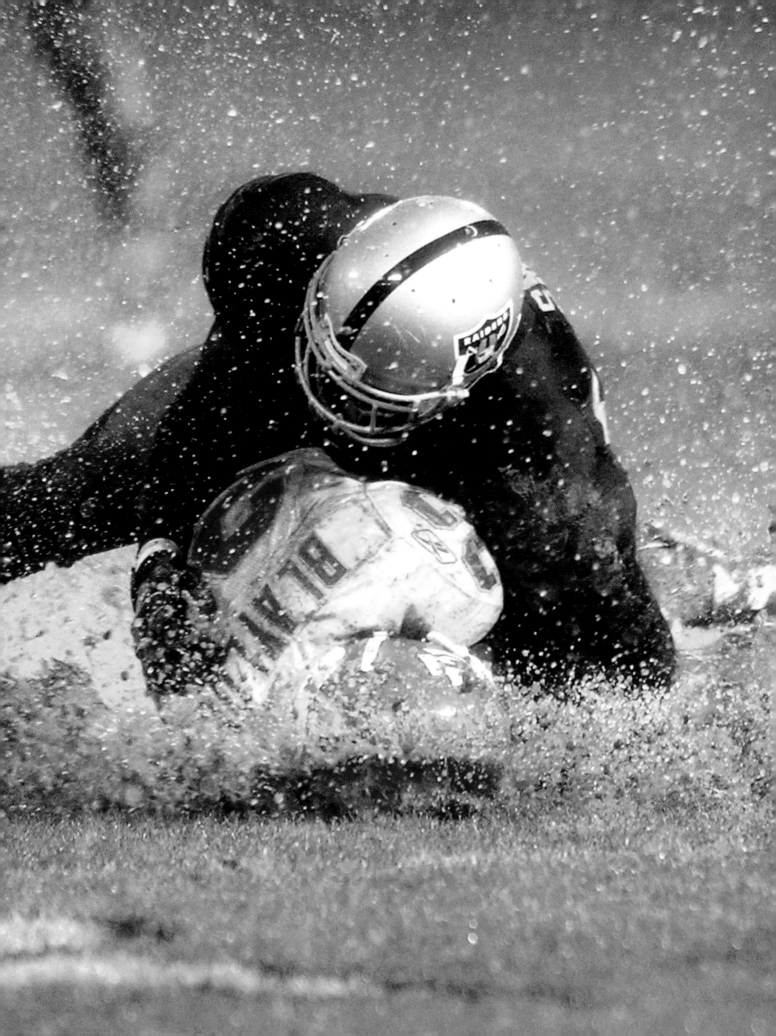

How I Made It in Sports Photography: My Story

CHAPTER

1

As I stood on the sidelines waiting for the start of Super Bowl XXXVIII between the New England Patriots and the Carolina Panthers, it dawned on me: I had reached my goal of photographing a Super Bowl game from when I got back into sports photography. Sure, I had been excited during the events leading up to the game, and it had always been a dream of mine, but I had never known how or if I would ever reach this goal. However, I started out on my own 10 years earlier and met some great contacts, learned the trade, developed my eye for sports, and worked hard to get the opportunity to photograph one of the biggest sporting events in the world. I also realized that many other photographers out there are more established, more successful, and perhaps even considered famous in the sports photography world, but for me, shooting the Super Bowl was like a dream come true.

Starting Off

It all started innocently enough. As a kid with an old Kodak 126 format camera in my hands, I took photographs of everything and everybody. It seemingly was my destiny to become a photographer, but becoming a professional sports photographer was certainly not in my mind at that young age.

Growing up, I was always a huge fan of sports, especially professional football. The colors, the action, and the excitement of the game were elements that I loved then and still love now. Little did I know at the time that I eventually would be on the sidelines photographing, and getting paid for it to boot!

My high school days followed much along the same path, as I played around with cameras and shot typical travel photographs and local sporting events for fun. But I always wondered how it would be to photograph a college or NFL game. I noticed what was published in newspapers and magazines, and as I watched plays develop on television, I imagined what I would do with a camera in my hands during a game.

Part of this interest was generated from NFL films. In the days before cable, professional sports wasn't the oversaturated product that it is today, and games on television were mostly limited to weekends, except for Monday Night Football. When these NFL films were shown, I always watched. I loved how the films created such a dramatic effect of the game, how they brought you behind the scenes and showed you all of the nuances of the game. I guess all of this correlated to my photography curiosity, too.

All of these factors enhanced my ideas for photography. During these high school days, I spent a lot of time where I was born: in New York City. I always seemed to have a camera in hand while I was there for those summer vacations. I took the subways up to Yankee or Shea Stadium and shot baseball shots from the stands, and I walked around the city taking shots of buildings or people.

Noticing my strong interest in photography, my mother suggested that I go to a summer school in Huntington, Long Island, called the Usdan Center for the Arts. Usdan had courses for all of the arts and a photography course that taught all of the basics. For two summers, I attended the school and learned many different facets of photography. I absolutely loved learning about the processes of taking images and then developing the film and making prints. I can still recall the first time I saw a black-and-white image appear in the dark-room. Granted, it was only an image of a flower, but seeing it suddenly appear in that darkroom is still a vivid memory. It was at Usdan that I learned about the fundamentals of photography. The school taught me about exposures, shutter speeds, apertures, and composition. My teacher assigned shoots for each weekend. Just being in New York City was always an adventure, so I didn't have a hard time coming up with material for those assignments. Photography seemed almost like a natural instinct to me. By summer that first year, my mother purchased an Omega enlarger for me to take back home. I ended up building my own darkroom and used it throughout high school. To this day, I still have that enlarger. It's a reminder to me about the journey on which pho-tography has taken me.

I took a brief break from photography during my first two years of college. I concentrated on obtaining the basic courses until I figured out what to do with the rest of my life. By my third year, I decided to take photography courses for a minor, and eventually, I worked for the university newspaper.

Just getting on the staff at the university was tough. I can't remember how many times I came into the office before they finally hired me. Probably half the reason was so that I wouldn't keep asking them anymore! I guess that old saying of being persistent finally paid off. Luckily, the university supplied the best equipment available at that time: a Nikon F3 body and several lenses to use for the events. Although I didn't have a long lens like a 400 mm, having a body that would shoot six frames per second was great, especially while using the manual lenses and learning how to focus on the high-speed action. Being able to use this equipment was a huge advantage for me, considering the costs and the budget of a typical student.

I ended up photographing all of the university sporting events: football, baseball, basketball, rugby, wrestling, and soccer. I was unaware at the time of the great experience I was gaining not only about shooting the events, but also about meeting deadlines for the weekly newspaper and having full control of the images I would select to be published. I had basically become a photojournalist, even though it was only at the college level. The school staff covered the events, processed the film, and provided the newspaper editors with prints to run in the next weekly edition of the publication. It was always nice to see my images published and my name credited. Even to this day, I get the same feeling of satisfaction when I see my published images.

My First Professional Game

One of the other university staff photographers was also a shooter for a local newspaper. He had a credential for an NFL game during the Thanksgiving weekend in 1985, but he couldn't attend, so he gave the credential to me. Back then, your name wasn't required on the credentials, and the teams usually just sent them out to the various outlets, so it wasn't a problem for me to get in and at least act like I knew what I was doing. It was my first credential to a professional sporting event, a game in St. Louis between the New York Giants and the St. Louis Cardinals (before the franchise moved to Arizona). I can still remember standing on the artificial turf field an hour before the game and looking around Busch Stadium. I couldn't believe that I was standing on the field for a professional football game. Before I knew it, the Giants were coming onto the field for their pregame warm-ups. I can still visualize Harry Carson, a great linebacker, leading the team and yelling at me to "Look out!" I was standing right where the team wanted to go. As the players ran past me, I was amazed at how big they really were. It was a lot different from the Division 1 Double A games that I was accustomed to.

My first professional game occurred at Busch Stadium in St. Louis in 1985. ©G. Newman Lowrance

This image brings back a fond memory from my first NFL game, a view of Busch Stadium from the press box.
©G. Newman Lowrance

Because the game was a 3 p.m. start, I didn't have the best lighting in terms of daylight. It was like shooting a night game by the second half, but I didn't mind. That day probably gave me the best experience a starter could have. Even though I had only an 80–200-mm zoom lens for action shots, a wide-angle lens, and my old Nikon FE2 camera, I was having the time of my life and was instantly hooked. I even went into the Giants locker room after the game and photographed Lawrence Taylor being interviewed. I guess they didn't mind a still photographer being there, because nobody said anything to me. I drove back to the university that night wondering when I could shoot another game, but it was eight long years before I stepped onto another NFL field. I graduated the following spring and went on to a professional career as an engineer with the Boeing Company in Wichita. By the time I made the transition from student to employee, I wasn't taking very many photographs. In fact, for five years, I hardly picked up a camera. That fact was about to change.

Going into an NFL locker room was a new experience for me after shooting my first NFL game.
©G. Newman Lowrance

Getting Back

In 1991, my father and I purchased Kansas City Chiefs season tickets. It was a great way for us to see each other more often because we were coming from opposite directions. Sitting in those seats made me think again about being on the field and photographing sports. I ended up purchasing some used equipment the following year: a Nikon F3 body and a 300-mm f/2.8 manual focus lens. At that time before security checks, I was allowed to bring that equipment into the stadium. I shot many photographs from our seats and had some reasonable success. Our seats were around the 10-yard line, 10 rows up, so when the teams came down toward our end zone, it was a decent vantage point for shooting. I did this until 1993, when I decided to try and make it onto the field. I went to some local newspapers and showed them my portfolio from my college days. I knew my work was a little outdated, because it was material more than six years old, but I hoped someone might notice my potential.

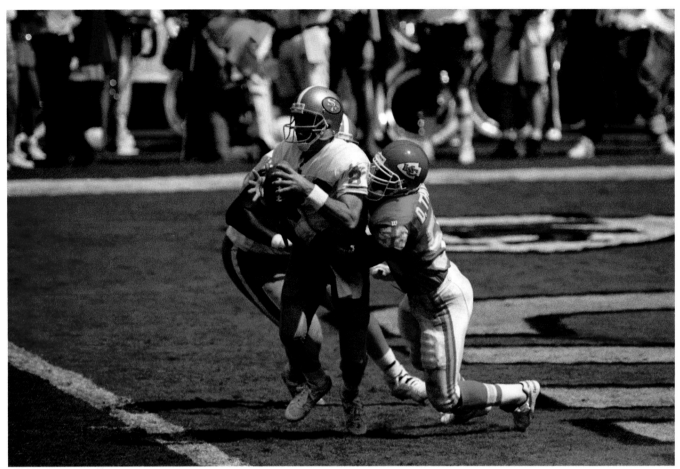

Before I made it back onto the field, I had some reasonable success shooting from the stands.
©G. Newman Lowrance

It didn't happen quite how I wanted it to. I couldn't get a job with any of the newspapers. I couldn't even get work as a part-time shooter. I finally ended up offering my services to a weekly suburban paper to shoot the local high school games for free, provided they would allow me to use the newspaper's name to obtain credentials for college and pro games in the area. They finally agreed, and before I knew it, I was getting into as many games as I could. I would shoot the high school games on Friday evenings and give the film to their editor. The next day, I would drive up to Kansas State University or Kansas University for a Big 8 Conference game (before they changed to the Big 12 Conference). Sunday it was on to Kansas City for an NFL game.

This was where I really noticed the speed of the game and the size of the players from level to level. The field seemed almost to dwarf the high school teams, and it was pretty easy to follow the action. The Saturday college games were another step up, and by the NFL games on Sunday, I was definitely aware of the differences. That was a great learning curve in itself.

That first season back on the field was memorable for me. I was learning from my efforts and making contacts. I joined a lab where I could process my own film and make contact prints and enlargements with either black and white or color. I was slowly getting back my knowledge of what I had learned previously at Usdan and the university.

It was also during this season when my first real break occurred. I met Tim Umphrey, who was then the head photographer for the *Chiefs Report*, a weekly publication produced in the Kansas City area during the football season. Tim was always friendly to me and helpful when I asked questions, of which I had many. He eventually hired me for a few games to help out with images for the publication, and he taught me the basics of sports photography in terms of exposure, shutter speeds, and what to look for to capture good images. Although I thought that I had a good idea of what to do, learning directly from a professional was a huge help to me. Previously, I had been shooting with automatic settings from the camera. I thought the images were okay, but some of them occasionally were over- or underexposed. Tim explained to me the reasoning for using a separate light meter and to keep the same aperture setting instead of letting the camera decide. The differences were amazing. Suddenly, the subjects in my images appeared to pop out at me. I realized then how much more there was to learn about shooting sports.

Over the next year, I eventually made my way into the local sports teams in Wichita, shooting for the local Central Hockey League team, the Thunder; the class Double A baseball team, the Wranglers; and baseball and basketball for Wichita State University. Suddenly, I was photographing year-round. I wasn't making much money, but it was enough to start purchasing equipment little by little and continue my passion for photography. My images started appearing in the teams' media guides and yearbooks, but I wanted more. I still wanted to make it in the national scene and shoot more on the pro level of sports.

In 1996, my regular job with Boeing changed. The company wanted me to move to the Los Angeles area to become a technical representative for all the outsourced work in the area. I immediately thought about all the sporting events that would be occurring in the area. My selections seemed limitless after living in Wichita, and Los Angeles had plenty to offer. Although I didn't have contacts into the Lakers for professional basketball or the Kings or Ducks for professional hockey, I knew I could try the Dodgers and Angels for major league baseball and USC and UCLA events for football and basketball, and even the San Diego Chargers and Padres were just a short hour and a half drive away. I just had to figure out a way in.

I eventually used my connections from the Wranglers, who are the Double-A affiliate of the Kansas City Royals, and my affiliation with Wichita State to get into the Dodgers and Angels games. These organizations wanted to have images of the former players who passed through Wichita in their professional uniforms. Of course, for me, it was just a way to continue shooting and to make more contacts.

That summer, I photographed as many baseball games as I could. I was still meeting other photographers and learning as much as possible. I even met with the Associated Press and was offered a position, but I decided it would've been too hard working two full-time jobs. Regardless, it was time to get serious. I had heard about a sports photography workshop that took place in Colorado Springs, Colorado, at the sight of the U.S. Olympics training facilities. I thought by attending, I would learn more from the world's top sports shooters. Photographers whose photo credits I had seen in *Sports Illustrated* were there, giving feedback on our portfolios and showing us their work in evening slide show presentations. I didn't really learn about any new techniques or ways to go about shooting, but being around 40 or so people who were interested in pursuing sports photography like I was had been worth it. I met some great people, and several are still friends whom I keep in contact with to this day.

One of these individuals was a shooter from Dallas named Walt Smith. We had similar backgrounds and similar opinions, and we hit it off immediately. Walt had been shooting Dallas Cowboys games for years and had a way into NFL games through his role as the official photographer for the Pro Football Referee's Association. He also shot for a company called ProLook, which at the time had an NFL license and sold 8×10 photo prints for consumer sales. By the time the weeklong workshop had ended, Walt said he would help me get into NFL games if I could shoot some referee stuff for him. ProLook would also review my images to consider them for their sales. I jumped at the opportunity. I knew the only way to get better was to continue to shoot as often as I could.

I still traveled back to Kansas City occasionally and kept my connection with the suburban newspaper to get into the Chiefs games, but I knew that connection wasn't going to work at other NFL locations. Therefore, I spent the next two football seasons shooting for Walt and gaining more experience. By this time, I had worked up to the Nikon F4 and then F5 auto-focus camera bodies and a 400-mm f/2.8 auto-focus lens. Now I had the equipment, and I had a way in. At that point, I wondered how I could get published in some magazines.

I had attempted several times before moving to Los Angeles to get noticed by various magazines. I had sent images into the annual magazines such as *Athlon Sports* and *Street & Smith's*, but the usual response I received, if any, was that the magazine would contact me if it needed a photographer in the area.

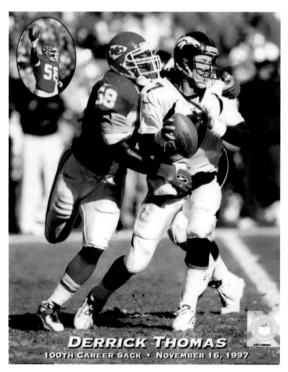

Working for ProLook led to my first licensed images being produced. ©G. Newman Lowrance

I even sent some images to *Sports Illustrated*, considered the best magazine of sports photography. I received a nice letter back from one of their editors, telling me in a nice way that my work was good, but it wasn't seasoned enough. Looking back, I had tried too soon. I didn't have enough experience yet, but I knew I was getting there.

Unfortunately, the next few years, I started to feel disgruntled with the whole process. It was hard even with Walt's connection with the referees to get into games because, on occasion, we were denied credentials. My regular job was keeping me really busy, and working 50–60 hours a week wasn't out of the ordinary. I also got married in the fall of 1996. Life was changing. I started to understand how competitive the profession was. Most of the shooters on the sidelines had the top-line equipment, which had closed the gap from the great shooters to all of the rest, so almost everyone could get some great photographs. Nonetheless, I realized it still took a great eye and feel for the events to capture a good picture, and that's what kept me going. But I was beginning to give up hope to make it any further, and I revised my thinking to being content just getting into games when I could and enjoying photography.

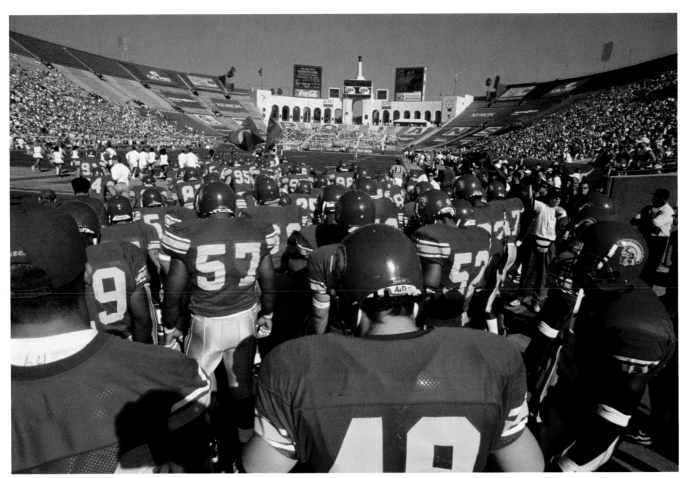

Shooting at the Memorial Coliseum in Los Angeles was part of my new start in photography.
©G. Newman Lowrance

I kept shooting in this manner, and I eventually worked with a small local agency in the Los Angeles area. At least through them, I could get into the local college games at USC and UCLA, and I continued to shoot the Dodgers and Angels

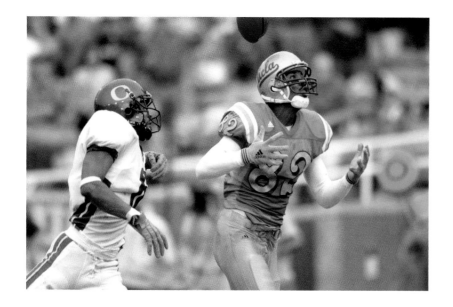

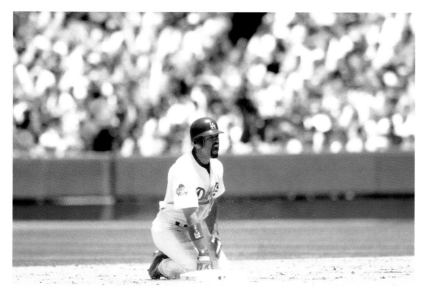

After moving to southern California, I eventually shot USC, UCLA, Dodgers, and Angels games. ©G. Newman Lowrance (4)

games; however, I still felt like I was stuck in my pursuit. I wasn't getting anything major published, but every now and then I had a couple of shots in an annual or monthly newsstand publication. It was nice to see my name on the credits, but I knew my work was good enough to be published more often. I just felt like I hadn't gotten the chance. Little did I know I was about to get the opportunity.

My Big Break

The great thing for me about living in Los Angeles (besides the weather) was the advantage of being a 1-hour flight to the Bay area or Phoenix, and the short drive to San Diego. Because of this, most of the NFL games that I covered were Chargers, Raiders, 49ers, or Cardinals games. I was always running into other shooters on the sidelines whom I recognized, and I eventually came to know many of them. One of these photographers was Kevin Terrell, who was employed by NFL Photos, the league's direct source of photography. I didn't realize then that Kevin was their managing editor, who worked under Paul Spinelli. I had heard of Paul before, but I had never tried sending images or my portfolio to him.

During my brief conversations with Kevin during a game, we usually just said hello or chatted a little about the game. I also saw him on occasion at LAX airport before flights to a game. He occasionally asked to see my work. I figured he just wanted to give me some advice. This went on for a couple of years when finally, late in the 1999 season during a game in San Diego, he asked me, "Are you ever going to send me some of your work to look at?" I didn't really understand why he had kept asking me, figuring he was just a photographer for the NFL. He gave me his business card, which said he was the managing editor for NFL Photos. I was almost in a state of shock. I had no idea he was an editor. I had almost given up on latching on with an organization or magazine. I told him I would send in something right away, although inside I was kicking myself for seemingly giving up on making any real contacts or getting published more often.

That night, my drive home from San Diego flew by. I was thinking about which images I should include to send in. I knew my work was good enough; maybe this would finally be my golden opportunity. I searched through my last few years of work, had prints made up, bought a nice portfolio book to include my images, and sent them and a few slides off to Kevin.

For the next several weeks, I kept calling my wife Kami from work, asking about the mail. I didn't really know how long it would take for him get back to me, but I was eager to know what he thought. Two months had gone by, and one day my wife phoned to tell me a FedEx package had arrived from Kevin. Of course, I raced home. "This is it," I thought. "I either go on with this pursuit, or it will just have to stay a hobby." I opened the package and read the letter. He liked the work and kept a few of my slides for the NFL library for future considerations. He also added me to their photographers' list. In short, I was in.

"Welcome aboard" was his closing. Those two words meant everything. I would be one of their contributing photographers. Although I still had to foot the bill to get to games because most of the work for them was "speculation," I no longer had to worry about getting credentials into games. Best of all, the managing editor of NFL Photos would be reviewing my work on a consistent basis. Now all I had to do was produce.

I finally found a home and eventually worked my way up
while shooting for NFL Photos. ©G. Newman Lowrance

Shooting for the NFL

My first game for NFL Photos was a preseason game in San Diego against the Minnesota Vikings. I'll always remember being somewhat nervous, just knowing I would be turning in my images to be edited and critiqued. Even the drive down to San Diego was an adventure because traffic was worse than usual, which is saying a lot for southern California. It took me more than four hours to get to the stadium, and I barely made the kickoff. I sure didn't plan to shoot my first game for them in a panic, but once I started shooting, it was business as usual.

Luckily, a preseason game is just that, for the players and photographers both. It's a warm-up for all to prepare for the upcoming season. As it turned out, it was finally a real beginning for me to get somewhere in this world of sports photography, and it was the start of good things to come.

My first year with NFL Photos was definitely a learning experience. My sales seemed slow at first, but after speaking to other shooters, I found out that wasn't a bad sign. Most other shooters went through the same thing. With such an enormous number of images coming into the offices on a weekly basis, it took time for my images to build up in the library for all of the various publications. However, once it got going, I was extremely pleased. Before I knew it, I was being published consistently in Super Bowl programs, Pro Bowl programs, *NFL Insider* magazine, *NFL Gameday*, NFL calendars, NFL videos, and so on. When my published images started to appear, I kept copies of them in a small box. After a while, I needed a cabinet to put everything in. I was also shooting preseason, regular season, and playoff games all over the country, and I enjoyed traveling to the various venues. It was the crowning achievement to all the years of just getting in to shoot, to learn and get better, and finally, to be noticed.

Unfortunately, I shot with NFL Photos for only four seasons, but it ended on a high note. I was part of the team to shoot the last Super Bowl that NFL Photos would ever cover. The game was in Houston, Texas, between the Carolina Panthers and New England Patriots on February 1, 2004. Not only was it a great game, but it was also a fitting conclusion of my ultimate goal to photograph such an event. The only downside was that we knew this was the final game. The NFL league office had decided to close down the photo services department in the fall of 2004 and outsource the league's photography to two separate companies: Getty Images and WireImage. Both companies agreed to split the commercial license for sales and have the option to bring in some of the contributing photographers that I was a part of. Although some of us had offers to go with either company and to continue shooting, the idea that NFL Photos would no longer be in existence was a hard pill for me to swallow.

This image will always remind me what I know about editing. I almost didn't send this to NFL Photos, figuring it was nothing special. It ended up being selected as one of the "Best Shots" of 2001 ©G. Newman Lowrance

I always felt a great sense of pride when I received my game credentials, knowing that I was shooting directly for the league. It was a long way from when I got in through a suburban newspaper, and I didn't want it to end. As I look back now on all of the events I photographed, the people I met, and the working relationships I built, I realize what an absolute pleasure it was to have been a part of that. And even though it was a sad day for me to see it end, the satisfaction of my success during this time will always reside with me, and working for NFL Photos was a major part of that success.

This shot of Charlie Garner of the Oakland Raiders hurdling was another selection to the "Best Shots" series included in each year's Pro Bowl programs. ©G. Newman Lowrance

Shooting my first Super Bowl in February 2004 was the crowning achievement in my personal goals.
©G. Newman Lowrance (3)

Moving Forward

As the Super Bowl ended, I knew that I would eventually have to make a decision about my future. Throughout the spring and summer of 2004, I had discussions almost daily with several other photographers who were in the same situation, and we were all trying to decide which way to go. After many sleepless nights trying to come up with an answer, I ultimately made the decision to go with WireImage for the 2004 football season. Sure, it was a tough decision, but at least I was fortunate enough to have a choice in where I ended up. Only the future will tell me if I made the right move. All I can do now is continue to work hard and continue to learn.

I now upload my images to WireImage instead of NFL Photos, which means posting images immediately after games for various types of use. In the "old days," if I had a great editorial shot, it might not see the light of day for months, if ever. With the "live" Web site of my uploaded images, clients can see my work immediately. That paid off for me during one stretch in October. *ESPN The Magazine* ran double-page spreads (one of which is the cover of this book) in back-to-back issues in their "Zoom" section, which was followed the next week with a leadoff double-page spread in *Sports Illustrated*. I was thrilled for the accolades that come with this type of accomplishment, but at the same time, I wasn't surprised. I knew my work had improved a great deal. However, it also makes me wonder how many of my images in the past might have been considered for these publications if NFL Photos had operated with a live site. Regardless, the benefit of immediate postings for my images could mean more such opportunities in the future.

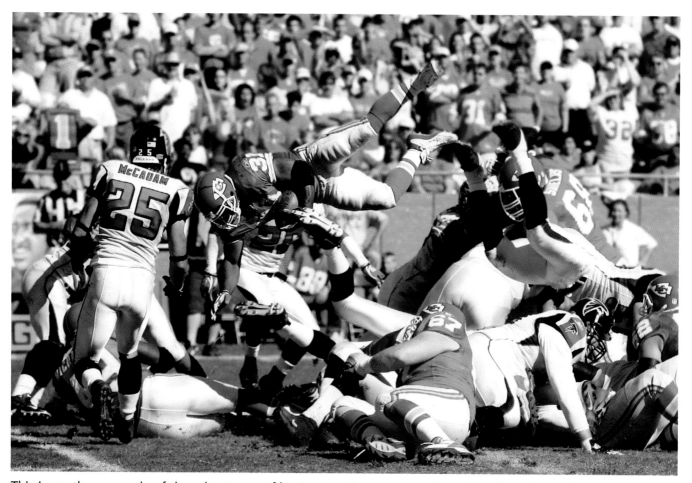

This is another example of the advantages of having your images posted to a live site, where clients can view them immediately after games. This shot of Priest Holmes of the Kansas City Chiefs leaping into the end zone was used in a double-page spread in *Sports Illustrated*. ©G. Newman Lowrance

My first season with WireImage ended up being quite successful. It concluded with another selection to the Super Bowl team, this time in Jacksonville, Florida, between the New England Patriots and the Philadelphia Eagles. It made me think back about shooting those high school games for free, and I realize now that it was well worth the effort. All those years of slowly upgrading my equipment, improving my skills, and making more contacts have resulted in my getting this far.

Ultimately, I have pursued and achieved the goals that I have set for myself, and it's been a dream that I've lived out. Anyone else who works hard, is determined, and makes the effort can do the same thing. Even after all these years, I'm still amazed by this world of sports photography. Somehow, the feeling of capturing a great image while freezing a moment in time is still a thrill for me. I imagine it always will be.

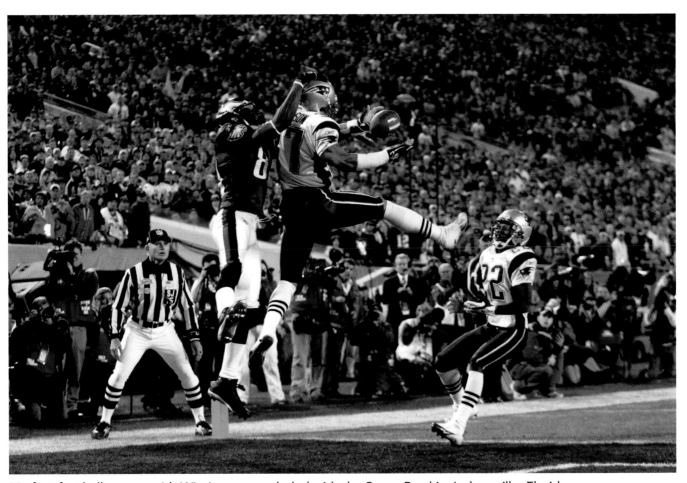

My first football season with WireImage concluded with the Super Bowl in Jacksonville, Florida, between the New England Patriots and the Philadelphia Eagles. ©G. Newman Lowrance

From Film to Digital: The Transformation

CHAPTER

2

As a sports photographer for many years, I've seen my share of changes in the photo industry. From the old manual-focus bodies and lenses to the revolutionary digital world, photography has undergone many significant advances in the past several years, with undoubtedly many more to follow. During my college days, I started shooting sports with a motor-driven Nikon F3 camera, which was a manual-focusing camera and at the time probably the most widely used and fastest camera in terms of frames per second for photographing sporting events. It was also an extremely durable body, and at 6 frames per second, you were able to capture some great images with that type of speed versus using a camera without a motor drive. During this period, most photographers also were equipped with manual-focus lenses, but soon afterward, auto-focus lenses made their appearance. These lenses have since improved their optic quality, become lighter in weight, and provided faster auto-focus tracking capabilities. Film format cameras also improved, with Nikon and Canon eventually releasing film bodies that shot 8 and 10 frames per second, respectively. Although all of these improvements helped the shooter immensely, the industry would soon discover the biggest change of all: the digital camera.

Digital Choices

When I first began shooting sporting events, the only choices I was concerned with were what kind of camera to purchase and what brand to choose. Although I saw several makes and models on the sidelines over the years, Nikon and Canon always led the sports world in terms of usage then, and they're still the brands that most sports photographers choose today. If you are fortunate enough to have either system, you are probably serious about your photographic adventures or at least have the financial means necessary to obtain such equipment. Both Canon and Nikon are the top of the line for sports photography and provide the latest digital technology advances available. They also consistently battle for sales and usage. This benefits photographers because the two companies constantly develop new digital bodies as the technology continues to improve.

Digital Advances

With digital cameras now selling more than film-format cameras and the technology for these digital cameras changing practically every day, it's difficult expense-wise to keep up with all the advances. The advances in digital cameras today are similar to those in the computer technology field. In the film days, you didn't see these types of frequent technology advances. You could use the same film body for many years. Today, however, new digital bodies are being released so often that your digital camera is outdated almost from the minute you buy it.

Whether for the good in terms of technology or the bad in terms of expense, digital photography has replaced film photography on the sidelines of the sporting world. So far I've been able to keep up with the latest technology advances, expensive though they've been. For example, in the past four years alone, I have purchased a pair of the latest digital cameras not once or twice, but three times! Other professionals have purchased more, but you get the idea. To make matters worse, the cost of digital cameras is higher than the old film cameras. Even before digital cameras started to appear, the latest professional film bodies could cost you as much as $3,000, so it wasn't an inexpensive situation anyway. However, obtaining the latest professional digital cameras costs you even more, upward of $4,000 depending on the model and brand.

Professional Versus Nonprofessional Cameras

Before digital photography, you could get by with a nonprofessional camera using film because a good shooter could still obtain great results, given his skill level. The bottom line was that film was film. Digital is different because these cameras have several distinctive differences in terms of specifications like image sizes, file sizes, pixel count, white balance options, exposure metering, motor drive speed, buffer size, and so on. With film bodies, you were mainly concerned with how fast the motor drive was. Now your choices with digital bodies are seemingly endless for both the consumer and professional photographer. The professional-level digital cameras are faster, allow for more control, and for the most part have larger and better imaging specifications than the less expensive consumer-type digital versions. Both Nikon and Canon have produced mid-range digital cameras that fall between the consumer and high-end professional cameras. These cameras do a remarkably fine job but have certain limitations, such as speed and full professional-level customization. Granted, it is your decision whether to keep up with all the changes, but if you choose not to invest in the latest technology, you will probably find yourself left behind the majority of professional shooters who do. Just remember that you can tailor your digital camera purchases to meet your photo needs and budget and still get professional-level results.

The Film Process

For the film shooters of the past 25–30 years, the process was pretty standard. The majority of us photographed the event, developed the film, printed a proof sheet from negatives or viewed the slide film images with a loupe, and then selected the best pictures. Perhaps we made prints to submit for publication, depending on what we were shooting and whom we were shooting for.

On the other hand, many newspaper photographers who shot color negative film took their film back to their office after the event for processing, editing, scanning, or printing. Users of transparency film had a similar process except that they had individually mounted positive film images to send off for the editors to choose from.

As a freelance photographer, I generally took my film to an E-6 film processing lab and then waited for them to complete the processing, because the only deadline I had through my work with NFL Photos was to have my film to them within 2 weeks of the game. This processing step took time and money that I don't miss in today's digital world, but I still miss editing my chrome images through a loupe and seeing the vibrant colors of transparency film. Of course, one disadvantage for users of film-format cameras is that you don't know if you have captured a great shot until you process the film. In some ways, waiting to see your images after processing is a nice mystery. Coming across an image that captures a great moment is always special. Conversely, you might think that you took a great shot, but it didn't come out quite the way you imagined. These procedures for using film, although now presently outdated for most professional sports photographers, served a great purpose for many years. Although using film is still an option, especially for youth sports or for new photographers starting out, it is no longer used for major sports publications in today's digital world.

Scanners

As the digital world started to creep in, personal desktop scanners became a major tool for photographers wanting to submit digitized images or to store digital copies of images on their computers. Before digital cameras were available or affordable, computer memory and storage costs were at a premium. The boom of the computer age had yet to begin, but you could see even then that it was only a matter of time before the technology advanced completely to the digital realm. Besides being able to convert film images to digital files for archiving purposes, scanners allowed you to e-mail preview images to various clients for a quick look. However, the most common method was to submit original film so that the publisher could scan it. The main use for desktop scanner–derived scans, besides client previews, was for newspaper and wire service submissions, because the output was generally not up to high-end printing standards.

Scanners in the Marketplace

The number of manufacturers that produce the high-end press scanners such as drum and high-resolution flatbed scanners has decreased over the past several years due to a lack of sales. Only a few manufacturers now produce high-end

film scanners, and there have not been many major technological advances in hardware in the past few years. Most of these companies have simply tried to keep up with computer operating system changes and connectivity while making only minor hardware changes. The only big changes that have occurred have been with the desktop scanners. Cheap flatbed scanners are now capable of decent output, and the desktop film scanners from Nikon and Hassleblad/Imacon currently produce scans that are closing in on the scans that the high-end output houses produced a few years ago. There is a growing market for desktop scanners for professional and consumer digital photographers alike. Because computer storage has become so inexpensive and available, it is a good time to start scanning and archiving old, fading film. You can get a good desktop scanner for less than $2,500 including software, which is still cheaper than buying most high-end large mega-pixel digital cameras. In other words, there is still life left in your current film cameras. Don't forget that you can also create almost any file size you need with a scanner.

Role of Scanners in Photography Today

From the film-format days, I have accumulated a large archive of older photos that could possibly be gaining historical and resale value. As mentioned earlier, film shooting required that original material was sent to the client and then scanned for the client's use. Now most clients want digital images delivered to them so that they can avoid the cost of scanning and the liabilities of handling original film. They have embraced a digital workflow and don't want to handle film. Many clients have developed FTP sites in which you can download digital images directly to a server, and the rest accept digital images on CDs and DVDs. Most of the major stock photography agencies now sell only digitized content because they no longer want to risk sending original film images. This presents a new dilemma for photographers because the only images that sell are digital, and most digital images have been produced only in the past few years, as digital cameras have become the mainstream. Many photographers now invest in desktop scanners so that they can digitize their older film stock for submission to stock agencies and clients.

A Nikon Super Coolscan 5000 with Lasersoft's Silverfast software produced many of the scanned film images in this book. It is not difficult, with good color profiling of the scanner (a 35-mm color target is supplied with the Silverfast software), to produce excellent scans that are dust free, thanks to Digital Ice dust removal software. My enthusiasm for digital photography has made me realize that there is going to be a big demand for scanned older images. Currently, only a small percentage of material shot before the year 2000 has been digitized. As this film and its content age, there is going to be a much greater demand for archiving in a digital format. That is why film and scanners still play an important role in the world of photography.

Film cameras produce a unique look compared to digital cameras because all prime lenses retain their original focal lengths and the corresponding effects of the original focal lengths. This is especially true with the short focal length and wide-angle lenses because you lose their qualities when you use them on a digital camera. The small CCD (charged coupled device) and CMOS (complementary metal-oxide semiconductor) sensor chip areas of the digital cameras reduce the image area that is captured and multiply the focal length of all lenses. This factor of 1.3X to 1.5X in lengthened focal length means that you can capture many effects only with film cameras when shooting with wide-angle lenses.

First Use of Digital Cameras

Wire service photographers who worked for such agencies as the Associated Press, United Press International, and Reuters and a few larger newspapers were the first main users of digital cameras, starting in the early 1990s. These first digital cameras were bulky, had a slight delay on the shutter release button, and were slow in terms of consecutive bursts, or frames per second. They also suffered by comparison to today's cameras from poor image quality, minimal storage capacity, and poor battery life. They were mostly hybrid cameras that were the result of marrying electronic film bodies to digital backs and self-contained battery packs. Kodak was the leader in producing these cameras and developing the early digital camera technology. These first digital cameras were expensive, with costs almost three to seven times those of current cameras. Of course, at the time, they were the latest technology available, and the industry welcomed them.

Another limiting factor in the daily use of these early cameras was the poor browsing and imaging software and computers that had limited storage capacity and processing speeds. The original image viewing software was proprietary to the camera manufacturers, and Adobe Photoshop wasn't particularly easy to use until version 4.0 was introduced. Also, the Internet was just developing, and transmission of digital files was done mainly on analog phone lines using early laptop computers and self-contained scanner/transmitters made by AP/Leaf Systems. Today's more elegant software, high-speed, large-capacity computers, and high-speed data lines have made this work quick and effective for deadline-oriented agencies and publications. The digital photography world has seen a level of progress since the early 1990s that equals the rapid advance in computer technology during this same time.

The biggest advancement in digital photography arrived in 1999 when Nikon introduced the D1 digital camera body. It sold for less than $4,000, used removable compact flash cards for image storage, and had all of the functions of a traditional film camera. The batteries were removable and rechargeable so that the photographer could carry as many as needed, and the auto focus and light metering

worked well. The camera was not particularly fast in terms of motor drive speed, but it was a huge improvement on previous cameras. It produced a high-quality image file size of 7.5 MB and allowed for automatic and preset custom white balancing for good color quality. This file size equaled a full-frame 35-mm film image scanned to 6.6" ×10" at 200 dpi, which was quite adequate for newspaper use. The camera had a dedicated flash system that worked extremely well as opposed to the previous hybrid cameras, in which you often had to dial down the flash by three or four f-stops to get a remotely decent exposure. Also, the camera was made entirely by Nikon and did not share parts with other companies. At half the price of the Kodak NC2000 with almost none of the drawbacks, this camera became the platform for the current cameras that Nikon and Canon have been refining to this date. The modern age of digital photography had arrived, as had comparable advances in software and computing hardware.

Contemporary Use of Digital Cameras

The advances in digital cameras have been as rapid as the changes in the computing industry. The early cameras mentioned earlier were adequate for the news industry but did not produce the file sizes and image quality that were needed for the commercial and high-end publishing markets. Large megapixel digital camera backs have been developed for medium-format cameras to meet the needs of this segment of the photography industry. The introduction of Canon and Nikon's new large-file (12.4 to 16.7 megapixel) 35-mm style cameras has produced cameras that can now be used for almost all aspects of photography. The professional-level digital cameras that are used today, such as the Canon EOS-1D Mark II or Nikon D2H and new D2X, are extremely fast. They have no delay problem and can shoot up to 8.3 frames per second.

Canon now has two professional-level cameras that meet the needs of a wide range of photographers. The Canon EOS-1D Mark II is a high-speed 8.3 frames per second (fps) 8.2-megapixel camera for the action shooter. The Canon EOS-1Ds Mark II is a 16.7-megapixel camera that is capable of shooting 4 fps with extremely high image resolution for magazine and advertising shooters who need the file size. In addition, Nikon just introduced its newest camera, the D2X, which can shoot full-resolution 12.4 million pixel images at 5 fps (up to 21 consecutive JPEGs and 15 NEFs).

When the situation demands yet faster frame rates, the D2X has a unique 6.8 megapixel High Speed Cropped Image mode that boosts the shooting rate to 8 fps (up to 35 consecutive JPEGs or 26 NEFs) by cropping the number of pixels used on the sensor to create the image. This also provides a focal length multiplier in the 12.4-megapixel mode of 1.5X and 2X in the High Speed Cropped Image mode so that the camera serves a wide range of photographers' needs.

I held out as long as I could to switch from film to digital because NFL Photos seemed to prefer transparency film images for its clients. However, during the 2001 NFL season, I finally purchased my first digital body: the previously mentioned Nikon D1H. This camera offered approximately 4.5 frames per second and a 1.5 multiplier of focal lengths on all lenses without a loss of f-stop, which was an advantage that I grew fond of. This meant that while I was using my 400-mm f/2.8 lens, it was automatically "converted" to a 600-mm f/2.8 lens. This was great while shooting in a dimly lit event or indoor dome game because I usually avoided using a teleconverter because of the loss of one f-stop. This added focal length for long telephoto lenses is a definite plus in going digital. Although 4.5 frames per second seemed slow when I compared it to my film body—a Nikon F5, which could shoot almost double at 8 fps—I could already see some major advantages when it came to using digital technology.

The initial users of this early digital equipment had to adjust to shooting events digitally with the delay that I mentioned, and they were required to send images to various newspapers or agencies during and after an event using a laptop computer. The upside is that photographers no longer had to waste time processing or developing film in a darkroom. For those wire shooters who had previously used film, stadiums at the major college-level and professional ranks usually provided darkrooms for these press photographers to process the film right there at the event. Today, photographers don't need to process film, but merely edit and caption the images on a computer before e-mailing or using a File Transport Protocol (FTP) process to send images directly to their clients.

The majority of sports photographers who are using digital equipment are adding a laptop computer to their shooting equipment so that they can upload their images immediately as more companies have gone to the digital side. The old darkrooms that stadiums used to provide for us have been converted to workrooms for the photographers who need a work area to process and transmit images. Many venues are also providing high-speed data lines so that photographers and editors can send multiple images in a short amount of time. Although in some ways the additional time required on the computer editing images is a negative, the speed at which images are handled in today's world is a definite plus. Editors and publications now can view hundreds to thousands of images in an instant from several wire services and photography-driven Web sites. Newspapers and other publications can use these downloadable images from events all over the world. In short, the use of digital images is faster, far more convenient, and less expensive for publishing than film is.

The Digital Workflow

With the learning curve somewhat established by the early digital news photographers, the race is on to see what the next new software and hardware improvement will be and who will one-up the current line of cameras. I have been an advocate of using a straightforward digital workflow for shooting, acquiring, processing, and delivering my images to my clients. I've stuck with using well-developed imaging software for the past five years. It has undergone constant revision to keep up with camera and computer changes.

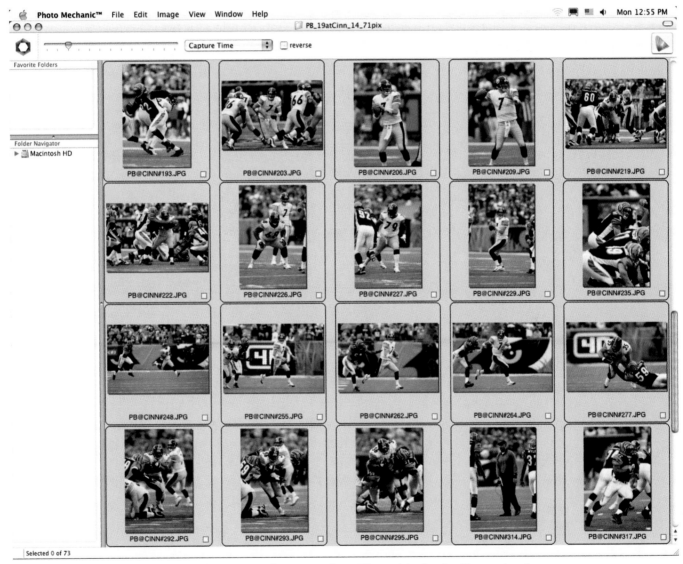

Many sports photographers use browser software such as Photo Mechanic. Illustration images
©G. Newman Lowrance

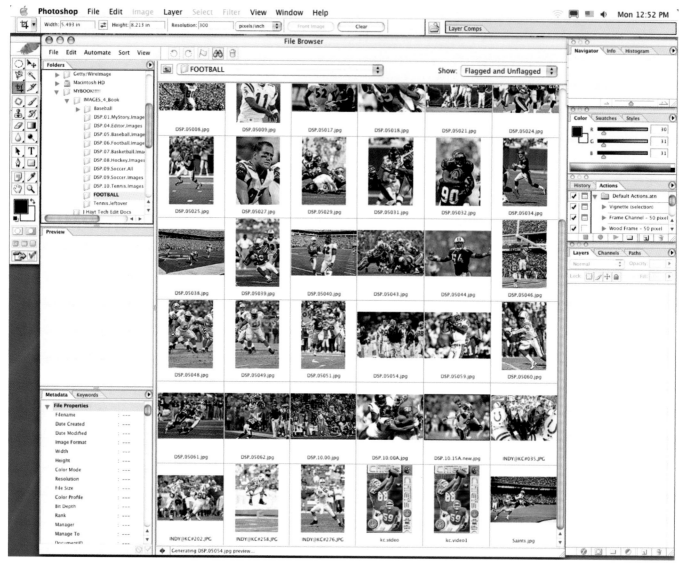

Adobe Photoshop is another popular browser that many sports photographers use. Illustration images ©G. Newman Lowrance

Certain basic camera settings seem to make a big difference in image quality, so proper camera setup is critical. The first two are the contrast and sharpening settings. Almost every digital camera that I have seen has default settings that work well for the nondiscerning photographer but leave a lot to be desired for high-quality output. Go into your camera menus and turn off or set the image contrast to the lowest setting available. Most digital cameras have a tendency to overexpose the highlights in the image; making the change to the image contrast allows you to retain highlight details.

The default settings for sharpening vary from camera to camera. I experiment with every new camera until I find what looks good without over-sharpening the image. It is better to be a little less sharp in the camera and do your sharpening in Photoshop, where you can control the results.

It is also important to set your camera for the AdobeRGB1998 color space because this gives you the widest range of color besides shooting in the RAW mode. Also make sure that your RGB color settings in Photoshop are set to AdobeRGB1998 and that the color profile is embedded in the image file. The RAW mode files are simply raw image captures that do not get processed through the internal software of the camera (sharpening, contrast, color balance, and so on) and must be processed through RAW processing software such as that found in Adobe Photoshop CS and other aftermarket image processing software.

One last little item is to always make sure that you turn on file number sequencing in the setup menu so that you don't duplicate file numbers every time you put a new card in the camera. I find that the auto white balancing works pretty well for most daylight conditions. I always create a preset white balance using a gray card when I shoot indoors under available lighting conditions or when I shoot on a strobe light setup. This really helps to eliminate the weird colorcasts that many modern and not-so-modern indoor light sources create. Most auto white balancing can't compensate for these mixed light sources, so take the time to learn how to do preset custom white balancing and avoid extra work when you have to process your images.

Most photographers that I see working in the various media workrooms around the country use similar but minor variations of the same software for image acquiring and processing. I keep my methods simple so that I can repeat them for consistent, mistake-free results. I follow a simple system so that I don't make mistakes during this process. My first step after I have removed a compact flash card from my camera and inserted it into my computer's card reader is to open the disc and view all contents as a list. Canon cameras generate multiple folders on a disc, so you don't want to miss one by viewing it as an icon. After that, I create a folder or set of folders if I want to separate the event by periods and then select and copy each card folder to my desktop folders. When I complete the download, I immediately eject the card and place it back in the camera so that I don't forget to have a card in the camera. I don't reformat the card until I am finished editing and saving my files. I also reformat my compact flash cards in the camera every time I replace them in the camera. Do this with the camera menu settings for a proper reformatting.

After I download my images to the computer desktop, I open them in a photo browser for viewing and editing. I use Photo Mechanic by CameraBits.com, although there are other excellent browsers such as FotoStation, iPhoto by Apple, and the browser used in Adobe Photoshop. Photo Mechanic is a stand-alone application that is not very expensive. It allows you to tag photos during an edit and copy them to a new folder that I call my Edit Folder. It also allows you to view photos as enlarged thumbnails or directly in Adobe Photoshop. Any browser that supports your camera file formats and allows easy editing and opening in Photoshop is the way to go.

For news photographers, it is important that the browser allows you to open the caption file that is attached to the image so that the photo can be tagged with all of the necessary caption information. You can also access this through Photoshop, but it is much faster to enter the information through the browser.

After I have finished my editing and sent the select images to my Edit Folder, I open this folder in Photo Mechanic and process each image in Photoshop. When I have finished this task, I apply the appropriate file name to the image and resave it for transmitting or delivery on disc to the client.

It is important to note that not all clients want you to do anything more than a rough edit on your shoot and then send them the untouched files. Many clients have their own settings that they are used to working with, and they do not want you to make changes that they then have to adjust to work with their output needs. Also, more and more clients want you to shoot in the RAW mode and provide them with completely unprocessed digital files. You have to own one of the professional-grade digital cameras to do this because they are designed with the ability to quickly write these large files to disc. I use RAW mode only when image quality is critical because there is minimal visual difference between a large, minimally compressed JPEG file and a RAW file, and I can shoot a lot faster and put a lot more images on a compact flash card. Also, don't forget that you need to have Photoshop CS or a RAW file processing software to work with these images.

Technical Lessons of the Digital World

All of this new technology has created an innovative way of delivering photos to clients and end users. It is also breeding a generation of shooters who seem to think that imaging software such as Photoshop will allow them to correct their mistakes and make up for sloppy methods behind the camera. This seems to be an attitude that some press photographers developed when they switched to color negative film in the 1980s, when there was a bit more latitude for compensating for poor exposure and bad lighting.

This thinking does not apply to digital photography. You need to approach the world of digital photography as if you were shooting color slide film, with its inherent lack of tolerance for poor exposure and bad lighting. The biggest issue that digital shooters ignore is the need to properly expose and color balance images, because every correction that you make in the computer means that you have removed or changed some of the original file information, which usually results in a slight loss of quality. After information is removed from a digital image, it cannot be replaced, so shoot as if you were using slide film and be meticulous in your work habits. The photographers who have been shooting for many years and have experienced the many changes in photography

over the past 25–30 years have seen how work in front of the computer has replaced hands-on work in the darkroom.

The new generation of digital shooters is not learning many of the technical lessons that photographers learned using film. The understanding of lighting, exposure, and composition in photography is now often replaced by using auto settings, with little knowledge of the fundamentals of good photographic technique.

Take the time to use your digital camera with strobe lighting setups and shoot under many different lighting conditions so that you see where the limitations and abilities of digital imaging compare to traditional film photography. The rest of this book is dedicated to providing an overview of the main sports that sports photographers come in contact with. You'll learn particular shooting methods so that you have a better understanding of all the hard-learned lessons that the writers of this book have gained over the past two or three decades of photographing everything that moves.

The Basics of Shooting Sports

Because you're reading this book, you must be interested in learning more about photographing sporting events, whether it is at the youth, college, or professional level. Shooting great action images involves everything from choosing the right photographic equipment to knowing what shutter speed to use. It won't do you any good to have the best equipment out there if you don't know how to use it. Likewise, you can't expect to get the best results if you don't have the proper equipment. The bottom line is that taking good sports photographs depends on the photographers, despite all of the high-tech equipment available in today's digital world. Other factors that influence your results include understanding the relationship among ISO settings, lens aperture, shutter speeds, and color balance, along with composition and knowing the limits of the equipment.

Equipment

The multitude of equipment that you must purchase so that you can photograph sports can be overwhelming. The choices are vast. Besides purchasing the basic digital photography equipment, such as cameras, lenses, and a computer, you need accessories. This section discusses those items that will make your life as a sports photographer easier and help protect your investment.

Camera Bodies

The selection of digital cameras changes practically by the day. You don't have the pleasure of purchasing a camera in today's world without knowing its replacement is probably already being designed or manufactured. Because of this, I'm not going to go into great detail about which camera to choose. However, after you understand some of the basic specifications and what you are getting in a camera, it should be easier for you to make a decision.

If you're like most people, one of your primary concerns is the ultimate sacrifice: How much does it cost? Most professional-level digital cameras currently sell for $4,000 and up, but the next level down from the professional models is much less, in the $1,100 to $1,500 range. Depending on your financial situation, costs might play a role in your camera choice.

Besides cost, some of the main differences between the professional cameras and the semi-professional versions are the number of frames per second that the camera is capable of shooting, the image file size, the auto-focus capability, and the buffer speed and size. Most of the professional-level bodies provide around 8 frames per second, whereas the higher-end consumer/low-level professional models are generally in the 3.5 to 5 frames per second range. The professional cameras are also capable of producing larger file sizes while capturing and writing these files to your removable storage (compact flash cards) much faster.

In addition, the auto-focus tracking and speed are much faster and more accurate on the professional cameras. It is money well spent if you want to ensure that your equipment is producing the best possible results that your skills allow.

When you're trying to decide on a camera, you need to be aware of several specifications. Two of the more important elements are resolution and frames (or bursts) per second. When you're shooting sports, the faster the bursts, the more images you capture on a given play. This leads to your having several different images to choose from on a given sequence. Out of these images, some will be better than others, but it's important to have a choice. It's easy to visualize the importance of this. If you have a camera that captures 8 images per second versus one that captures 4 images per second, the faster camera allows you to capture twice as many images in the same period of time. In terms of image or resolution size, a higher-resolution image reproduces in a publication better than a lower one.

As mentioned previously, your financial situation might offer the best reason for your final selection, but you should definitely check out all the camera specifications before you decide which one to purchase.

Camera Basics

Even though most of the newer digital and so-called "automatic" cameras today don't require you to set the aperture and shutter speeds, you still need to understand what these do so that you can shoot quality photographs. I generally photograph using manual exposures anyway, at least when the lighting allows, because a basic light meter reading can often provide better exposures than letting the camera decide them for you. Even though this practice isn't as frequent in today's digital world, which leads to some post-production modifications to your images with software programs such as Photoshop, I find reassurance in using manual settings.

In the days of shooting with transparency film, you needed to be dead on with your exposures or your images would be under- or overexposed. Just remember that shooting digital photography requires the same level of precise exposures as shooting transparency film. There is no leeway here, and the idea of fixing something like this in Photoshop is one of digital photography's great fallacies. Every adjustment that you make to an image in Photoshop creates a change in the pixel structure and content of the original image. As you make changes, you remove information, and this information is never replaced.

The best quality that you can obtain in digital photography is through proper and exacting exposure when the image is shot and not in post-production image processing. This is probably the reason I still use a light meter to this day. I do, however, use the automatic features if I'm on a field that is half shaded, or when I'm shooting at an event when the clouds are moving in and out of the sun's light rays and changing the exposure from moment to moment.

In today's sports photography world, many shooters use these automatic features exclusively, although they might "tweak" their exposures using the camera's features to do so. An example of this might be to add plus 1/3 or plus 2/3 of an f-stop to an automatic exposure to gain some detail in an image that otherwise might be underexposed using the camera's automatic features.

Aperture

The aperture and shutter speed settings work together to control your exposures for a given image. The *aperture* is basically the opening and closing of your lens iris diaphragm, which changes in size and allows more or less light to enter through the lens, depending on your setting. It's similar to the way your eyes change as you leave a dark setting and walk into the bright sun. The iris in your eyes gets smaller to allow less light and gets bigger to allow more light. The aperture in a lens works the same way. These aperture control features are called *f-stops.* They are usually found embossed into your len's rear ring near the camera mount. These f-stops usually range from f/22, f/16, f/11, f/8, f/5.6, f/4, and f/2.8 on your lens. The best way to remember how it works is this: The bigger the f-stop number, the smaller the opening that your lens allows light to pass through. In addition, each higher number lets in half as much light as one number lower. For example, an f/4 setting allows twice as much light as an f/5.6 setting, whereas an f/8 setting lets in only half as much as f/5.6. Most digital cameras allow you to set either 1/3 of 1/2 f-stop increments electronically in the camera for finer adjustments of exposure. Remember, however, that these aperture settings need to correlate with your shutter speed so that you obtain a proper exposure. Here's an easy way to remember your depth of field control: The higher the number, such as f/11, the greater the depth of field. A lower number, such as f/2.8, allow less depth of field.

For an elementary look at how aperture controls your final image output, I'll use my boys Jordan and Austin as examples. These images were taken with a 70–200 mm zoom lens, so it's easy to distinguish the depth of field using a high and then low aperture. I shot Figure a with an aperture of f/2.8 and a shutter speed of 1/2000 of a second. Notice how only the main subject of my focus, Austin, is in focus, while everything behind him is blurred. Now notice figure b. I shot this image with an aperture of f/11. You can easily see the difference between the two figures. With Figure b, Jordan and practically everything else in the image are in focus. Note, however, that with a shutter speed of 200, you see a little blurring with Jordan's hands.

Shutter Speed

The shutter speed controls the amount of time that light is allowed to expose the image. The shutter opens and closes at varying speeds to determine the amount of time that the light entering the aperture is allowed to provide the exposure

Figure a. ©G. Newman Lowrance Figure b. ©G. Newman Lowrance

of the resulting image. Shutter speeds on cameras are measured in fractions of a second. A 500 setting means 1/500 of a second, a 250 setting means 1/250, and so on. Most professional digital cameras today typically provide shutter speeds ranging anywhere from 30 seconds to 1/16,000. A shutter speed setting for a bright, sunny day, using an aperture of f/4 and an ISO rating of 100, might be 1/1000 of a second or even faster if you are shooting a subject that is front lit. A cloudy day might use 1/500 of a second with the same f/4 aperture and ISO settings of 200 or 400, exposing to allow light for a longer period of time. Of course, you need to know what your settings should be to get a good exposure. You can do this by using a light meter as previously discussed or by using your automatic exposure and built-in light meter features in your camera. Also, knowing what you want your final result to be dictates your choices on exposure, whether you want to freeze the action with a fast shutter speed or control your depth of field with the aperture. Whatever the circumstance, the light readings that you obtain offer many choices for choosing your exposure.

Because the shutter and aperture settings approximately halve or double the light reaching the final exposure with each change in setting, you can use different combinations of settings to create a good exposure. For example, perhaps you take a light meter reading that reflects a 1/1000 of a second shutter speed with an f/4 aperture setting at ISO 100. You could also shoot this at f/5.6 and 1/500 of a second. Besides shooting this second exposure at half the shutter speed, you also gain one f-stop for more depth of field with the f/5.6 setting.

Just remember that the benefit of additional depth of field, which gives you a greater depth of focus, is almost irrelevant when using a lens that has a focal length longer than 180 mm. Because most sports photography is done with long telephoto lenses, shooting with a minimal depth of field keeps your background out of focus and helps isolate your subject from the background, making a visually stronger photo. If you look at the depth of field hash marks on telephoto lenses, you'll see almost no real gain in depth of field from f/4.0 to f/16. Always opt for a higher shutter speed and maximum or close to aperture because this freezes the action and makes a sharp picture look even sharper. I have seen lots of great action shots that are lost to motion blur due to slow shutter speeds, so avoid them unless you intentionally want this effect. Intentionally shooting with slow shutter speeds can bring some unique results and can be a fun way to experiment when you are in dimly lit environments.

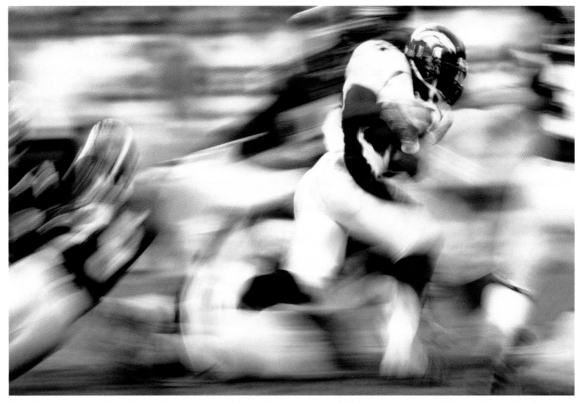

Here's an example of blurring caused by a shutter speed that is too slow. I intentionally shot this play with a slow shutter speed hoping for something dramatic to happen. Even though there's nothing special about this image in particular, slow shutter speeds can give you some interesting-looking images ©G. Newman Lowrance

The newest digital cameras have incredibly fine image quality at higher ISO settings. Experiment with your camera to see how far you can push your ISO rating before image quality suffers. It is always better to shoot above 1/500 of a second whenever possible because this is really the minimum speed to stop action and minimize blurring effects.

If each of the previously mentioned settings provides a good exposure, you might ask why a certain exposure really matters. Basically, it comes down to what is more important to you: the depth of field controlled by the aperture or the shutter speed that will freeze the action. Generally for sports, especially at the professional level, I like to use a shutter speed no less than 1/640 of a second. Here is where it can get confusing. Along the same lines that f/4 is one stop different from f/5.6, most cameras allow for 1/2 and 1/3 stops between the full f-stops. For example, from f/4 to f/4.5 is 1/3 of a stop. From f/4 to f/5 is 2/3, and from f/4 to f/5.6 is one full f-stop. You can use these intermediate f-stops to have full and accurate control of your settings. Because I don't like to go down to 1/500 of a second for a shutter speed, using the 1/3 stop faster speed cuts down on the blurring effect I might have otherwise.

Although you should now understand the relationship between aperture and shutter speeds, you should also comprehend the reason for using a large aperture opening (such as f/2.8, f/3.2, f/3.5, or f/4) and fast shutter speeds above 1/640 of a second to obtain quality sports images. Shooting an event in a dome or at night also requires you to use a wide open setting, such as f/2.8, because of the insufficient lighting, thus making your aperture setting an easy choice.

ISO

Understanding how to achieve your exposure settings using the aperture and shutter speed controls is dictated by and related to your "film" speed, otherwise known as your ISO rating. The *ISO rating* is a numerical rating that describes the light sensitivity of your "film," or in the case of digital cameras, the ability of the sensor chip to acquire an image at a corresponding rated exposure.

Previously, if you were using film, you needed to change the film cartridge to a higher ISO film or "push" your film during processing so that it was rated at a higher ISO. With digital cameras, the ISO rating is incorporated into a simple change to your camera settings. Thus, if you feel your shutter speeds are getting too slow, such as when an afternoon day game turns into a night event, the alternative is to change your ISO rating. Usually ISO ratings range from ISO 100 to ISO 1600 on most cameras. If you recall purchasing film in the old days, you usually had choices of ISO 100, 200, or 400 for most consumer negative films. Sports photographers usually used transparency (slide) film of the same ISO ratings or purchased ISO 800 color negative film and pushed it one f-stop to ISO 1600 when the additional speed was required in dark buildings or at night.

The main difference in these ISO settings is what is commonly referred to as *grain* or *noise* in the digital world. For example, an ISO setting of 100 has almost no noticeable noise, but if you compare that to an ISO setting of 1600, you easily notice the difference in noise that this higher setting shows in the grain structure of the image. Another difference when using higher ISO ratings is the image

file size when using a digital body. A higher ISO rating reduces the number of images that a memory card can store. This is why having fast lenses with an f/2.8 opening is an advantage. Shooting a night event with a lens that opens only to f/4 or f/4.5 requires you to use an extremely high ISO setting with a slower shutter speed. The result is that your images show more noise than when you use the faster lens. Of course, if you are shooting mostly youth sporting events or events played during the day, using the slower lens is an adequate, less expensive option.

For an example of noise using diverse settings, notice the following images. Figure c has an ISO setting of 200, whereas Figure d has an ISO setting of 1600. You wouldn't notice the difference so much if the image were published small; however, after zooming in close, you can see the difference in the grain in Figure c enlarged versus Figure d enlarged.

Figure c enlarged.

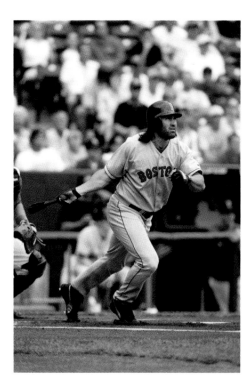

Figure c. ©G. Newman Lowrance

Figure d enlarged.

Figure d. ©G. Newman Lowrance

White Balance

Most people fail to realize that photography is all about light, color quality, and accuracy. Most light sources are not a pure white anyway but maintain a certain *color temperature* that is measured in degrees Kelvin. Typical light source color temperatures range from warm to cool, as follows:

Incandescent	2500K–3500K
Twilight	4000K
Fluorescent	4000K–4800K
Sunlight	4800K–5400K
Cloudy daylight	5400K–6200K
Shade	6200K–7800K

How often have you taken a photo under household lighting conditions such as using a floor lamp with an incandescent bulb and had a nice orange cast to your photo? As seen in the previous chart, an incandescent light source has a typical color temperature of around 3200K. As color temperature rises, the color gets bluer and cooler until it becomes almost grayish blue, as seen in deep shade or low light. The most natural and sought-after color temperature is basic daylight, which is around 5400K. This renders the most natural skin tones and reproduces the most accurate colors. In the past, color film was offered in only three color balance types: daylight balanced transparency, tungsten (incandescent) balanced transparency, and color negative. Color negative had the advantage of allowing color correction at the time of printing through the use of light balancing filters to give accurate color. Digital cameras allow for an almost infinite ability to adjust for the color temperature of any given light source through preset or custom white/gray balance settings. This is a huge benefit to sports photographers who shoot under a myriad of lighting conditions.

The white balance feature in digital cameras attempts to calculate these temperatures to reflect a faithful color rendition of your images. Most digital cameras allow you to choose from several different preset white balances, such as sunny, shaded, cloudy, tungsten, fluorescent, flash, and automatic white balance, which is otherwise known as AWB. The camera menus allow you to apply a "custom white balance," which occurs when you photograph a white object (I have often used a person's white T-shirt or white uniform if I didn't have a white or gray card available) that serves as the standard for the white balance or use a gray card to get accurate measures of the color temperature.

I cannot stress enough the importance of learning how to accurately white balance your images for any given lighting that you might shoot under. Daylight is pretty simple because the built-in camera settings work well, as does the AWB setting. This also usually works well if you have to go from sun to shade

during a play and can't do a manual adjustment quickly enough. When shooting indoors or at night under the available lighting, it is worth the extra few minutes it takes to perform and set a "custom white balance." I do this under all artificial lighting and when using strobes because it removes color casts that the camera presets can't handle. Read your camera's instruction manual and learn how to do this because it dramatically improves the color of your images and saves a huge amount of post-production cleanup on your images.

Careful and proper white balancing is a new added dimension of digital photography. Treat it with the same diligence as your exposure settings. Don't be lazy and rely on your camera to do all the thinking. Learn how to do these custom setups, and you will see a big difference in your image quality, especially when shooting under poor lighting conditions.

As photographers have converted from film format to the digital world, the general feeling about color temperature from the conventional manner has changed. Previously, most of us weren't that concerned with the color temperature when we used the conventional methods. Today, however, being unaware of this aspect of photography is no longer acceptable. Although we might go to great pains and still not get an exact color with digital format cameras, getting close is now a probability and a high priority.

Color Space and Camera Settings

When you first start going through all the menu options in your new digital camera, you come across many options that ask you to make choices that are completely foreign to the traditional film photographer. The first that you usually encounter is a choice of color space settings, which include AdobeRGB1998 and sRGB IEC61966-2.1. This is one of those moments in which most photographers scratch their heads and leave the camera on the factory default setting, which is usually the sRGB color space. Each one of these color space designations represents an important aspect of how your camera captures and provides color information that is an embedded part of the digital image's information. The color space describes the range of colors in the visible spectrum that is captured by the camera and made available and embedded in the digital file of the image.

Different color spaces were originally developed to match many different output devices, such as printing presses and other devices that output color photos and printed materials. Many devices can handle only a limited range of color and simply discard or clip colors that aren't within the range of the equipment. The sRGB color space was designed as a more limited range (gamut) of color to meet the needs of the printing industry. In recent years, developers have created inkjet and other multi-ink printers that can handle a much wider range of colors.

A wider-gamut color space, AdobeRGB1998, was developed by Adobe Systems, Inc., as part of its imaging software. The AdobeRGB1998 color space contains much more color information than sRGB and should be used as a general setting for most of your digital photography. The only time that I use the sRGB setting is when I know I will be printing my photos on a printer that can only handle this limited color space. It is always better to have to convert colors to a narrower color gamut and throw away digital information than to have to make a limited range of colors work in a wide-gamut color environment, such as a new high-end printer.

This is also a good time to mention a few words about color management. Color management is another one of those areas of digital photography that sounds much more mysterious than it really is. *Color management* is just what it sounds like. It is the process of communicating color information that was originally captured in your digital image so that other devices, such as computers and printers, can understand it. Simply put, it allows other devices that might not work well with your original color space to translate or understand the color in your image.

Remember what was previously discussed regarding printers that cannot use all of the color information contained in the AdobeRGB1998 color space? What typically happens is that a printer manufacturer creates what is called a *color profile*, which is simply the range of colors that the manufacturer equipment can handle and output.

This color profile describes the range of color that the equipment can use and acts as a translator that takes your original color space information, such as AdobeRGB1998, and converts it to the colors that the printer can use. Basically, this is like taking a word in English and translating it into Spanish so that it has the same meaning but can be understood by a non-English speaker. This is a simplistic explanation, but it gives the idea that there needs to be a means for one device to communicate with another in a translatable language.

The big difference here is that there is also a conversion of the color information from one profile to the next as each profile describes a specific set or range of colors and thus makes conversion of the original color information work with the particular piece of equipment. This just means, for example, that a particular shade of red described by AdobeRGB1998 might take on a new name in sRGB, but it still appears to the eye as the same shade of red and prints out as the same color. Just remember to always retain the color space as an embedded color profile in your image so that the colors are interpreted properly from one device to another. If you discard or don't apply a color space to an image, no one knows what your original colors were. You let another device or person decide what they should be. This is similar to shooting a negative image and letting the printer decide what the color should be.

The next item that often ends up confusing most new digital photographers is the issue of "sharpening" your digital images. Almost all digital cameras allow the user to set the level of in-camera sharpening from "off" to "more sharpening."

I try to do as little image processing in the camera's built-in software as possible. There is much more accuracy and control of digital image processing in Photoshop than there is in the 35-mm format digital cameras. I either turn off the sharpening completely or leave it on its lowest setting. You can always do a series of tests with a new camera to see which looks best, along with applying your normal sharpening in Photoshop. Remember that if you sharpen an image that is going to be used in a publication, the printer almost always adds some sharpening as part of the pre-press process. This can really add a pixelized or over-sharpened look to an image that looked fine when it came out of the camera, so be careful about applying sharpening in the camera or even during post-production processing. Always check with your printer or publisher to determine how it wants the images to be processed.

The other and probably most significant adjustment in the camera software is the contrast range setting that you can apply in the camera's software. I always turn this off or set it to the lowest possible setting that the camera allows. This is the single biggest image destroyer in your camera's arsenal of imaging software. Turn it off, and you will see a huge difference in the quality of your image highlights and noise reduction in the overall image.

Always apply contrast and sharpening in image post-production processing because it is easy to add contrast and sharpening if an image needs it. Shoot a player in a white uniform and look at the image with and without the contrast setting. You will see a significant change in the detail quality of the photo. I have seen way too many digital photos that have absolutely no detail in the highlights, and this is inevitably caused by this one little camera function.

The last camera function that is worth mentioning is the setting of sequential file numbering in your camera menu settings. This allows the camera to write a continuous sequence of file numbers up to a certain limit (usually 10,000) before it reverts back to 1 again. This feature enables you to download images to your computer into a single folder so that you can sequentially arrange the photos for easy editing and retrieval.

Lens Selection

Most likely you will have a camera that uses interchangeable lenses. You will have many choices in terms of lens selection. The main difference in lenses is their focal length. Focal length controls the magnification, or the size of the image, in addition to the angle of view.

The digital age has changed these specifications somewhat. Regardless of what brand you select, most digital cameras have a magnification ratio, which makes your lens automatically "longer." Because Nikon and Canon cameras

are widely used in the sports photography world, I'll use them as examples. The Nikon D1, D1H, and D2H cameras all provide a magnification ratio of 1.5 to 1. The new D2X has two modes that give either a 1.5 or 2 times magnification. This basically means that a 300-mm lens is now a 450-mm lens. Similarly, a Canon 1D or 1D Mark II camera body provides a 1.3 ratio, so a 300-mm lens actually provides you with a 390-mm lens.

The other important fact to note is that this magnification ratio does not change your lens opening or aperture settings. Thus, a 300-mm lens that has a magnified focal length on a digital body still has the original lens aperture. This factor might alter your original decision on which lens to choose if you were previously shooting with a film-format camera. You might not need a long telephoto lens such as a 500 mm or 600 mm, because the magnification and the use of a teleconverter can provide the same basic focal length as an additional lens.

Wide-Angle Lenses

Besides having a long telephoto or long zoom lens to photograph the various sports, you might consider adding a wide-angle such as a 20-mm or even a "fish-eye" lens to your arsenal. These lenses are excellent when you want to obtain an overall shot, such as a view of an entire stadium or a group shot of an entire team. Although you might not use this lens when shooting the actual game action, the uses that you gain with these types of lenses allow you the freedom to get many different looks while shooting the event.

Because the advent of the digital cameras includes the magnification ratio that I spoke of earlier, these wide lenses aren't as wide as conventional, or film-format cameras, but you will still find many uses for them. You can also consider a wide-angle zoom lens, such as a 20–35 mm, 16–35 mm, or 17–40 mm instead of using a fixed focal-length wide angle. The advantage of these lenses is the range they offer when composing an image. The speed of the lens usually dictates the cost. Faster lenses are always more expensive.

Telephoto Zoom Lenses

Numerous telephoto zoom lenses are available to choose from. Many sports photographers carry a 70–200-mm f/2.8 zoom lens for relatively close action. This type of lens comes in handy during a football or soccer event, when the teams get close to a scoring opportunity. While you are 20 or 30 yards away from the action, these lenses work well to get you close enough to the action, but not too tight, like a 400 mm might be under the same circumstance.

These lenses are also excellent for obtaining vertical portrait shots of the athletes prior to a game. Again, they give you enough freedom to compose your image so that you don't have to move closer or farther away, like you would if you were using a fixed focal length lens.

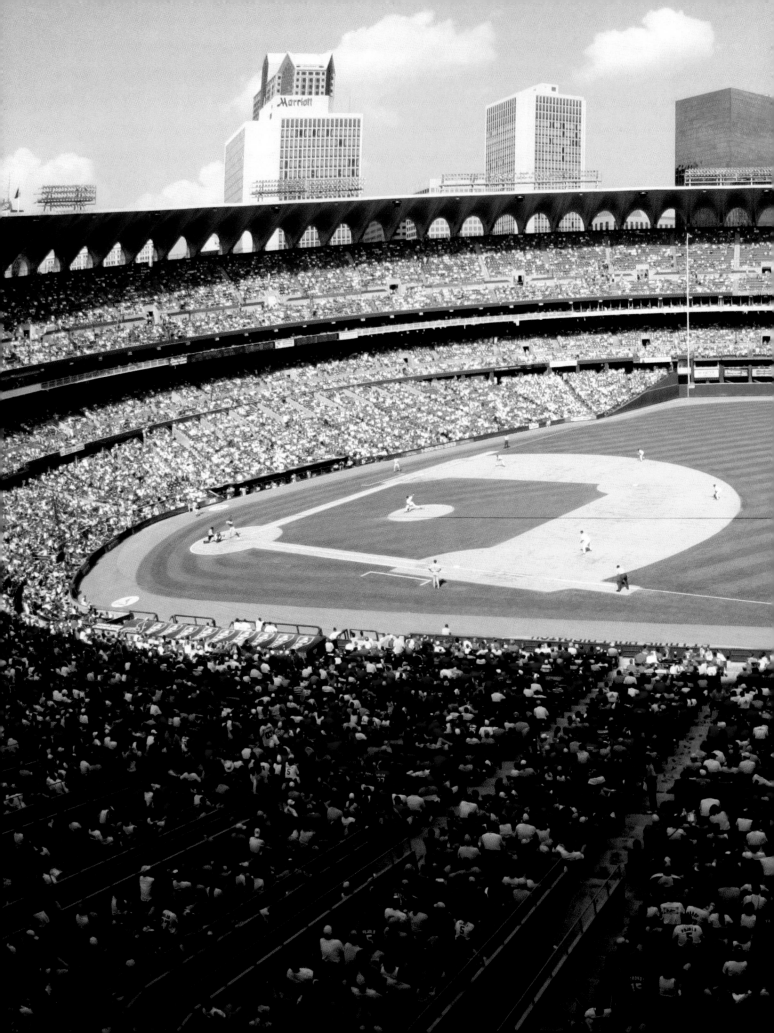

Wide-angle and "fish-eye" lenses are excellent
for stadium views. ©G. Newman Lowrance

A wide lens is also useful for capturing large group shots. ©G. Newman Lowrance

When choosing these types of lenses, or any lens for that matter, consider the speed of the lens. The f/2.8 openings that are available for some of these lenses allow you to shoot night events or give you a better range in which to work with your exposures and keep your shutter speeds relatively high. They are also offered with f/4.0 and f/4.5 and as high as f/5.6. However, keep in mind the restrictions you will be putting on yourself relative to your shutter speeds in low-light conditions.

Telephoto Lenses and Extenders

Long telephoto lenses—such as 300-mm f/2.8; 400-mm f/2.8, 500-mm f/4, and 600-mm f/4—are practically required for photographing sporting events. The reason for this is quite simple: You typically are far away from the action, and you need to bring the action closer to you.

The most frequently used lens in field-event sports is the 400-mm f/2.8 lens. A new Nikon or Canon lens of this length could cost you $6,500 or more. An alternative is to purchase a less expensive 300-mm f/2.8 lens and add a 1.4X or

2X teleconverter. This option is significantly cheaper and allows you to have the relatively same focal length as purchasing a 400-mm f/2.8 lens. The only downside of this method is that you lose one f-stop when using the 1.4X extender, or two f-stops if you use a 2X converter.

I don't recommend using a 2X converter because you tend to lose a lot of sharpness in your images, and it slows down the tracking of the auto-focus mechanism in the camera. The 1.4X is not as severe in this situation and is fairly common in the industry. I do, however, recommend purchasing the same brand converter as your lens. They might be higher in price, but you will definitely notice the difference in sharpness and auto-focus speed.

Although these usages might prohibit you from using the shutter speed that you want for a night event, for most day events, it is a viable option. You can always take off the teleconverter and go back with the faster f/2.8 opening of your lens. Another advantage of purchasing the 300-mm f/2.8 versus a 400-mm f/2.8 lens is the size and weight factor. The 300-mm f/2.8 lens is much easier to carry around while you are shooting your event.

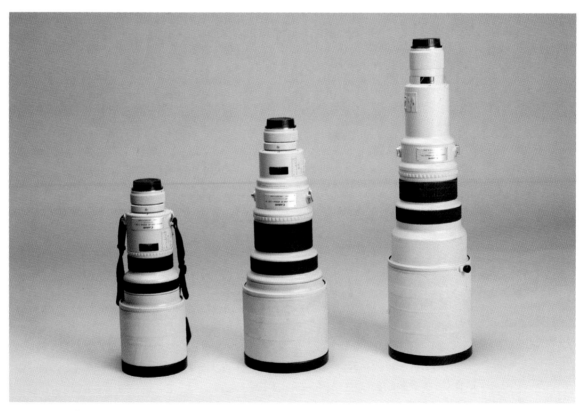

A 300-mm f/2.8 lens (far left) is much smaller and lighter than a 400-mm f/2.8 or 600-mm f/4 lens. The yellow tape you see added to the lenses protects them from minor dings. ©G. Newman Lowrance

Since the magnification of the digital camera bodies has come into play, the use of these longer lenses, such as the 500-mm f/4 and 600-mm f/4, is not as important as it was in the past. Before the digital age, when a photographer used, for example, a 600-mm f/4 lens, the lens was just that: a lens with a focal length of 600-mm. But now with the magnification that a digital camera provides, a 600-mm f/4 on a Nikon digital camera body is actually a 900-mm f/4! Similarly, the Canon 600-mm f/4 lens is a 780-mm f/4. By using these focal lengths, your angle of view is significantly limited; however, if you are in the back of an end zone with the action 70 or 80 yards away, having these extremely long lenses is an advantage. A drawback to these long lenses occurs if you notice heat waves in your viewfinder. Using a teleconverter also increases this possibility. You can usually see the heat waves in your viewfinder while you are photographing.

Here, my positioning is from the back of the end zone, a good 70 yards from the action. However, with a 400-mm f/2.8 and added teleconverter, I am still close enough to capture a worthwhile image, even without cropping. ©G. Newman Lowrance

Accessories

Besides the basic camera bodies and lenses required to photograph sporting events, many accessories are considered necessities in the field. The list of accessories is extensive, but this section covers the basic must-have items.

Monopods

You won't find many sports photographers trying to hand-hold a 400-mm f/2.8 lens on a camera body to capture a picture. If you've noticed how much gear the professionals carry for a typical event, you've surely seen how they mount their long telephoto lens on what is called a *monopod*. Similar to a tripod except with one leg instead of three, the monopod is a must-have in the sports photographers' line of equipment. Besides, tripods are not allowed on the sidelines of most professional and college sports events. They are a danger to the players and photographers because of their lack of mobility.

As with most photographic equipment, monopods come in many different brands and styles. Typically, they have a limit on how much weight they can hold. They can come in three or four sections, which reduces their size when not in use.

Some monopods are available in carbon fiber, which is lighter in weight but just as strong as aluminum or alloy versions. Also, during cold days, the carbon fiber types don't feel as cold as the traditional alloy monopods. The downside is the cost, because they are much more expensive.

Regardless of the material, I prefer the four-section types that when broken down are not as long and fit in a carry-on bag to take on an airplane. Of course, with the new security measures that airlines now employ, you might not be allowed to bring one on board. So far, this hasn't been a problem for me.

Waist Bags

Another handy item, the waist bag is great for holding all your small items that you typically use while shooting sports, including memory cards, teleconverters, filters, small lenses, light meters, and the like. You can choose from many different sizes, brands, colors, and materials. If you prefer, you can wear a belt pack to carry several small lenses and perhaps a water bottle and use a bag for the other accessories I mentioned. I typically use a waist bag that's large enough to carry a fish-eye and a wide-angle lens, in addition to extra batteries and anything else you might need at a game, such as a cell phone or compact radio so that you can listen to the game as you shoot if you desire.

A waist bag is a great way to hold many small items that you will need during an event.
©G. Newman Lowrance

Carrying Cases

Another must-have is a case to hold your camera bodies and at least one long telephoto lens and still leave enough room for your smaller accessories. Most of these cases are offered as a backpack or as a roller case, which is extremely convenient for all aspects of traveling with your gear, regardless of whether you are getting on an airplane or just driving to an event. I like to carry my expensive items on board when I'm flying because I've heard too many stories about equipment being damaged, lost, or even stolen.

Caring for Your Equipment

Photographers often take this subject for granted, but it's important to take good care of all your photography equipment. You can spend a small fortune to set yourself up to photograph sporting events, so you need to properly maintain your equipment. The better you take care of your equipment, the better it will work. If you constantly bang your lenses around and drop your gear instead of placing it down softly, you will notice the eventual wear and possibly the malfunction of the gear. This also lowers its resale value, as you will find out when you want to upgrade your gear. Remember never to carry a camera with a long telephoto lens by the camera body, because this stresses the lens mount and can easily throw off the collimation (the alignment of the optics) of the lens and the body and cause focus problems. Camera body lens mounts are not designed to take much weight, so always carry the camera by the lens.

A roller case to hold a long telephoto lens, camera bodies, and smaller
accessories is a must-have for the professional sports photographer.
This case is small enough to carry onto an airplane, which makes it extremely handy.
©G. Newman Lowrance

It's also good to carry a lens cleaner with you whenever you go to an event. If
you didn't take the time to clean your gear previously while you were packing
up, you should at least wipe all your lenses as you are setting up to remove
any dust particles that might show up in your final output.

Another good investment is an ultraviolet or skylight filter for each of your
lenses. These filters not only protect the actual glass of the lens but also elimi-
nate ultraviolet that the eye does not see. Using these filters protects your glass
and might even prevent a lens replacement if you happen to drop or bang your
lens into something. If you are not a big fan of lens filters, always use a lens
hood that is properly designed for your particular lens. A lens hood really
helps to protect a lens from scratches and impact damage.

When you aren't actually at the event, always replace the front and rear caps
of each lens and the body cap of your camera. If you don't, dust could enter
your gear and cause spots on your images.

A big word of caution should also follow in the cleaning of the sensor chip in your digital camera. These chips are extremely fragile and susceptible to scratches and damage. Only a factory-authorized repair service or a cleaning system that is specifically designed for this application should clean them. Several products on the market are designed for this, but use them with the utmost care. Don't use traditional lens cleaner fluid or tissues, and avoid canned air products. After a chip has a blemish, the flaw is noticeable on images that are shot with any amount of depth of field. Be careful.

In closing, take care of your equipment keep it clean and dry, and you will get many years of good use from it. Photography equipment is rugged only to a certain degree. You need to treat it like the delicate computer that it is.

What an Editor Looks For

by Kevin Terrell

CHAPTER
4

I was blessed to have the pleasure of being the managing photo editor and a staff photographer for the National Football League (NFL) for more than 13 years. I loved every day, hour, minute, and second of my job. Editing photos is an exercise in admiration and critique. When I'm editing, I'm not only admiring the body of work I'm examining, but I'm also being critical in deciding whether to retain an image. An editor needs a thorough knowledge of what he's looking at and the discretion to know what to keep and why he's keeping it. During the time that I edited for the NFL, several of our photographers, regardless of how long they had been shooting professional sports, asked me, "What do you look for when you're editing?"

The answer to that question is broad and somewhat complex. An editor should consider so many things as he's choosing an image: the appearance of the subject(s), the sharpness of the image, the clarity, the contrast, the crop, and the image's ability to be cropped to fit a layout for a publication.

Although no two editors are alike, and we don't always see the same thing when observing a photo, we do look for some similar qualities. Editors who are liberal in their selections usually pull heavily (choose to keep many images) from each contributor. In giving some slack to the shooters, they reason that quantity often generates quality. At times, it does, but it also leads to retention of imagery that might never be used. It means extra storage space that can over-populate an agency's or wire service's Web site with mediocre material.

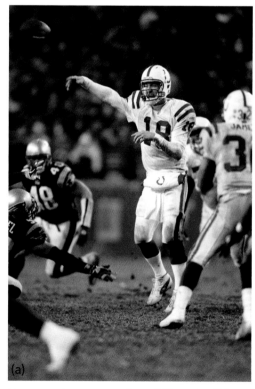

Here are two examples of liberal editing. There's no special action occurring in either of these photos, but both made the cut because Peyton Manning (a) looks as though he is exerting a lot of effort, and Priest Holmes (b) has a shadow in the foreground that makes him stand out. ©Kevin Terrell/NFLP

Others editors are more selective and somewhat stricter in their editing and choose only the best of each take. When looking through a sequence of images, they might select the best two or three images, as opposed to a liberal selector, who might opt to keep the entire sequence.

When submitting a series of shots of the same play, don't be disappointed if an editor doesn't retain the entire sequence. Their selection really depends on what is occurring on the play. In this sequence, I would keep the second and maybe the third photos of this group, but not all four. ©Kevin Terrell/WireImage.com

Both styles of selection have advantages and disadvantages. For instance, as I said before, the liberal editors will likely end up keeping many mediocre images that might never see the light of day. This also increases the number of photos that an editor would have to look through when researching specific images. The more images you keep, the more you have at your disposal and have to wade through when trying to find the perfect shot(s).

If an editor is going to be lean in his editing and keeps only the primo material, he runs the risk of deleting or returning material that he could end up needing later. You never know what a story editor is going to ask for from a game.

Good editors might not remember everything they see, but they should be able to recall whether they've seen something when someone asks them for a particular image. There's no worse feeling than being asked for an archived image that you're not sure if you've returned or deleted, especially when you're on deadline. Sure, you can go back and ask a photographer to resubmit it, but if the photographer didn't happen to keep the image on file or sent it to another publication or stock agency, you have some explaining to do.

Editorial Use

What a photo editor pulls and why are usually determined by what the images will be used for. For example, when we're selecting images for editorial use—a newspaper, magazine, or online publication—we usually keep an eye out for photos that will best tell a story. Editors need photos that vividly display what the author is reporting on or the subject/theme that is conveyed in the text.

Getting a shot of a big-time player making a big-time play usually ensures that an editor will keep a shot. Here Muhsin Muhammad of the Carolina Panthers makes a catch for a touchdown in Super Bowl XXXVIII. ©Kevin Terrell/NFLP

When I'm editing and selecting images for editorial use for an NFL publication, I'm generally given more freedom to submit images that aren't the generic action shot. The managing editor and editor in chief of an NFL publication (who often have the final say as to which images run in an editorial use) usually allow more leeway for selecting images that are over the top, such as a player getting flipped or doing a celebratory dance in the end zone. These are images that often aren't used. But if something I had a photograph of was mentioned in the copy, I could often persuade editors to use what I felt were the best images. My argument was, "Hey, it's mentioned in the copy," or "The athlete was quoted referring to this."

Story editors usually want photos to display something pertaining to the piece, and the best way for sports photographers to do this is by getting images of the key play and players. I can't stress that enough. Think about how many times you've grabbed the sports page from the newspaper and were immediately attracted to a photo on the front page. This likely lead you to read the caption under the photo, which in turn might have prompted you to read the story. All of this came about because of the impressive photo you saw on the front page.

This photo of Indianapolis Colts player Brandon Stokley celebrating after scoring a touchdown in the 2003 AFC divisional playoff game against Kansas City displays a journalistic-type approach that would catch your eye and likely lead you to read the story. ©Kevin Terrell/NFLP

News editors think that we read newspapers and magazines because of the copy (the text on the pages), and most of us do, but how many newspapers and magazines would sell if they didn't contain photography? Most biographies, even if they're paperback, have photos in the middle of the book. Although the written word can stand alone and be informative and intriguing, it's the imagery contained in these editorials that we spend time examining to get a better understanding of the story. The photos add to the piece and enable us to get a better description of what we're reading. All of us can paint pictures or conjure up images in our mind from something we've read, but photos give us a more accurate vision than anything we could imagine. In fact, photos can ruin a vision of what we've imagined from reading just the text, which is why some people refuse to look at photos of something or someone they've read about.

Often, when we sports photographers or photo editors look through a copy of a magazine such as *Sports Illustrated* or *ESPN The Magazine*, we peruse the issue cover to cover, examining all of the photos. We pay little regard to the features and columns in the magazine. We admire and critique the images and read the photo credits. We also think of other photos we might have seen of the same play or the same subject and compare it to what we see in the magazine. Basically, we edit.

Although a photo editor through his selections often has some input on what photos to use, someone above can and often does overrule us. Some of the most impressive images ever shot haven't been published because a managing editor or someone above the photo editor decided not to print a certain photo for any number of reasons. This can be frustrating, but it is part of the job. It's important to be flexible when you're a photo editor.

Commercial Use

Editing for commercial projects is somewhat different from editing for editorial use. Commercial editing usually entails looking for images that get across a message that an advertiser or client wants to convey in an advertisement or promo piece. Some clients want images that scream out to you and make even the non-sports fan stop and pay attention to their ad or the packaging of their product. Others just want to see their product's logo somewhere prominent in the photo. Gatorade, for example, likes to see its logo on towels, coolers, or cups in players' hands. Shoe and apparel companies such as Nike or Reebok are big on this display of logos, too.

If a client doesn't have likeness rights to athletes or teams, it's looking for generic photos. In football, these could be of the goalposts, grass, yard markers, hash marks, taped hands, equipment, or towels and bags in the bench area. In basketball, it could be of the ball, the hoop, the backboard, the hardwood court, an overhead of the lane, and so on. In baseball, it could be the ball, a background of the stadium, or perhaps a dugout shot. It all varies with the product that the client is trying to advertise.

When a client has the license that gives it the approval to use a player's likeness in their ads but has not struck a deal with an individual player, it often relies on the rule of six to get around this. The rule says that you can consider six bodies in a photo as a photo of the team and not just the individual players in the frame. In football, this brings about the need for group horizontal action photos.

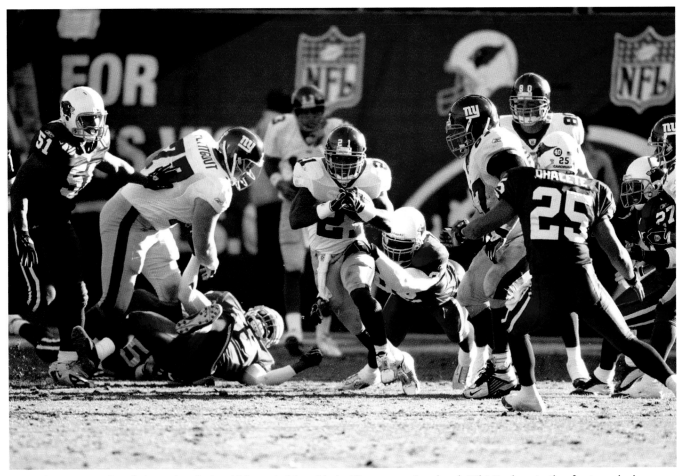

A perfect example of the rule of six. Although New York Giants running back Tiki Barber is the featured player in this shot, the extra players in the shot make it an image of the New York Giants instead of just a photo of Barber. ©Kevin Terrell/NFLP

For example, a photograph of a running back such as Edgerrin James of the Indianapolis Colts running in the open with defenders in pursuit of him and a couple of other Colts players in the image can be considered a shot of the Colts offense instead of a photo of Edgerrin James as an individual. The rule of six is frequently used in team calendars and print ads. You'll often see rule of six photos in print ads involving the teams playing in an upcoming or recently played Super Bowl. This usually means that a client didn't strike a deal with any of the key players on the opposing teams; in the client's haste to get something out, it just went with a team action photo.

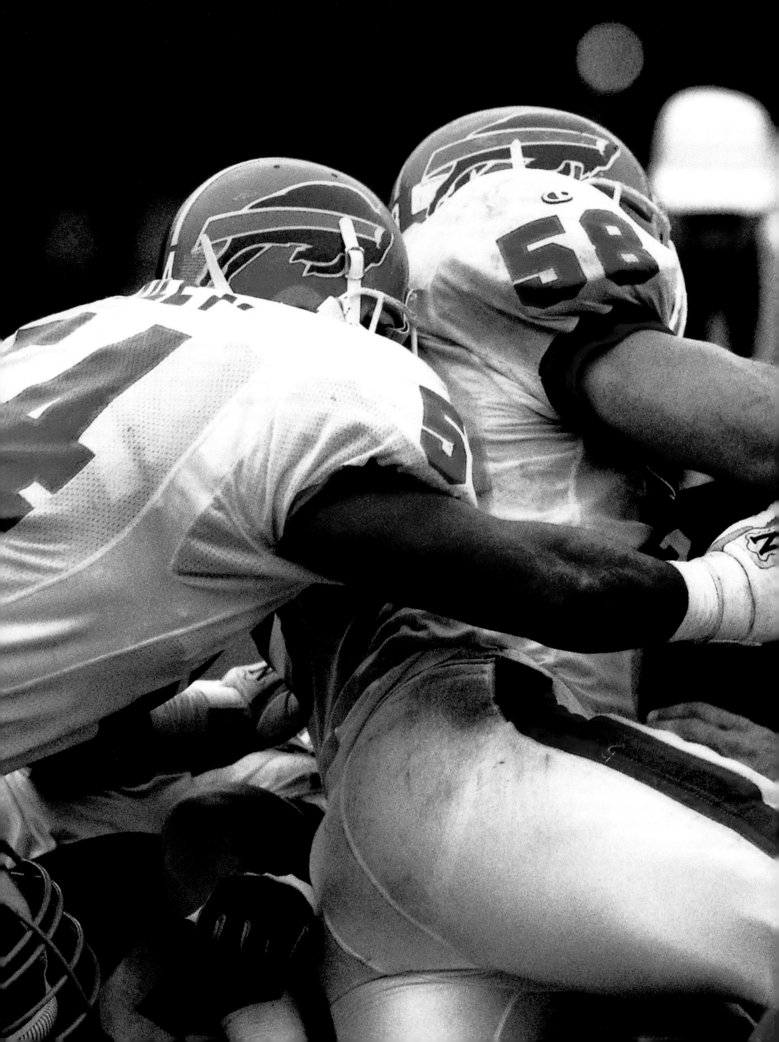

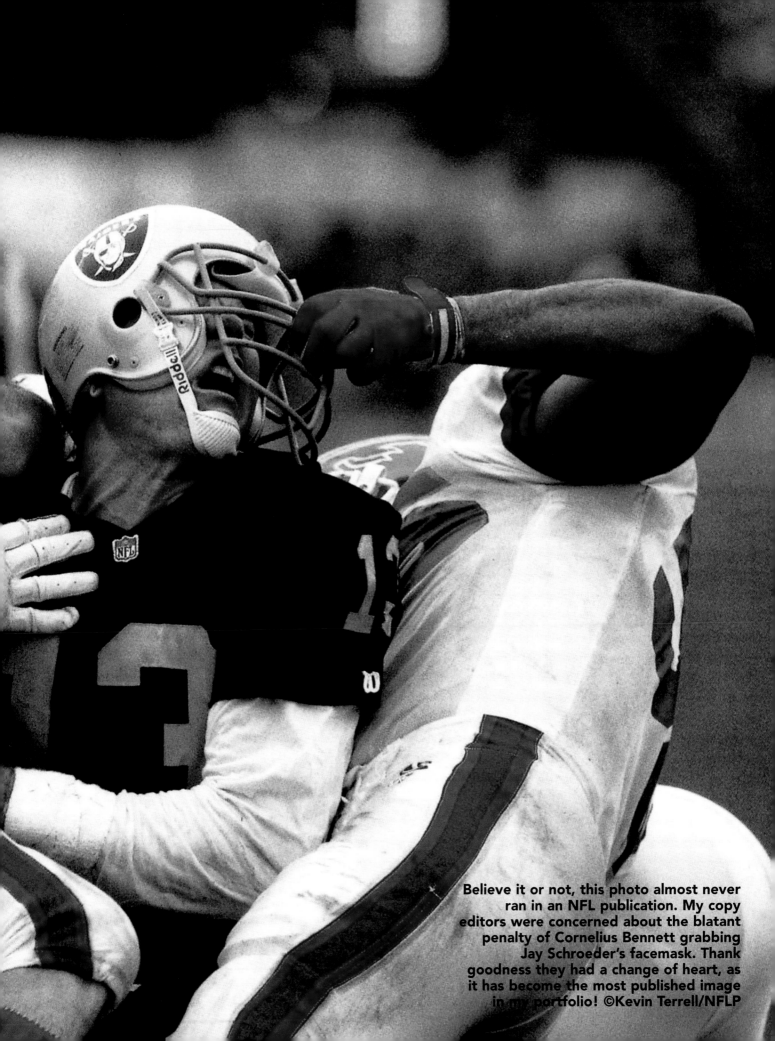

Believe it or not, this photo almost never ran in an NFL publication. My copy editors were concerned about the blatant penalty of Cornelius Bennett grabbing Jay Schroeder's facemask. Thank goodness they had a change of heart, as it has become the most published image in my portfolio! ©Kevin Terrell/NFLP

Image Criteria

Regardless of the situation, when an editor is selecting photos for an editorial or commercial project, he generally uses certain criteria. These criteria include quality, peak action, artfulness, and stock images, discussed next.

Quality

Good exposure is essential to getting a photo selected. Most editors require their shooters to correct the color, contrast, and sharpness on images before submitting them, but sometimes editors still receive poorly exposed images, and little to nothing can be done with them. The better the exposure, the more strongly an editor will consider your submission for selection.

Peak Action

Editors always need photos that capture good hard-hitting action. Look at the opening spreads in *Sports Illustrated* or *ESPN The Magazine*. The "Leading Off" (*Sports Illustrated*) or "Zoom" (*ESPN*) shots are usually tight, horizontal action images. They don't have to show a touchdown, a basket, or an acrobatic catch in the outfield; they just have to be great action shots. These types of shots are useful not only as double trucks (spread across two pages) in magazines, but also in print ads and calendars—even when they're not of the rule of six. These types of images pay a premium and are always in demand. Sometimes, overhead shots are preferred for this type of image. For some shooters, horizontal action is easier to get than a tight vertical action shot of an individual player because of the difficulty of framing a subject while he's in motion, especially if you're shooting him tight.

Still, vertical images are needed and work well in just about any kind of commercial or editorial product that calls for an individual photo rather than a group shot. Editors want both horizontal and vertical images of peak action shots, although more end up framed or cropped horizontally.

Artfulness

Editors are always looking for unique shots. These shots can be either action or feature photos. A lot of emotion occurs on the sidelines or in the dugout throughout a game that presents an opportunity for some nice images. It really depends on the way you shoot something. Try to be aware of the available light and the various surroundings of the stadium or arena you're in. During pregame warm-ups or moments between the actual game action, think of what you can use or include in an image to create an interesting shot. It could be the goalposts, a pylon in the end zone, or a lone helmet on a bench. Use your creativity and take a chance. The shots could be motion blurred (shot at slow shutter speeds), extreme close-ups, or zoom photos. Your camera is your tool,

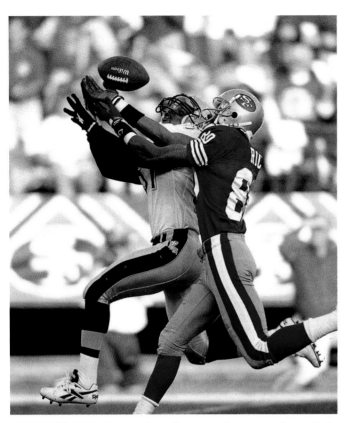
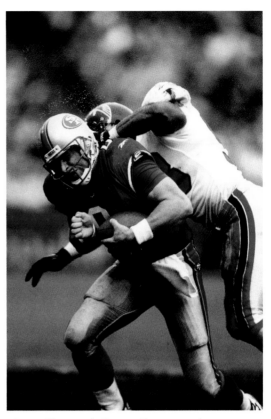

These oldies are two of my best peak action shots. I shot the Jerry Rice and Jimmy Spencer photo backlit. I shot the photo of Steve Young (#8) getting drilled by Jessie Tuggle in the rain at 1/500 of a second at f/2.8, and I pushed the film one f-stop in processing to ISO 400. The color shifted red, which was common for Kodachrome, but the raindrops froze in the air as they came off of Young's helmet. ©Kevin Terrell/NFLP

so try to make use of the various exposure settings and your flash. This could lead you toward some interesting shots that are different from what most shooters photograph.

Stock Images

There is *always* a need for stock imagery. Regardless of who or what a photo editor is selecting images for, he is always on the lookout for stock images because of the uncertainty of what will be requested. Try to get something of just about every player on offense and defense in football and every player in basketball, baseball, hockey, and soccer. An editor will likely keep a great action shot of an athlete, but he also needs shots of players between plays or just doing something on the field with or without the ball, bat, or puck. I used to receive images from an NFL shooter who took shots of every player on the team in every game. He submitted them in slide sleeves from jersey number 1–99. Some were great action shots, but most were average shots of a guy either in his position stance or standing around between plays. The shooter made a ton of money with the league because whenever a client needed an image of a player—regardless of whom it was—this photographer had something on him.

The pregame introduction is a good time to experiment with shooting artsy shots. This photo worked because of the people inside of the inflated helmet, the smoke, and the sunlight at the end. It also didn't hurt having a star player like LaDanian Tomlinson of the San Diego Chargers as the subject. ©Kevin Terrell

What Not to Submit

A photographer should never submit certain types of images, such as ones that are soft or out of focus, to an editor. There are too many good shooters and top-notch photos for an editor to have to keep photos that aren't tack sharp. Sure, some images break up or pixellate when they're blown up or when they're cropped really tight, but a soft photo reproduces soft and doesn't look good no matter what size it's used—unless the medium is a newspaper, which tends to be more liberal in its standards of sharpness. The only time that submitting a soft or somewhat out-of-focus picture is okay is when you're submitting a newsworthy image or a record-breaking play.

Rarely do editors select a photo of a player running away from you. If you can't see the player's face, you probably shouldn't submit it. A wide-angle photo of a great jump shooter like Kobe Bryant of the Los Angeles Lakers taking a game-winning shot from the back might be the exception, but in just about every other sport, especially in football, refrain from submitting images of the back of players. If you can read the player's name on the back of his jersey, you should perhaps look at other elements surrounding that player, such as the defenders who are coming toward you.

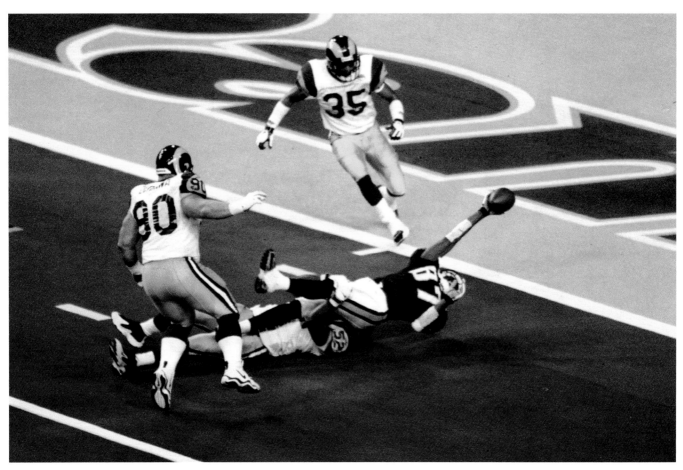

If this were not the last play in Super Bowl XXXIV, this photo would have been tossed in the trash because it's very soft. I shot this from an overhead seating section. When Kevin Dyson caught the pass, the fans jumped up in anticipation of him scoring. I had to maneuver my lens between the fans to get in position for this shot. ©Kevin Terrell/NFLP

Try to avoid having a player's legs or arms cropped out of the frame because it can lead to some awkward photos. Although there are times when the ankle and feet of an athlete are cropped out of a tight photo, try to avoid submitting loose images in which this occurs. If you're shooting loose, try to get the full body in the shot as the athlete approaches you. Use your better judgment in deciding what to submit. Always include pictures in which the arms are in the frame.

The ball should always be in the frame when you're shooting an athlete who is handling it. If you happen to crop out the ball when you're shooting, or if your reflexes weren't quick enough to capture the ball just as it's in flight and leaving the player's hands or flying off a tennis racquet or bat, it's probably best if you don't submit that photo. The exception is shots of tennis, baseball, and hockey players finishing their swing.

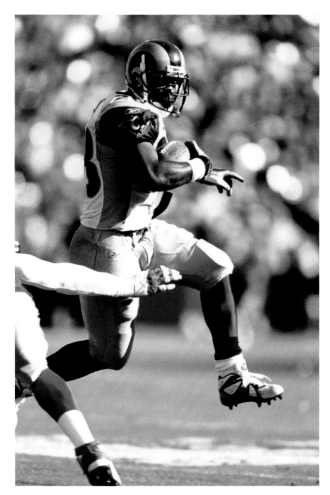 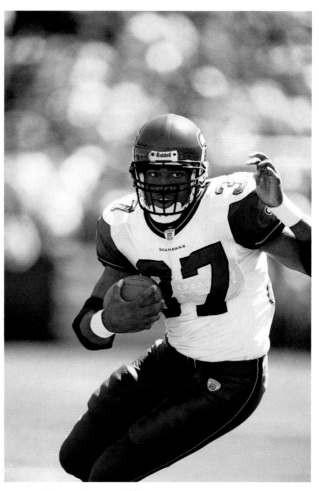

In both of these images, the subject's limbs are cropped out. Although it's difficult to crop images perfectly while you're shooting eight frames per second, you improve your chances of getting an increasing number of images selected if you submit more that are full frame. ©Kevin Terrell/NFLP

Tools of the Trade

Before the days of digital cameras, I received more than 500,000 35-mm color transparencies (slides) and mounted negatives per year. I spent several hours per day with a Schneider Lupe pressed up to my eye and the loupe pressed up to a sleeve of slides on an upright aligned light box. I scanned each slide with my right eye, often stopping when I saw something I thought was nice or just a good photo. I was liberal in my editing in both preseason and early regular season games because I felt it was important to keep material on every player, especially the stars, because if a player happened to suffer a major injury, I wanted to be sure I had photos of him before he was hurt.

Now that we're in the digital age of photography, I use the software program Photo Mechanic to browse and edit images. It displays the images on your computer screen as if they're a proof sheet on a light box. It allows you to rotate and delete images, and it opens them in Adobe Photoshop if you have it loaded on your computer.

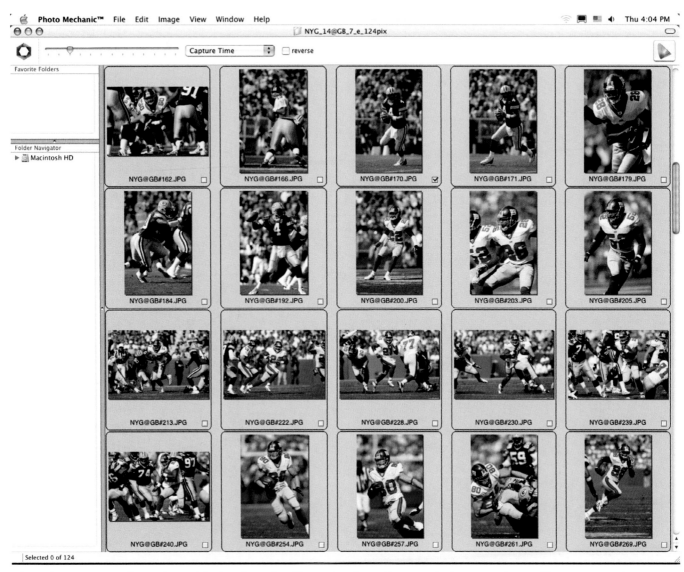

Photo browsers such as Photo Mechanic make life easier for editors and photographers alike, versus using a light box to view slides in the days prior to digital cameras. Illustration Images ©G. Newman Lowrance

The digital world has also made it somewhat easier to find a certain image or images that a client is looking for. For instance, instead of having to sort through and find a file full of 35-mm slides and then view them on the light box, with digital, most agencies that post images on a Web site can search for a particular player or team or from a certain game that a client might be interested in. Web sites have also helped immensely in that regard. Now clients can practically choose directly from the source instead of waiting for someone to pull images for them. This is where changing to the digital world has benefited clients.

Portfolio Submissions

Just as we photo editors differ on what we like to see submitted from a game, we also differ on what we like to see submitted in a portfolio. Before the digital age, back when slide film was all the rage, I always preferred to see original slides when I received a portfolio. If original transparencies weren't available, 8×10 prints were my next preference. I also welcomed tear sheets from those shooters who had been published. However, I never wanted to see duplicate slides. Duplicates sell a photographer short and aren't an accurate representation of the photographer's best work.

When submitting your portfolio, always send in your best images. Don't just submit your favorite photos or the ones that mean the most to you, but your very best. Your portfolio is in essence your résumé and your interview combined.

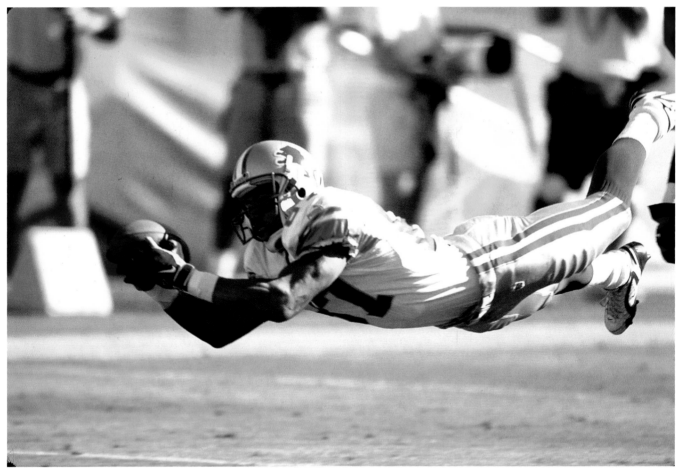

In this photo of Johnnie Morton, you can clearly see that his face is out of focus, and the sharpest part of the image is his legs and feet. This is one of the first things a good photo editor would notice, and it's why I never placed it into the NFL Photo library database. Use this same criterion when choosing the images for your portfolio. ©Kevin Terrell/NFLP

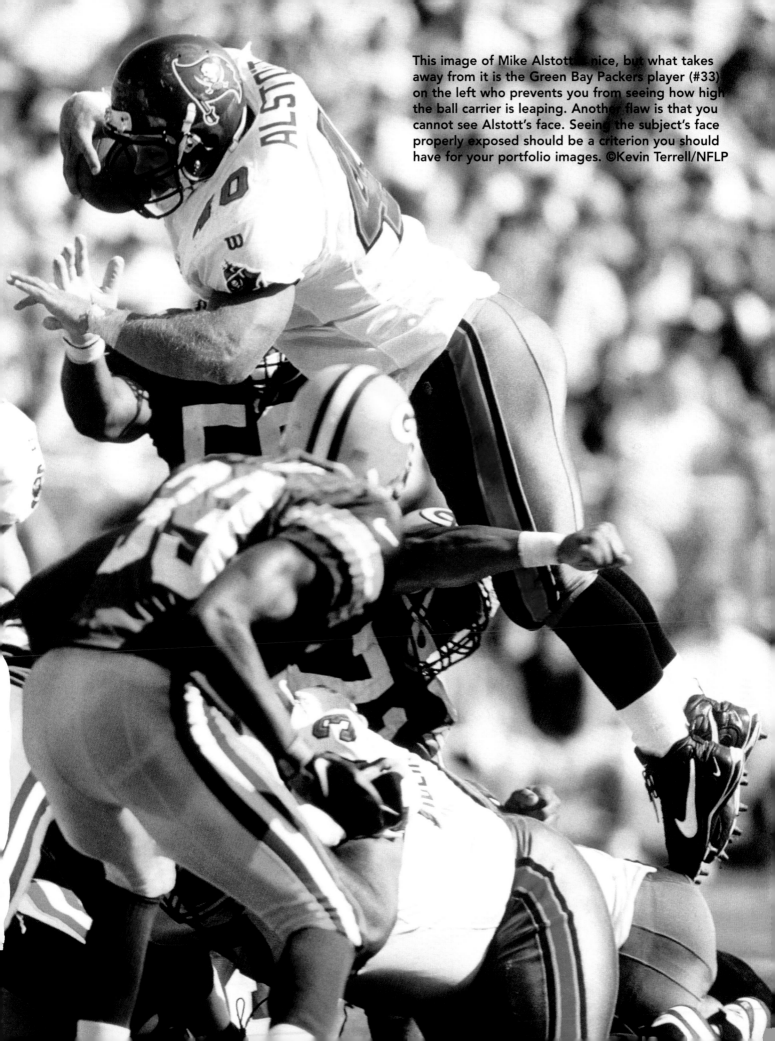

This image of Mike Alstott is nice, but what takes away from it is the Green Bay Packers player (#33) on the left who prevents you from seeing how high the ball carrier is leaping. Another flaw is that you cannot see Alstott's face. Seeing the subject's face properly exposed should be a criterion you should have for your portfolio images. ©Kevin Terrell/NFLP

Send in a variety of action and feature photos, both horizontally and vertically cropped. If you have some nice images that you have shot with a flash, send those in, too. Although you are trying to show your skills as a sports shooter, and an editor will more heavily scrutinize your action photos, there is so much that occurs before, during, and after a game. An editor wants to see your best feature shots.

Now that everyone is shooting with digital cameras, I prefer to receive a shooter's portfolio that is burned to a CD instead of receiving prints. I can make a more accurate assessment of a photographer's shooting skills—and his ability to use Adobe Photoshop—from a photo CD. Editors are busy; the ability to pop a CD into their computer and view images saves them a lot of time.

Many shooters have their own Web sites, which have proven to be a convenient way for an editor to view a portfolio. The only problems occur if a site is down or isn't updated with a shooter's most recent spectacular shot. I've had some shooters include an impressive shot on the portfolio CD and then include a cover letter asking me to go to their site. When I go to the Web site to see what else they have shot, the impressive image(s) on the CD aren't uploaded to it. It should be on both.

Your portfolio should be the most impressive representation of your shooting skills. Be your own worst critic to ensure that your portfolio includes your very best body of work.

In my biased opinion, football is the best sport to photograph. No other sport displays the intensity, passion, athleticism, and acrobatic beauty of what's demonstrated on the gridiron each week during the months of August through February.

In football, it's possible to capture a good shot on almost every snap. Consider that on a single play from scrimmage, you could shoot the quarterback calling signals as he awaits the snap from center and then get him as he either hands the ball off to a running back or rolls out or drops back to pass. You could also shoot the cohesiveness of the offensive linemen as they wage battle in the trenches with opposing defensive linemen. Alternatively, you could aim your lens at the running back who is going to block, carry the football, or flare out for a pass. Or you could follow a receiver as he blocks or sprints upfield on a pass pattern. By moving quickly and shooting rapidly before, during, and after the quarterback takes the snap from center, you could photograph some of these things all on the same play. And this is just while shooting the players on offense!

A sporting event is a compilation of spontaneous occurrences in which no one can predict exactly what will happen and what the outcome will be. As a photographer, it is up to you to capture as many of these moments as you can every time you step onto the field or court. Regardless of the sport and the level you are photographing, keep in mind that your photo editor expects nothing but the best from you, and you should expect it of yourself.

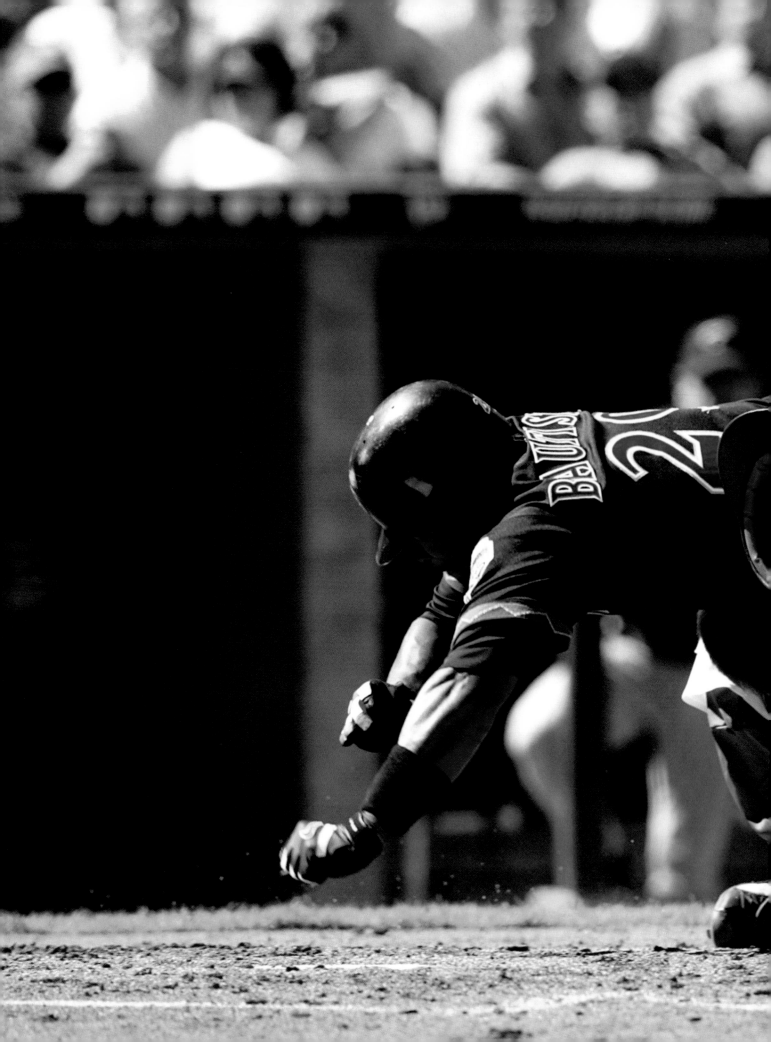

Baseball

Baseball is perhaps the most familiar sporting event that people can identify with, and it's probably the most photographed sport because of all the youth baseball that's played across our nation. Baseball offers some advantages when it comes to photography because of the basic fundamentals in which the game is played. Because most of the action centers on the batter and pitcher, it's easy to capture the batter swinging the bat and the pitcher throwing the ball. In addition, you can shoot each of the defensive players in his stance as the pitch is made. These shots are considered "safety" shots because you probably won't capture them fielding a ball if you are concentrating on the batter or pitcher. Getting an action image of a defensive player is the challenging part of photographing baseball. Odds are if you aren't concentrating on an infielder, you won't be able to get a shot of him diving for a sharply hit ball. Also, when you photograph baseball, you remain in a relatively stationary position, unlike football or soccer. You don't have to move too often to follow what you intend to shoot.

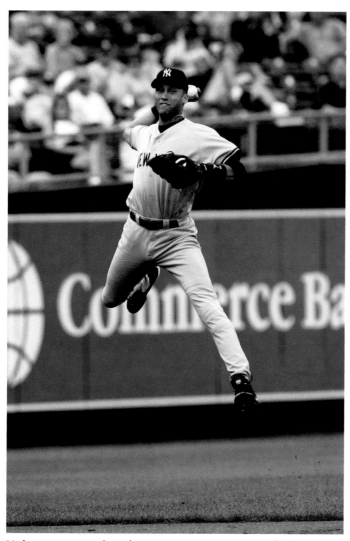

Unless you are already concentrating on an infielder, it is difficult to capture him as he fields and then throws the ball. ©G. Newman Lowrance

Generally when I photograph baseball, I bring at least a 300-mm or 400-mm lens and a 1.4X teleconverter, depending on how close to the field I will be. If you are shooting a youth event, you can probably get away with a long zoom lens such as a 70–200, depending on how close to the action you are. Regardless, preparation is always an important factor when you decide on the equipment that you need. Major league stadiums have photo wells or areas along the first and third baselines and sometimes behind home plate. Most of these wells are on the outside ends of the dugouts, although some stadiums have them on the inside, too. Some photographers prefer to cover the action from elevated or overhead levels. For that situation, a shooter might want to use a 500-mm or 600-mm lens, depending on how far away the action is from that location. Every stadium is unique in these aspects, so you should be prepared with different focal lengths of lenses for your positioning.

Positioning

Baseball typically has several different vantage points to choose from, with specific spots for photographers at the major-league level and most major college levels. The following are examples of these locations and what to look for from these points of view.

Shooting from First Base

For the most part, I prefer to start out shooting from the first base vantage point unless those spots are already filled at a big game or a stadium that has limited room in the photo wells. That's because it's possible to cover most of the action from this location. For example, while you are shooting the player batting, you can focus on him as he swings the bat and follow him during his run to first base. As you are doing this, watch the batter's eyes, because he usually tells you if he likes where the ball is going. A good indication of this is how he is running. You should be able to tell immediately if the batter has a chance for an extra base because he is running hard down the line. Of course, if he hits a routine fly ball, his pace usually slows down because he realizes he has probably just made on out. If he knows he has hit a home run, he might even admire his ball for a few seconds. Regardless of the situation, this is a nice shot of the player watching his ball in flight as he heads down the line. You can obtain these shots regardless of whether the batter is left handed or right handed. Even though the left-handed batter has his back toward you while he's in his stance, he eventually turns toward you as he's hitting the ball and proceeding to run toward first base. This is one advantage of being on the first baseline.

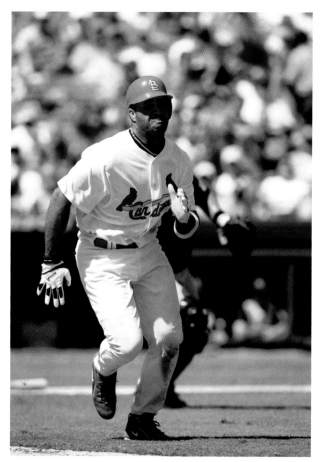 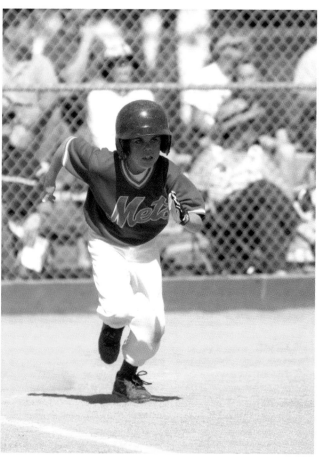

Whether shooting youth or major league baseball, you can get similar results. ©G. Newman Lowrance

Another advantage of the first baseline location is that you are in an ideal position for stolen bases and double plays that could occur at second base. If a player is on first base with less than two outs, it's highly probable that the next batted ball could include a play at second. If a batter hits a ground ball to the infield, the shortstop or second basemen covers the bag for a possible double play. The infielder rotates as he attempts to throw to first and in doing so, he turns right toward your lens. A typical shot from this situation occurs when the infielder jumps up to avoid the runner sliding into second base as he throws. Although this is a fairly common shot, it's always a good one to try to capture. You never know when the sliding player will make contact with the infielder and possibly flip him over. This can make a great image, and one that editors love to see. You might also get a great shot of a tag during a stolen base attempt or a ball thrown by the catcher that gets past the infielder as he is covering the bag. Consider where the base coaches and umpires set up on the field. I always try to shoot from either end of the shooting wells so that I can adjust my position as much as possible to avoid being blocked by umpires and coaches during peak action plays. They seem to work from habitual spots, so figure out where the best spot is that lines you up with the play and gets the coaches and umps out of your line of sight. Just know the situation and anticipate all the different possibilities that might occur.

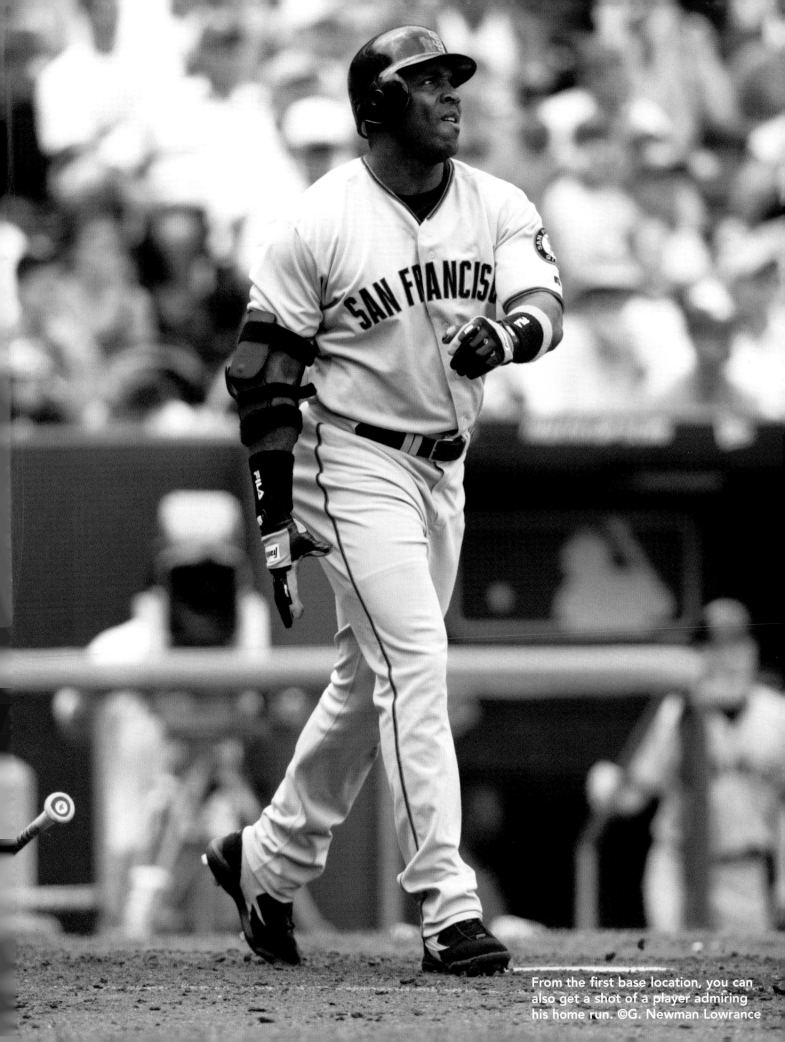

From the first base location, you can also get a shot of a player admiring his home run. ©G. Newman Lowrance

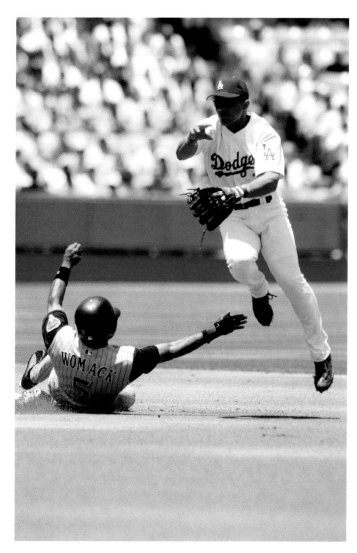

Knowing the situation:
When a runner is on first base
with less than two outs, be
prepared to shoot a possible
double-play situation, which is
always good to photograph.
©G. Newman Lowrance

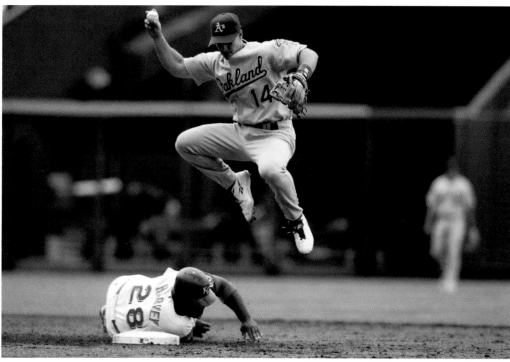

In addition, with a runner on first base, the pitcher sometimes attempts to pick him off or keep him close to the bag. This often occurs if a speedy runner or someone who is known to steal bases is on first base. The runner frequently has to slide back to the base if he takes a big lead. If you are watching for this shot, it is a fairly easy shot to photograph, because you can prefocus on the first base bag and see if it occurs. I like to keep a 70–200-mm zoom lens on a second camera body handy for this and other infield shots. Again, knowing the game's tendencies is an aid in determining what you plan to photograph.

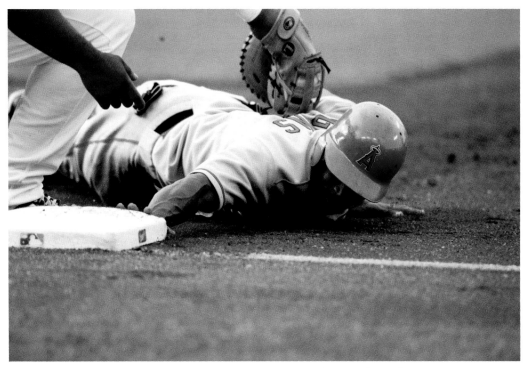

If a runner on first base is considered a threat to steal, a pitcher often throws over to pick him off. Concentrate on the runner getting back to the bag on these pickoff attempts. ©G. Newman Lowrance

Shooting from first base is also a perfect time to capture the right side of the infield on defense or the center or right fielder while using a long lens such as a 400 mm. Of course, if you are shooting the first baseman, you might need to switch from your long telephoto lens to a long zoom lens, depending on how far away you are, but understand that you always have the option for tight candid shots versus wider shots when you try to capture him fielding a ground ball. If you are holding a zoom lens while the ball is hit to the outfield, you will probably be too far away to shoot the outfielder moving toward the ball to make the catch. Sure, you can always shoot the play anyway, but odds are that, with the smaller lens, you will be too loose to get a good shot.

While shooting from the first base location, watch for the infielders as they get in their stance or prepare to throw the ball to the bag. ©G. Newman Lowrance

Between innings, the first baseman usually keeps the infielders loose by throwing them ground balls. This is a good opportunity to photograph each fielder throwing the ball back to first. It might not be a real action shot, but it's a good safety shot in terms of capturing all of the infielders throwing the ball.

Shooting from Third Base

The opposite view from first base along the third baseline can also be a great location. You might initially think that you can get the same shots from this vantage point, but some things are different. You can still shoot the batter at the plate, because a left-handed batter faces you in his stance. Conversely, even though a right-handed batter has his back facing you during his stance, he might pull the ball down the left field line, and his body will turn that way as well. At this point, you can shoot the player watching the ball just as the example explained from the first base vantage point. However, because you are not in a good location to photograph the player as he runs toward first base, a good

These two images are examples of getting infielders in action from the first base location. Notice in the second image that the ball doesn't always have to be present to make a worthwhile image. ©G. Newman Lowrance

"Safety" shots of infielders between innings are good to have for backups in case you don't get the fielders during actual game action. ©G. Newman Lowrance

shot to attempt is to pull away from the batter after he has hit the ball and try to follow where the ball goes. If you are fast enough, you might be able to photograph the shortstop or third baseman fielding and throwing the ball to the eventual base. This throw could lead to another play at second base if a runner was previously on first base.

Remember to watch the base coaches and umpires, because they usually line up nicely between you and second base to block your shot. Again, you might get a contact play, albeit from a different angle. Of course, if you are shooting major league baseball, odds are you won't capture the fielder ranging toward the ball because the action is too fast. Getting this type of shot is difficult unless you are already concentrating on that player in his defensive position. The part of shooting baseball that is the most difficult is getting an infielder diving for the ball. Watch where the infielders are positioned. Are they playing "back" for a possible double play, or are they playing "in" for a play at the plate? Maybe the entire infield shifts for a pull hitter, or it hugs the lines late in the game to

prevent hits down the lines. All major league teams have scouting information that aids them in aligning defensively. Use your eyes to view where they are playing as you focus in on a player. You might get lucky and capture an infielder diving or ranging to a sharply hit ball. Of course, the infrequencies in which these plays occur also add to their difficulty, but a little preparation can help you make some decisions in these situations.

You can photograph a batter from the third base vantage point as he watches his ball in flight.
©G. Newman Lowrance

From the third baseline, you can get great close-ups of the infielders near you. ©G. Newman Lowrance

Shooting from this vantage point also places you in prime position when a base runner comes across second base and digs for third. Usually, the base runner is advancing from first base and is showing some great facial expressions while running as hard as he can to third base. He might even be sent home on the play, and you can shoot him as he runs through third base. Just be prepared for a play at the plate that might follow during this situation.

Watch for great facial expressions as the runner digs from third to home plate to try to score. ©G. Newman Lowrance

Sliding plays at third base aren't as frequent as pick-off attempts on the first baseline, but sometimes a runner arrives at the base as the ball is thrown. This is often a great opportunity to capture a runner going full speed before sliding head or feet first into the bag. Again, know the situation before the pitch and realize the different plays that might occur when the batter makes contact.

Again, know the situation of the game: A player who realizes that a throw is coming will run toward the bag at full speed, preparing to make a slide. ©G. Newman Lowrance

Another situation to look for from the third base side occurs when a first baseman is holding a runner close to the bag. As explained previously, the first base location is ideal for capturing a pick-off attempt when the base runner is diving back to the bag to avoid getting picked off. Conversely, the third base location is better at capturing the first baseman catching the ball and applying the tag. This photo works well as a horizontal image showing the runner diving back to first with the ball heading toward the first baseman. This also works well as a tight vertical image of the first baseman making a catch from the pitcher. You can also watch for the first baseman to catch a throw from the various infielders who are attempting to throw the runner out.

You can shoot the first baseman in action from the third base vantage point as he receives a throw or attempts to apply a tag. ©G. Newman Lowrance

Whereas the first baseline provides opportune shots for the right side of the defense, the third base vantage point offers the same for the left side of the defense. Often, the third baseman or shortstop has several plays when balls are hit to him. The left fielder is frequently busy, too, especially in youth leagues where most players bat right handed and generally hit toward that side of the field. Of course, you can always get your safety shots of the fielders in their respective positions if you don't happen to catch them in action fielding a ball.

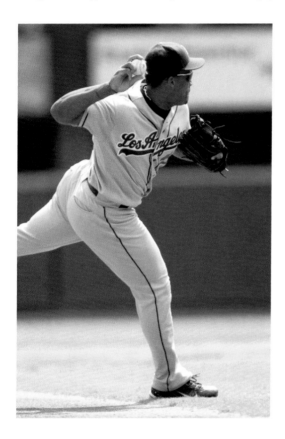

You can also capture a tight shot of the third baseman throwing the ball.
©G. Newman Lowrance

Shooting the Pitcher

Photographing the pitcher is probably the easiest shot in baseball. First, the pitcher is in a stationary position. Second, you can capture the pitcher from several different angles because he is in the center of the field.

I prefer shooting from behind the home plate area when shooting pitchers because the ball is in a direct line of sight. Shooting with your high-speed camera, you can see the many different stages of a pitcher's windup. You can see the leg kick, the release point, and the strain on a pitcher's face as he throws the ball, all in a few frames. Upon viewing these images, you can see why pitchers commonly have arm problems. You can observe the tension of the elbow when pitchers throw. Although certain stadiums might not have an actual location behind home plate for photographers, they usually allow you to shoot this angle from the stands.

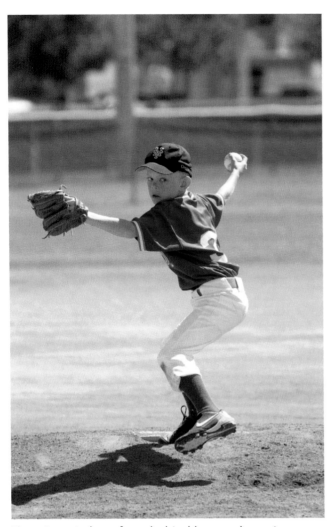

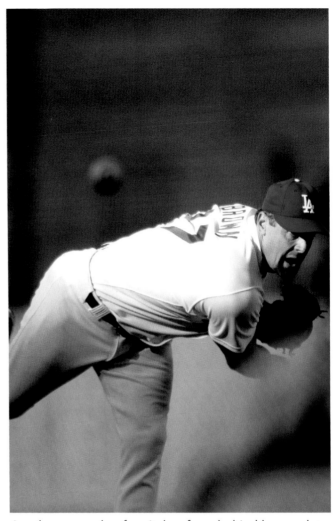

Shooting pitchers from behind home plate gives a great view of their throwing motion. ©G. Newman Lowrance

Another example of a pitcher from behind home plate, this time after he has released the ball. The intensity on his face tells it all. ©G. Newman Lowrance

Depending on the pitcher's throwing arm, you can also photograph him from the first or third base area. It's a good idea to shoot the pitcher from both front and side angles because you never know what an editor is actually looking for. Obviously, you would photograph a left-handed pitcher from the first baseline and a right-handed pitcher from the third baseline so that the pitcher faces you as he turns to throw to the plate. From these angles, you can also capture the pitcher while he's stretching and while he's looking over to a runner to hold him closer to a base.

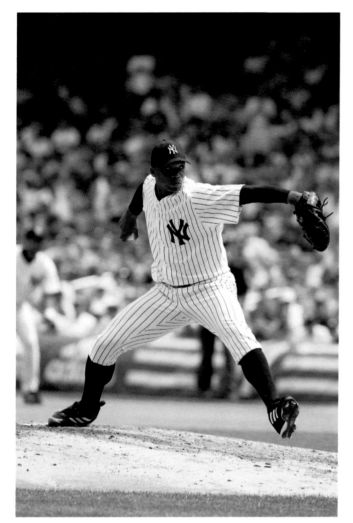 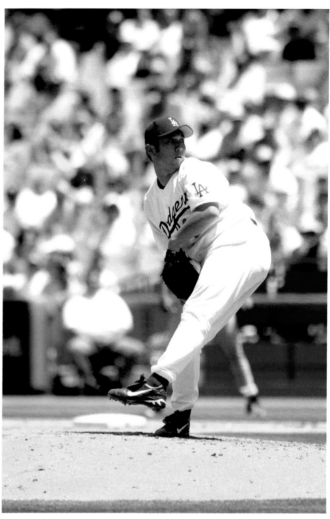

Usually when you photograph a pitcher from the first or third base area, you need to be on his throwing side to capture his face as he throws the ball. ©G. Newman Lowrance

Shooting the Outfielders

Shooting outfielders is a difficult task for a photographer. The problem is that they are usually far away. If you are concentrating on a batter, pitcher, or infielder with a long zoom lens or even a 300-mm lens, and a ball is hit to an outfielder, you will likely be too loose for the play. Conversely, if you use a long lens with a teleconverter waiting for some outfield action, you might be too tight for a play at the plate or a double play and still not have a good action shot of an outfielder. In these respects, some of your decisions depend on what level of baseball you are shooting. Obviously, a youth game is completely different from a major league game in terms of lens selection, but the perspectives are similar.

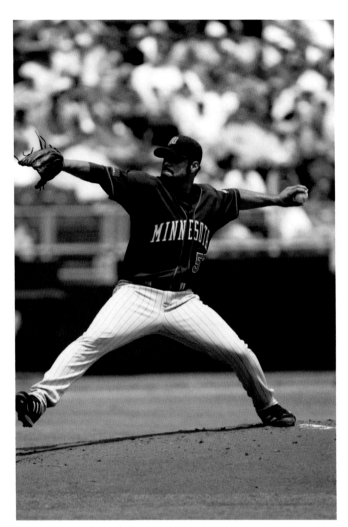

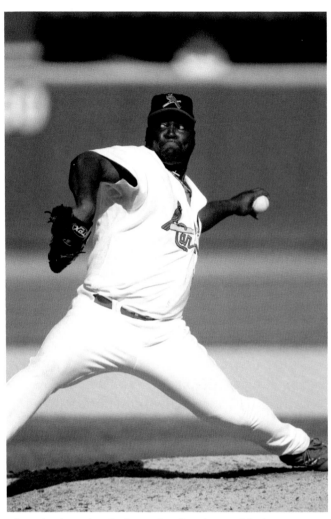

More examples of shooting pitchers from the side. Notice that the location is from the first base side because both of these pitchers are left handed. ©G. Newman Lowrance

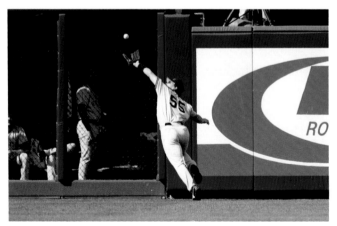

Because outfielders are the players who are farthest away from you, a long lens is mandatory to get good results. ©G. Newman Lowrance

Many times, it is challenging trying to capture an outfielder in action. When I say action, I'm not referring to a routine fly ball with the player camped under it. The best action shots that a photographer can have for an outfielder is when he dives for a ball or when he leaps at the outfield wall, attempting to catch the ball. As I mentioned, the distance is already a disadvantage, and the frequency with which these plays occur is even more of a factor. I sometimes recommend trying a looser horizontal image of an outfielder leaping up the wall for a catch because it can be visually graphic to capture the expanse of wall and the player high in the air. You might try to capture these shots for several games without them transpiring. Of course, when these photo opportunities do occur, you might not be prepared with the right lens. This fact is perhaps less likely now with digital cameras and their respective focal length multiplying factors. Currently, professional Nikon cameras such as the D1H shoot with a 1.5X multiple factor, and Canon's 1D and 1D Mark II cameras have a 1.3 ratio. In other words, for Nikon users, a 400-mm lens is actually a 600-mm lens. A Canon user's 400-mm lens is now a 520-mm lens. Don't forget that the aperture setting of the original lens doesn't change. As an example, a Nikon 400-mm f/2.8 lens becomes a 600-mm f/2.8 lens, so you gain a 1 f-stop advantage in low-light situations. This allows a shooter to be closer to the outfield activity and acquire a tighter shot.

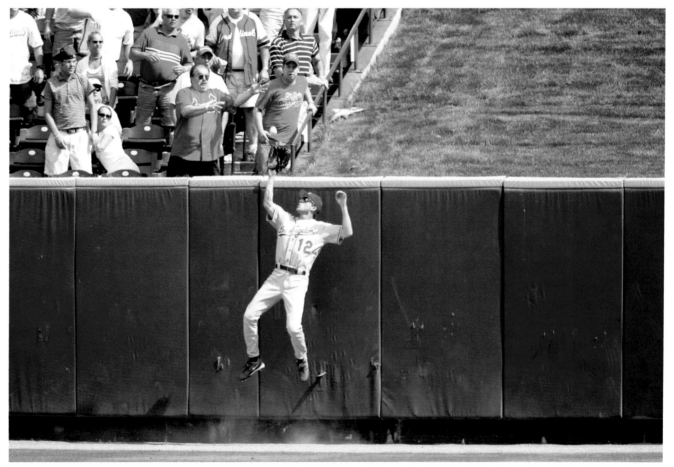

Shooting a looser horizontal image of an outfielder leaping in the air at the wall can be a nice visual effect.
©G. Newman Lowrance

Shooting from Overhead Locations

Although most youth photographers don't need to shoot from an overhead or elevated position, major league shooters often use these locations as a viable option for a different shooting perspective. Some of the most famous baseball photographs have been taken from overhead, and you can get similar results by using the same approach. Your view is typically unobstructed across the whole playing field, unlike from field level, where other players and umpires can get in the way. Granted, the area behind home plate has a fence to protect fans, but if you are off the first or third baseline, this shouldn't impede your view. You might also find it easier to follow the action because you can pan from an outfielder throwing to home plate quicker from this position than being down on the field, where you and your lens might have to make a big turn.

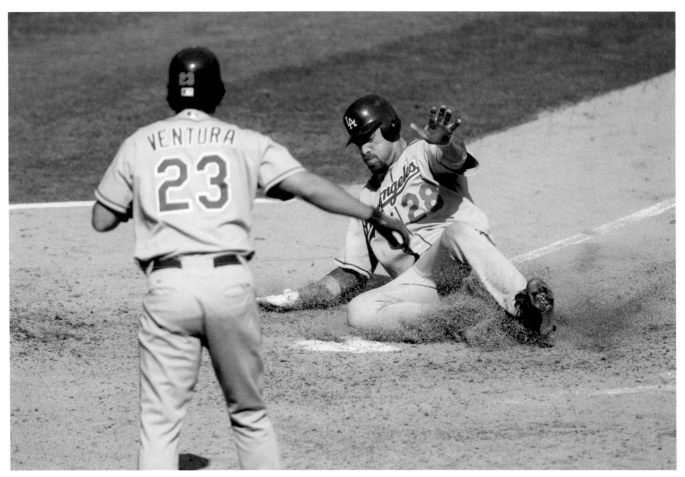

Shooting from a higher position than at the field level gives a different perspective and feel to your images.
©G. Newman Lowrance

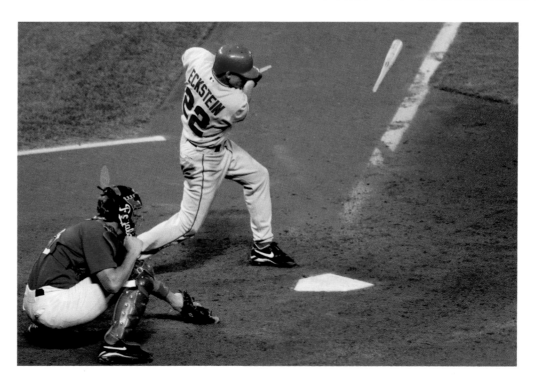

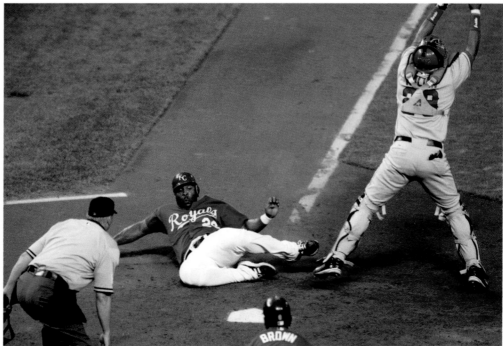

Overhead locations also allow you a better overall view of the field and a reduced chance of being obstructed. ©G. Newman Lowrance

Because you are farther away from the action at these overhead locations, a long lens is a necessity. Even with the extra length that the digital cameras give you, a 300-mm lens with a teleconverter is the minimum for capturing a particular play from an overhead location. If you want to show a wider view, other lenses will suffice. However, for a particular play at the plate, a tighter shot probably makes a better picture, even though you are up high.

Plays at the Plate

I would be surprised if most baseball shooters don't regard a play at the plate as their favorite to try to capture. Because baseball is mostly an isolated sport in terms of the way it's played, it's always nice to capture plays with more than one player. It's difficult to capture good plays at the plate because you have no control over whether the catcher will be facing you or whether he will block your view of the tag. If you are on the first baseline, you will undoubtedly see the base runner's face as he is running toward home plate, but the catcher might be in front of the plate with his back facing you. In these situations, you might capture the action, but you might be on the wrong side in terms of having the best angle. Similarly, if you are on the third baseline, you might have a better view of the catcher, but the base runner might block your view of the tag as he slides in. Regardless of the outcome, shoot freely when you have the opportunity for this type of play, because it can easily be the most dramatic shot from a baseball game.

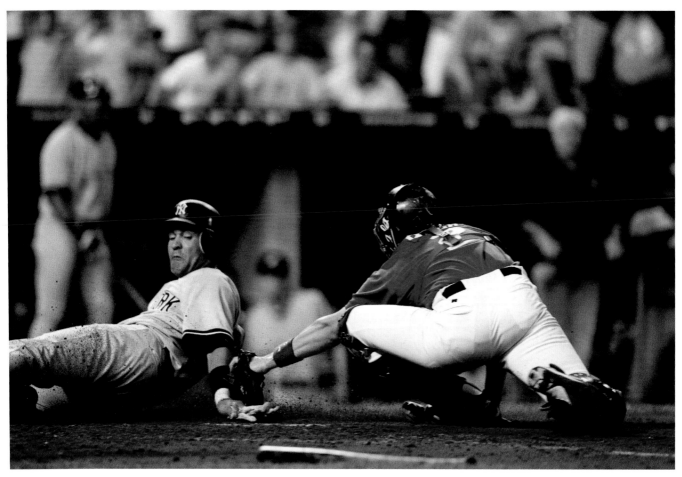

Here is a play at the plate from the first base vantage point. In this instance, the base runner has turned toward me, which turned out to be the better location than the third baseline. ©G. Newman Lowrance

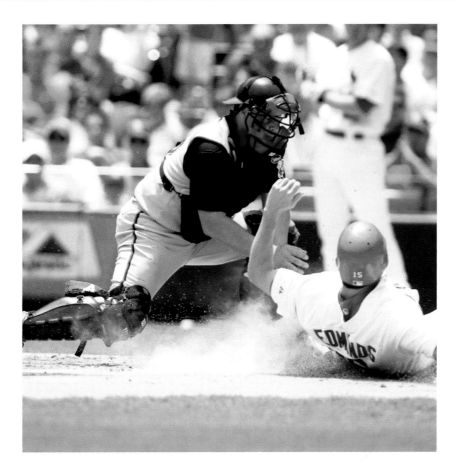

Additional examples of plays at the plate, this time from the third base side. These plays are always an adventure because you never know what vantage point will make the better image. ©G. Newman Lowrance

Other Elements of Baseball

One good thing about baseball is the general feeling of relaxation among the players compared to other sports. It's easy to obtain player portraits and great tight facial expressions. For major league teams that play 162 regular season games, the players are conditioned to the media and photographers that surround them during batting practice. This is an opportune time to take several portrait-type photographs or tight candid shots because the players loosen up and mingle among themselves. These events usually occur about two hours before a game, so if you can get to the event early, you can capture these types of images. In addition, a few minutes before the game starts, it's typical to find several players throwing the ball to one another in front of their respective dugouts. This is another great time to photograph tight candid shots.

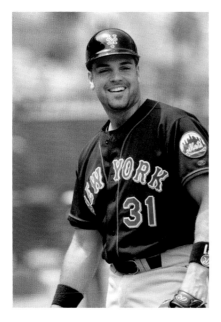

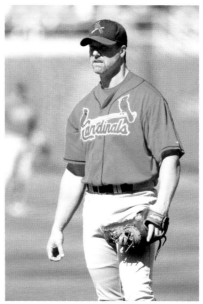

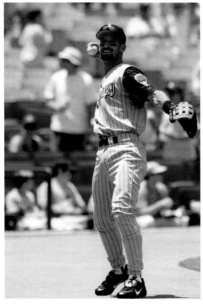

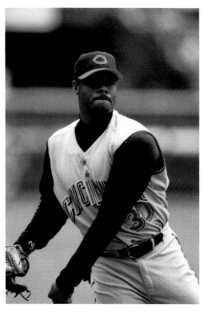

Shooting before the game is a great time to photograph the various players up close. ©G. Newman Lowrance

107

Using Remotes

You can avoid some positioning challenges by using remote cameras. Remotes are almost like being at more than one place at the same time. Depending on the stadium or stands that surround the playing field, you can usually find several areas to use a remote that is radio triggered from anywhere that you are situated within the stadium.

For example, you could set a remote that is prefocused on the home plate area. I generally like to use a 70–200-mm zoom lens for these shots, set up for a wider view. It's better to be too loose than too close for this situation. You can always crop the pictures later for a tighter shot. I also like to set my aperture setting at f/4 or even f/4.5 to make sure that I have a sufficient depth of field. Of course, this depends on the lighting situation. You should always use a high enough shutter speed to stop the action, at least 1/500 of a second. Regardless, if your current shooting position doesn't supply you with a good view of a play, you can reposition the camera stationed at your remote location. Just be sure to anticipate when you'll want to use a remote, because there is nothing more frustrating than being prepared in this manner and then forgetting to use it. In addition, shooters often point a remote at the first or third base bag to capture a runner sliding in or avoiding a tag. If this type of play happens a few feet in front of you, and you are currently shooting with a long telephoto lens, having this alternative vantage point might be a reliable option.

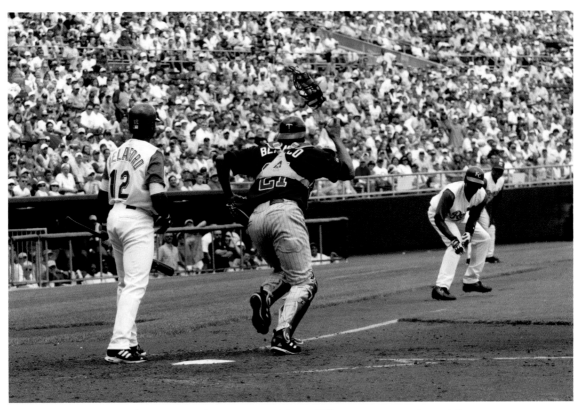

Using remotes is another option that can provide a different perspective while you are at another location during the game. ©G. Newman Lowrance

Baseball might seem like an easy sport to shoot because a lot of the photos come from fairly static spots on the field, such as the pitcher's mound and home plate. Many shooters get caught daydreaming as the game lengthens and the sun beats down. They sometimes forget that a dull game can get interesting in the later innings as relief pitchers are brought in. The whole rhythm of the game can change in a few short throws. Also, the relievers are as important to shoot as the starters, so don't leave early. Many big plays don't happen until the end of the game, when teams start to play for the win and substitutions of players take place. If you are shooting one team more heavily than the other, place yourself on the other team's dugout side because you can get good shots of players and staff in the bench area. When players make a big hit or home run, they usually celebrate toward their dugout, and their teammates greet them with cheers when they return to the bench. Think your way around the field as the game progresses, and you'll be able to capture the interesting and unique images that the shooters who are fixed in one spot often miss.

Football

CHAPTER

6

Football has always been my favorite sport to photograph. Period. I love the colors, the action, the atmosphere, and the intensity of the sport.

While I was growing up, I was like every other kid and had a favorite team or star player. I had teams that I rooted for and teams that I rooted against. The bottom line for football fans is that they love the game because of the action, the big plays and, of course, the big hits. Photographers would probably tell you that they value those same elements while working a game. In fact, I would be surprised if most sports professionals didn't choose football as their favorite sport to cover.

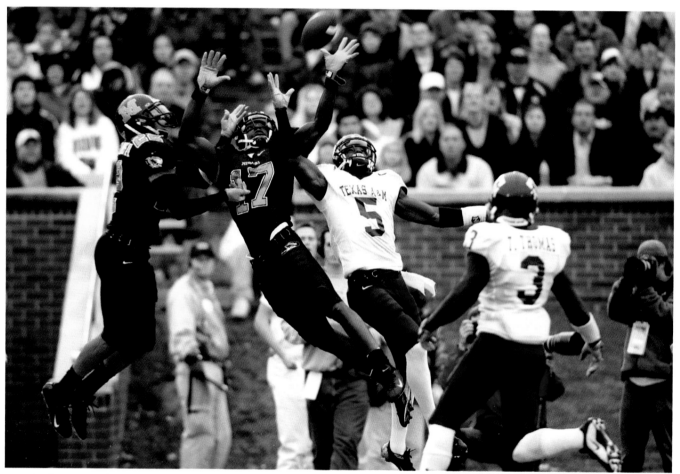

Football is great for capturing moments like this, when many players are leaping in the air in an attempt to catch the ball. ©G. Newman Lowrance

Maybe my love for the game is why a lot of my photography success has involved professional football shots. Part of my enthusiasm for the game was established when my father took me to my first professional game when I was a young boy. It was a cold December day in Kansas City, and on that day, the Chiefs were matched against the Colts. Although I remember the freezing temperature, what really stands out in my mind is the aura of the surroundings. The huge stadium, all the fans, and the crowd noise were a new experience.

Going to that first game definitely amplified my interest in professional football. It led me to following the sport throughout the rest of my grade school, high school, and college years. When I finally dug back into photography and eventually shot games as a contributor for NFL Photos, I was fortunate enough to be able to choose practically any game, in any week, and in any city to cover during the season. When the schedule came out each spring, I studied it almost as if I were preparing for an exam. I tried to predict which games would provide the best match-ups, which teams had the top star players, and what the weather and lighting situation might be at that game. As each season progressed, I sometimes altered my choices because a rookie might end up being the hottest player in the league, or an upstart team that was predicted to do poorly might excel and surprise everyone. I undoubtedly wanted to cover these situations and capture many different teams to market my images.

Following the Action

Unlike most other sports that you photograph, football is one in which you need to physically follow the action. You don't have photo areas to stand or sit in while covering the action like baseball, basketball, tennis, or hockey do. All college and professional stadiums have lines painted around the field designating the photographer's areas. These lines form the basic angles for the situations that you encounter while photographing the game. Photographing football also requires running up and down the sidelines the whole game, trying to get the best angle for the next play. You almost find yourself thinking like a coach would, wondering where the next play might go.

Of course, all the other photographers at the game are thinking the same thing. Sometimes it looks like a track meet out there with all of the photographers trying to get a good spot on the sidelines. At the next major college or professional game you view, watch what happens when a team makes a big play to the other end of the field. The sidelines become visibly active with shooters running down the sidelines to get into position for the next play while attempting to find a good location. Even after you go through this, you might still have a major problem: Some of the sideline personnel might move in front of you, restricting your visibility.

Over the years, the major college and professional sidelines have become increasingly crowded. There are more photographers, more national television coverage for the different angles that replays show, and additional sideline personnel. The sideline personnel include the chain gang, the ball boys, the sideline officials, television officials, and even team officials. I can understand why the NFL employed a separate line for the national television coverage in front of everyone else, but for the life of me, I still don't understand why it takes so many individuals for the ball crew. One person wipes off the ball, another takes it from the official, a third holds the separate footballs for the

kickers, and so on. A few years ago, the league moved the photographers' designated area to 5 yards from the out-of-bounds stripe. This was partly for our protection, but it also cut down our angle when trying to shoot past the players' bench area. Another hindrance is the timekeepers for television who stand on the white border surrounding the field, usually at the end of the home team's bench. Their presence cuts down the photographers' angle of view tremendously, and they continue to stand in that area even during the game action. The only option is to move farther down the sidelines away from the action. Hopefully, understanding all of these elements will make you more appreciative of what it takes to capture great photos. We as photographers enjoy the challenge, but it's not as easy as it appears.

Many obstructions on the sidelines can hinder a photographer's view of the game. Here is a typical chain gang crew that I obviously need to move away from if I want a clear vantage point. ©G. Newman Lowrance

After running around with all the equipment you need for a typical three-hour game, you can understand why it takes so much energy. After some games, I'm physically spent. Maybe it's not close to what the athlete endures, but on some occasions, my knees and back beg to differ.

Most professional shooters today carry at least a 300-mm f/2.8 or a 400-mm f/2.8 lens, along with a wide-angle lens for plays that occur within close range. Lugging around this equipment all day can take its toll. Some photographers even carry an additional long lens, perhaps a 600-mm f/4.0, but with the added focal length that a digital camera provides you with today, those uses are becoming less frequent. I prefer to have both long lenses with me during a game, as long as I have a handy assistant, or *grip*, to carry the one that I'm not using at the time. Believe me, running around with one big lens all day is tough enough, let alone two. Of course, the alternative is to use a teleconverter, which saves not only weight but also cost. I've used a teleconverter for years; however, I believe that using a true focal length lens without a converter usually results in sharper images.

Preparation

In preparing for a football game, be sure you bring all the equipment you plan to use. Depending on whether it's a day or night game or if it's a dome game, you can determine which equipment is better suited for the event. For a typical day game, I bring 2–3 camera bodies, my 400-mm f/2.8 and 600-mm f/4.0 lenses, a 70–200-mm f/2.8 zoom lens, and a 28–70-mm f/2.8 zoom for wide-angle shots. For a night or dome game, I typically bring only lenses that have an f/2.8 aperture—thus, the "faster" lenses. This type of lens allows me the fastest shutter speed at the lowest usable ISO, which is what is typically needed for a night game. Using anything lower than 1/500 of a second shows some motion blur if you are shooting professional games. Even at that shutter speed, you might see some motion in your images. You can get away with a longer shutter speed if you are shooting high school games because at that level, the players aren't nearly as fast. Experiment with different settings and see what works best for you, depending on what level of football you are shooting.

If the lighting conditions allow, I prefer to maintain a minimum of 1/640 of a second shutter speed. Previously, if you were shooting in low-light conditions using film—especially color transparency film—this would probably entail pushing the ISO rating of your film one or two f-stops during processing or using a high-speed film that would show more grain. Today, with the latest features of the digital cameras that have reduced the noise factor from previously released models, using a higher ISO rating of 1000, 1250, or even 1600 brings better results than in the past with a click of a button. During the film-format days, you needed to bring several different speeds so that you could adjust accordingly to any lighting changes that might occur. It was sometimes necessary to replace a film canister halfway through the roll to a faster speed because of a change in light at an outdoor event, which was a waste of film.

Dome games are not as difficult to shoot as in the past with the advances of digital technology and reduced grain in the images using a high ISO speed. ©G. Newman Lowrance

Another factor to consider is to know the weather conditions when you are shooting at an outdoor event. Games that are late in the year can get extremely cold, especially in the Northeast or places like Green Bay or Chicago. In these types of conditions, plan ahead and select the clothes you need to keep you comfortable. I'll never forget a game in Chicago in late December when the temperature was 5 degrees with a wind howling from the lake right off Soldier Field. I had forgotten my insulated shoes, and by the end of the game, I couldn't feel my toes. Needless to say, I didn't forget to bring them the next time I was at a cold-weather game. Purchasing some type of hand warmer is also a good idea. Trying to change settings and memory cards and shoot in general can be major problem if your hands are cold. Just remember to plan ahead and bring everything you need to handle the weather conditions.

Hot weather conditions can also be problematic. Early in the season, you might encounter games in the mid-90s or more with high humidity indexes. It doesn't matter if you wear shorts and a tee shirt, by game's end, you most likely will be soaked from perspiring the entire game. It's important to stay hydrated to keep your energy level up. Drink plenty of water, or make your

way to the team coolers behind the players' bench as you walk by. Generally on hot days, the equipment personnel allow the photographers a drink when needed. Also remember to apply sunscreen and wear a cap for protection. Any factor that makes you feel uncomfortable might hinder how you photograph and how your final images turn out.

Rain is another consideration to plan for. Several companies sell handy camera and lens covers to protect your equipment from becoming wet. Although some of these can be rather expensive, remember the investment in your equipment that you're trying to protect. At a bare minimum, keep an extra trash bag in your camera bag in case you get caught in a sudden storm. Also, bring a rain cover or a jacket that is waterproofed to keep you dry. During the days of using film, nothing was worse than trying to change your film canister and attempting to keep it dry as you loaded it into your camera. At least now with the digital cameras, you can use the high-capacity compact flash cards that you might only need to change a few times during the game.

This image from Super Bowl XXXIX is a prime example of getting a usable image with a high ISO speed. This was taken at ISO 1250 at 1/640 of a second with an f/2.8 aperture. ©G. Newman Lowrance

Rain is probably the least favorite weather condition for photographers to shoot in. The main reason for that is the required frequent checking of your camera gear to make sure your lens isn't covered with water spots. A good rain cover helps to keep your camera and lens dry. ©G. Newman Lowrance

Lighting

Lighting is another important element you should consider when deciding your positioning on the field. Although you can't control the weather or lighting, you can plan accordingly. Generally, most shooters tend to start a game from the front-lit side, which means the sun is behind you with the light on the player's faces as they come toward you. If you happen to be shooting for a publication with a crew of other photographers, your team usually discusses and communicates with each other regarding what areas of the field each shooter will cover before the game. If you find yourself on the backlit side, you will be faced with a different lighting situation, with the sun facing toward you and usually *behind* the player.

Generally, if you are shooting with the camera's automatic features, some images might come out underexposed. For this reason, I always carry a light meter. Because most professional shooters have switched to the digital realm,

not everyone uses light meters like in days past, but I still like to know what the ambient light is under most circumstances. Maybe I'm old school, but the light meter is a safety tool that I use regardless of the lighting situation I'm shooting in.

Here is an example of a photo that is moderately backlit. Also notice the stands in the background that are in the shade, but you can still see the player's face due to the correct exposure. ©G. Newman Lowrance

Some photographers prefer to be on the backlit side anyway. Most other shooters are on the other side, so you have more room to work and don't have to go through as much finagling to get into position. Your images also have a different look to them compared to the front-lit side. In some ways, backlit images are an advantage during a high-contrast day because from the front side, the high-contrast lighting presents shadows under the players' helmets and face masks. Due to this backlit effect, you need to open your exposure sometimes as much as two f-stops plus. This offsets the direct impact that the sunlight has because it is facing you. If you are shooting aperture or shutter priority, be sure to add compensation accordingly to your camera, or your images will be drastically underexposed. My recommendation is to manually set your aperture and shutter speeds because the exposure doesn't change much in backlight, and most camera light meters get fooled by this sort of lighting. Even a slight underexposure in backlight makes your photos almost unusable, so be careful about setting correct exposures.

Lighting plays an important role regardless of the sport you are covering. Here, both players are front lit very nicely to bring out their face details. ©G. Newman Lowrance

I often shoot the backlight toward the end of the afternoon when the sun is lower and shadows start to move across the field. The frontlight exposures become tricky as players quickly move from full sunlight to full shadow. Another big problem occurs when the players are in shadow but the background is in full sunlight. The background of the stadium becomes overexposed. This is the time of day when the backlight creates a beautiful separation between players on the field and the darker shaded background of the stands, and the exposure stays consistent across the field.

Sometimes your credential might prohibit you from being on one side or another. It all depends on the different teams' credentialing systems. Just try to understand the various lighting elements that you might encounter and shoot accordingly with whatever situation you are in.

Positioning

There are many variations in the locations for shooting football. Your positioning on the field is dictated by what you want to photograph and what the situation of the game is. You also typically have the option to kneel or stand as you are photographing. I prefer on most occasions to kneel because I like the lower angle of actually looking up at the players. Kneeling makes the players seem larger than life, which most of them are anyway. Also, during a tackle as the players get close to the ground, kneeling seems to be a better angle to capture some faces than standing does, which cuts this angle down.

From the Sidelines

If you want to capture the quarterback attempting to pass or make a handoff, a great spot is just a few yards ahead of or behind the line of scrimmage. Regardless of which side of the field you are on and whether the player is left or right handed, he might or might not turn toward you as he throws the pass. It all depends on which receiver he's throwing to, but it's a great vicinity to get this type of shot. At this position, you also have a great vantage point for shooting a quarterback getting sacked or a running back who might come right toward you on a sweep or pitch play. For these shots, I typically use the 400-mm lens f/2.8, which is actually a 520-mm lens f/2.8 with the added focal length of my digital camera. Sometimes you might be too tight and can get by with a 300-mm lens. It all depends on the equipment you have and how far away from the action you are.

The sideline vantage point close to the line of scrimmage is a perfect spot to capture the quarterback dropping back or rolling out to pass. ©G. Newman Lowrance (4)

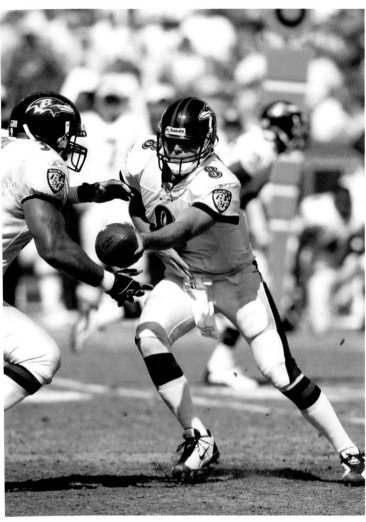

You can shoot other aspects of the quarterback from the sideline position, such as this example of Kyle Boller of the Baltimore Ravens making a handoff. ©G. Newman Lowrance

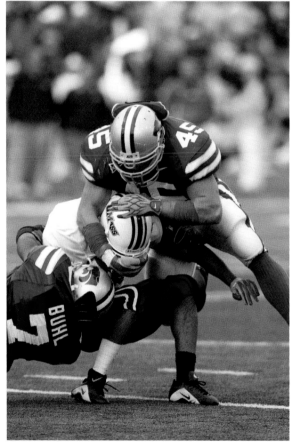

Quarterback sacks are also a prime shot to capture from the sidelines. ©G. Newman Lowrance

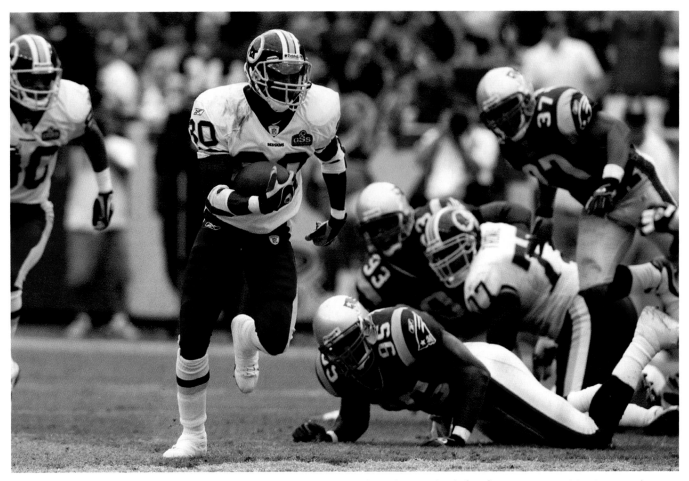

Capturing a running back coming around on a sweep is another shot to look for from your positioning on the sidelines. Here, Trung Canidate of the Washington Redskins leaves several defenders as he runs with the ball. ©G. Newman Lowrance

From the sidelines, you can also capture a field goal kicker or punter as he goes through his actions kicking the ball, or the defensive end on the far side of the field coming in to rush the passer. The choice about positioning is yours, but remember to think about the game's circumstances to help you decide.

While you are on the sidelines, it is also worth your time to watch the activity that occurs inside the players' bench area. Depending on which unit is on the field, the other is usually getting instructions from coaches or communicating with one another as they try to determine a way to beat the opposition. This is a great time to photograph the human elements of a football game. An injury to a player that evokes visible pain or a confrontation from a coach or teammate can show great emotion and tell a portion of the story that leads to the final outcome. Just remember that you are not allowed to stop behind the bench area to take pictures, so do your shooting at either end of the team bench. Always keep your eyes busy between each play, because you never know when one of these moments will occur.

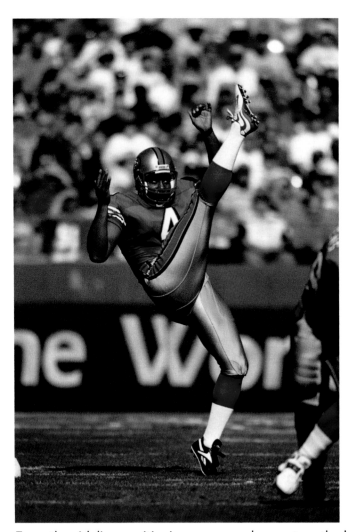 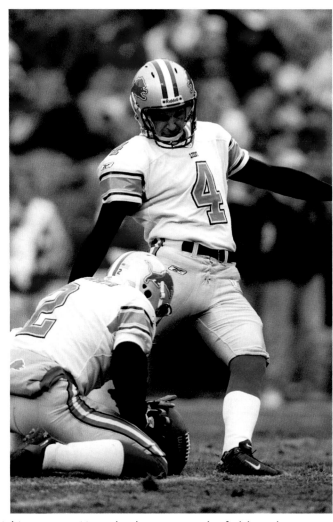

From the sideline positioning, you can also capture the kicking game. Here, both a punt and a field goal attempt are shot from this vantage point. ©G. Newman Lowrance (2)

The sideline area is usually the best vantage point to capture a kickoff or punt returner as he fields the ball. In some cases, the runner turns toward you as he makes his way up the field, and you can capture this situation easily. If he runs past or away from you, you can always concentrate on the defenders attempting to tackle him.

Watch for shots in the players' bench area, as players and coaches alike visibly display their emotions during a game. ©G. Newman Lowrance (3)

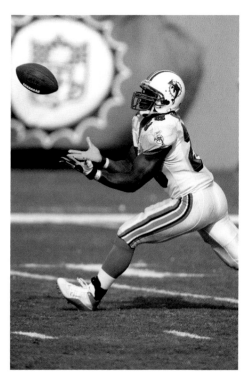

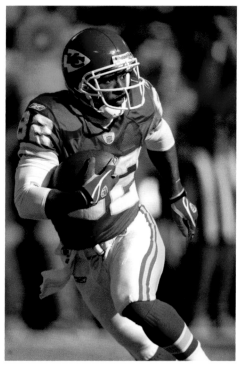

Another aspect that you can easily capture from the sidelines is the kickoff and punt returns. The player returning the ball often turns right toward you as he makes his way up the field. ©G. Newman Lowrance (2)

From the End Zones

Another great location for shooting football photos is behind the end zone, capturing the offensive or defensive team. From the offense perspective (because you are behind the defense), the end zone gives you a great view of the holes that the offensive line opens up for a running play or the wide receivers who are running their various pass routes. If you need an offensive lineman making a block or setting up for a pass, the end zone is an ideal location for those images in which a player is isolated. Another end zone advantage is that most of the action is in front of you, regardless of which way the play goes. Also, you won't have to deal with the chain gang crew, the ball boys, and all the various sideline conditions. Remember: Anytime you can have an unrestricted viewing position, you have an advantage. If you find that you are dodging the sideline microphone or officials and timekeepers, odds are your shooting abilities are restricted. From this end zone perspective, you usually need the longest lens that you have, especially if the line of scrimmage is 40 or 50 yards away from where you are standing. You will find yourself in a superb position if the quarterback launches a 30- or 40-yard pass downfield or if a running back breaks free for a long gain. In either case, if you are on the sidelines at the line of scrimmage, your vantage point for these types of plays will most likely be at a disadvantage.

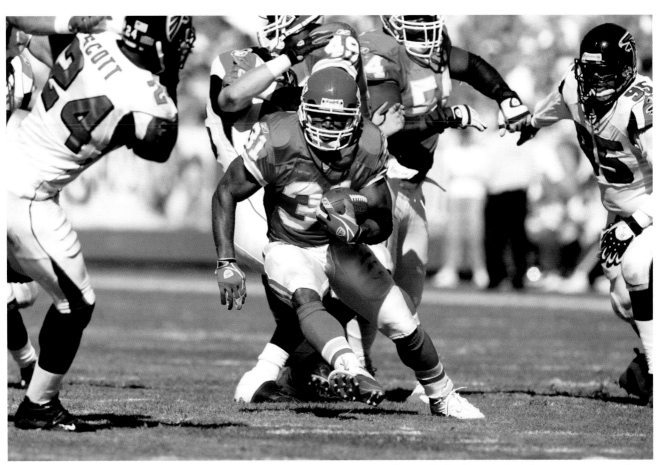

Shooting from the end zone can be an advantage because regardless of which way the play goes, you will be able to capture the moment. ©G. Newman Lowrance

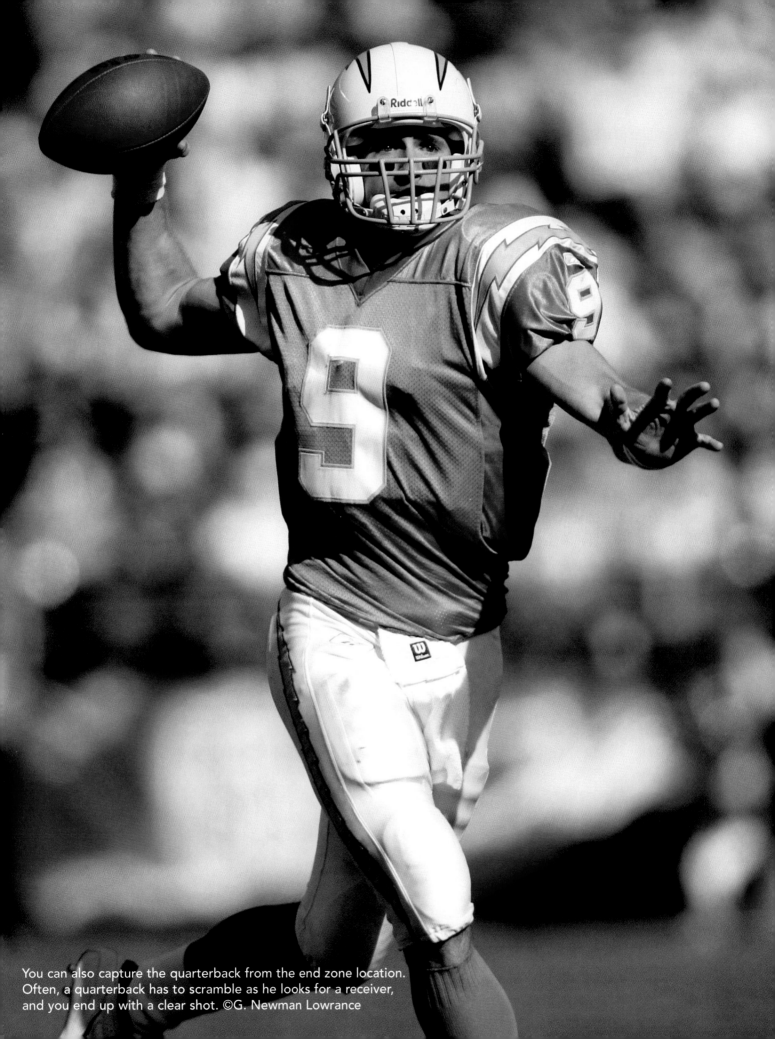

You can also capture the quarterback from the end zone location. Often, a quarterback has to scramble as he looks for a receiver, and you end up with a clear shot. ©G. Newman Lowrance

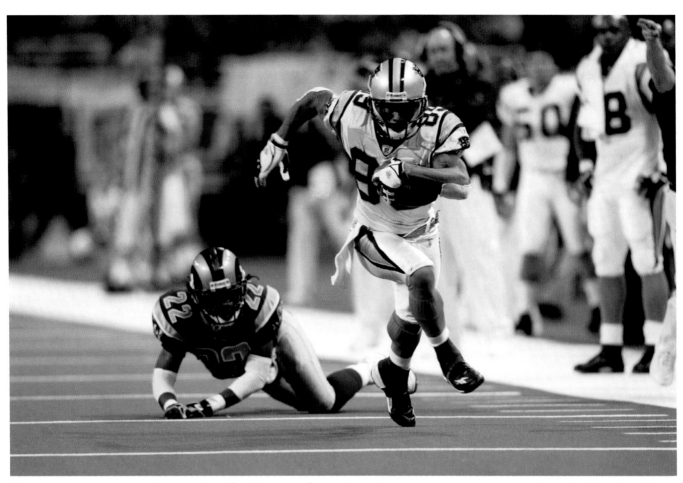

When you are concentrating on the offensive team from the end zone, you can get a great shot of a big play. Here, Steve Smith of the Carolina Panthers breaks free as he leaves a defender on the turf. ©G. Newman Lowrance

Of course, if the offensive team is close to the goal line, you might consider using a zoom lens such as the 70–200-mm f/2.8 or even shorter, such as a 28–70-mm f/2.8. You never know where a play is going to go, so you need to be prepared for any situation. Most photographers carry at least two bodies so they're prepared for every angle or play that the game offers. This is especially important if you have a long lens as the teams make their way closer to the end zone area. If you are looking through your viewfinder and notice the quarterback looking toward you, you might need a wider zoom lens to capture the receiver just a few yards in front of you. If you don't make the switch in time, you will probably miss a great opportunity to capture the receiver catching the ball for a touchdown or a defensive back making an interception or batting down the pass.

The disadvantage of being behind the end zone is that the offensive and defensive lines typically block the action behind the line of scrimmage. It's doubtful that you would be at the ideal location for a fumble recovery or an interception because these plays more often than not go away from you. However, because most big plays are from the offensive standpoint, odds are you will be able to capture a lot of big plays and game moments from the end zone vantage point.

You can also focus on the offensive linemen from the end zone location as they set up to pass block.
©G. Newman Lowrance (2)

Having a zoom lens near the goal line is a great way to shoot an important play. Here, I captured the Rams Isaac Bruce scoring in the 2002 NFC Championship, which helped the Rams to the Super Bowl. ©G. Newman Lowrance

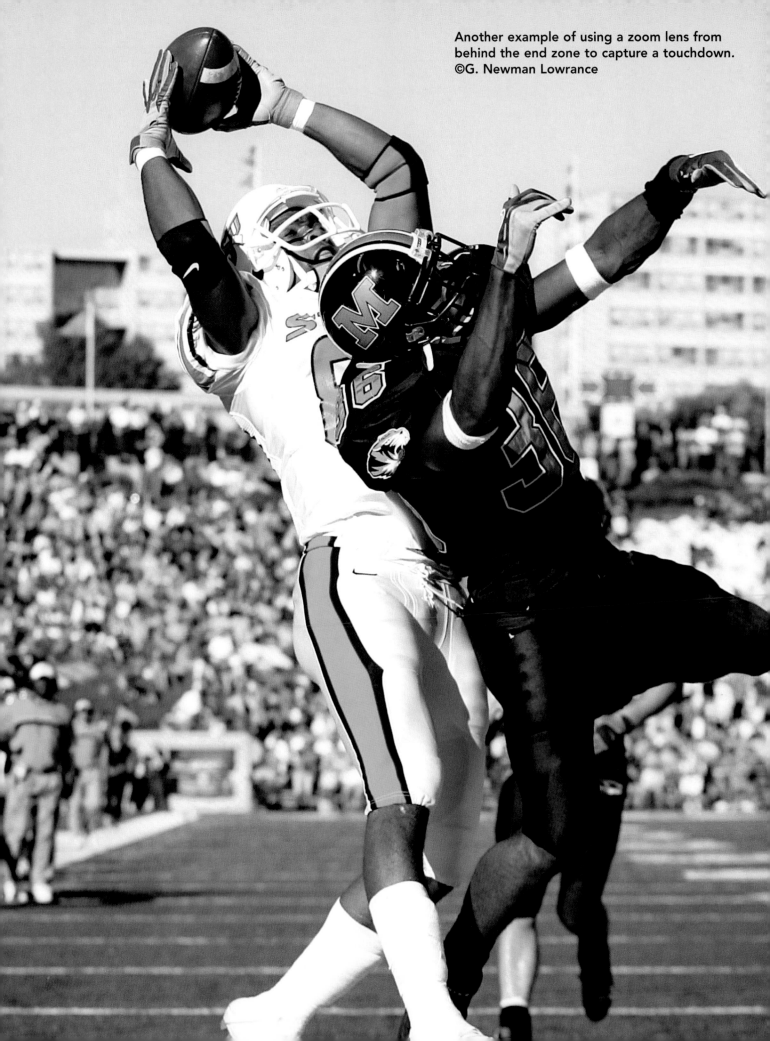

Another example of using a zoom lens from behind the end zone to capture a touchdown.
©G. Newman Lowrance

You can also capture the defensive side of the ball using this same location. Facing the defense, you can shoot the defensive linemen rushing around the offensive linemen and sacking the quarterback or stuffing a run in the backfield. You can also watch for a linebacker pursuing a ball carrier, a defensive back peering into a receiver's eye, or a player making a big interception or fumble recovery. In addition, a defensive team trying to block a field goal attempt can show a lot of impact in a photograph. Capturing the defensive players leaping up to block an important kick can definitely demonstrate the intensity of the game. You might even get lucky on those infrequent occurrences when a kick is actually blocked.

Facing the defense, you can concentrate on a defensive lineman as he tries to rush the passer. Here, Duane Clemons of the Cincinnati Bengals leaps away from a potential block as he pursues the play.
©G. Newman Lowrance

Linebackers are another group to focus on when you face the defensive side of the ball. Linebackers usually drift back into coverage on pass plays or cover a running back coming from the backfield. In this example, Donnie Edwards of the San Diego Chargers tackles Jacksonville's Fred Taylor after a reception.
©G. Newman Lowrance

Defenders often peer into the backfield to get a feel for what the offense might call. Facing the defenders is a great vantage point for capturing these types of images. Here, Brian Urlacher of the Chicago Bears makes his presence known from across the line of scrimmage. ©G. Newman Lowrance

Of course, from the defensive side, you are now at a disadvantage if the offensive team makes a big play, but that's the chance you take, given your positioning on the field.

Regardless of your shooting location, the basic element is this: You can only capture the action that happens in front of you. With 22 players on the field, you won't get everything, and you can't worry about what you miss. Sometimes you'll be focusing on a certain player for an isolation shot and miss a big play. Being ready for the various situations that arise will give you the best chance of getting a good shot. Just be prepared for what you see through your viewfinder, and anticipate the action. If you can continually capture the action that takes place in front of you, you will be successful more times than not.

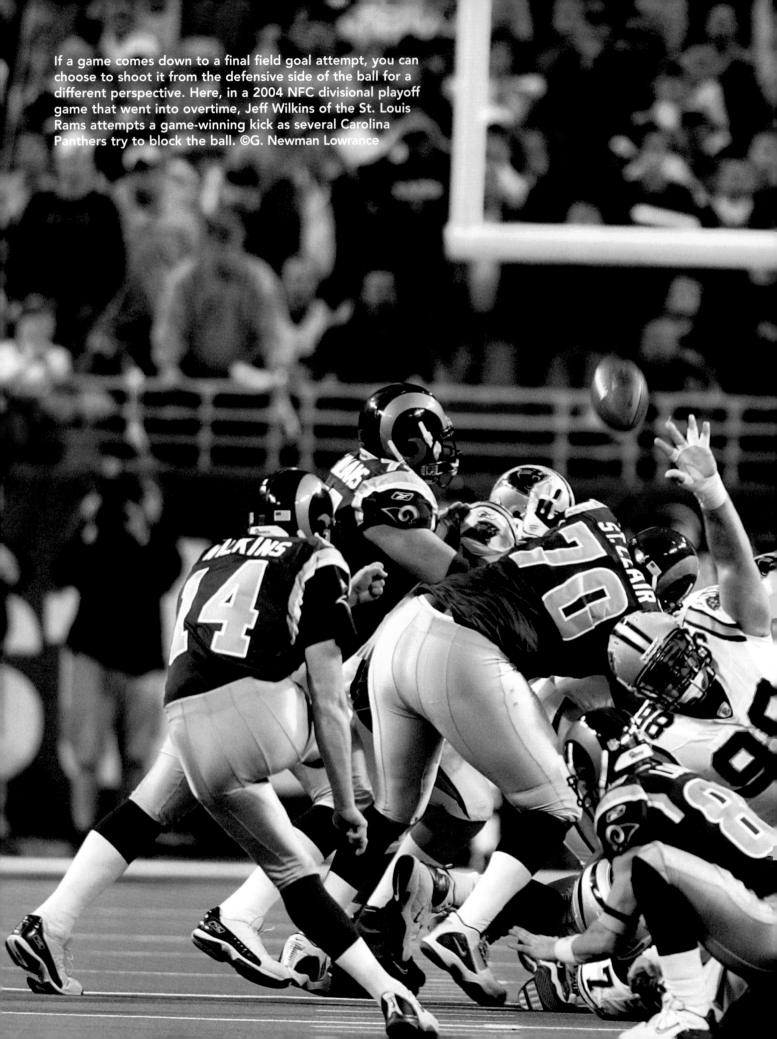

If a game comes down to a final field goal attempt, you can choose to shoot it from the defensive side of the ball for a different perspective. Here, in a 2004 NFC divisional playoff game that went into overtime, Jeff Wilkins of the St. Louis Rams attempts a game-winning kick as several Carolina Panthers try to block the ball. ©G. Newman Lowrance

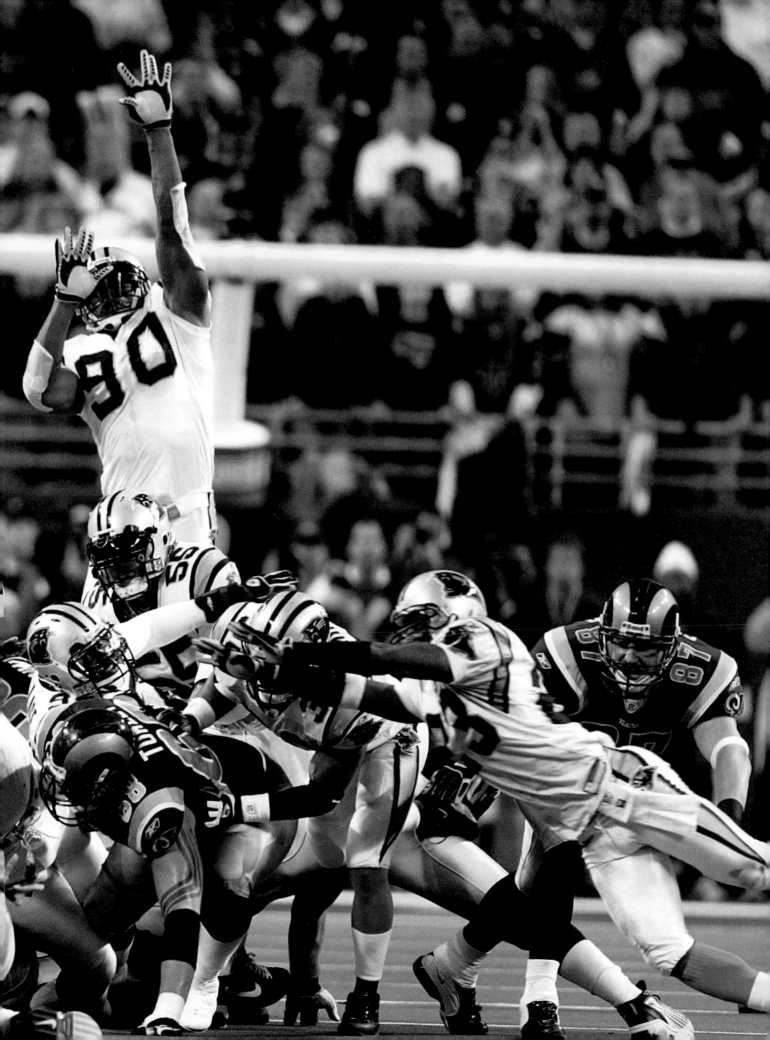

Shooting Methods

Different photographers shoot different ways at a football game. Newspaper and wire service shooters generally try to capture a big play for a journalistic-type approach. They try to get images they can use editorially for the next day's local or national publication. In contrast, a photographer for a magazine might be writing a story on an individual player. In that respect, a shooter might follow a player or certain players around all day to build a story.

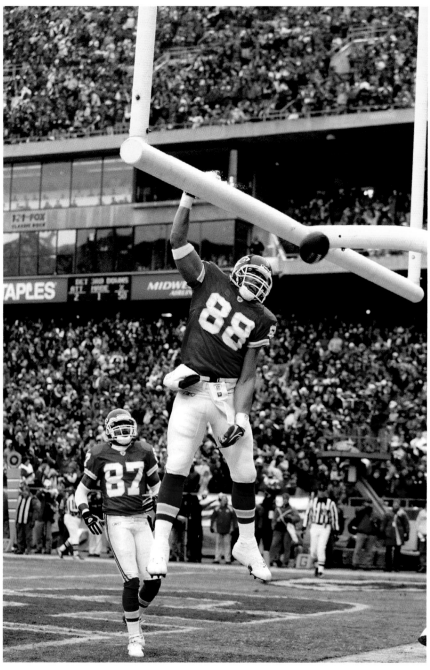

Images that tell a story or show an important score are great for journalistic-type uses such as newspapers or magazines. Here, Tony Gonzalez of the Kansas City Chiefs makes his trademark dunk after a touchdown. ©G. Newman Lowrance

Unfortunately, injuries are another part of football. If an injury occurs to a star player, editors might seek an image reflecting his status. ©G. Newman Lowrance (2)

Trading card companies such as Fleer, Topps, Playoff, and Upper Deck and annual publications like *Athlon Sports*, *ATS Consultants*, *Lindy's*, and *Street & Smith's* require individual shots of players in action. Photofile is a company that sells 8×10 images of players. These images are typically used for autograph appearances, so they steer toward being isolated images of players. For most of these usages, you would probably shoot almost everything vertically because most trading cards and stock images are used in that respect. Editors are basically looking for isolated shots of players in great lighting conditions. For this reason, many of these images are shot at the start of the season during the early Sunday games, when the light is good and before daylight savings begins. You rarely see night game images used for this purpose; however, with the improvements from digital cameras, these images are starting to appear, especially during preseason games when it might be rare to photograph a rookie or backup player actually playing. As a sports photographer, you try to acquire as many marketable images as you can.

Annual publications generally like vertical, isolated images of players for their usage. Here, Brad Smith of Missouri drops back to pass without anyone else in the frame. *Street & Smith's* eventually ran this image for one of its covers. ©G. Newman Lowrance

This photograph of Cedric Benson of Texas is another example of an isolated image that card companies and annual publications frequently use. ©G. Newman Lowrance

You can also capture defensive players with an isolation shot for a card company–type shot. ©G. Newman Lowrance

Before the Game

All of what I have explained so far has dealt with shooting the actual game action. However, other elements of a football game can lead to some great images suited for publication. You can usually capture some impressive isolated images before the game during the teams' warm-up rituals. This could include the quarterbacks—especially the rookies and backups—throwing on the sidelines and the receivers and backs catching the ball. In addition, each unit of each team prepares for the game in its own specific area. Take advantage of every opportunity for photos that you're offered. If you need a certain defensive back or a certain linebacker, search for his respective area, get the images you need, and then go to the next group. This is also a good time to photograph the coaches on the field because during the game, coaches are sometimes difficult to capture, considering your positioning on the sidelines.

The coaches might be conversing with the opposing head coach or greeting their own players as they prepare for the game. Be sure to catch these types of moments, because you never know when someone will request them.

The college environment provides interesting crowd shots from the student sections.
©G. Newman Lowrance

Shooting a star player, such as Ray Lewis of the Baltimore Ravens, during pregame warm-ups is a perfect time for an isolated image.
©G. Newman Lowrance

Before the game, you have numerous opportunities to photograph players and coaches alike. Be sure to watch for these types of opportunities because these images are needed frequently. ©G. Newman Lowrance

Sideline activities are another element in football that you should photograph. Annual football publications typically use images of cheerleaders. ©G. Newman Lowrance (3)

You might even encounter some worthy fan shots or an interesting banner. Annual publications also ask for shots of cheerleaders or the band in college football. Something can always catch your interest if you try to take in the entire environment.

Publications also like to see other entities of the game, such as band members or team mascots. ©G. Newman Lowrance (2)

Another pregame ritual is the announcement of the starting lineups for each team as they head onto the field. At this point, the intensity increases from not only the players but also the fans. As a photographer, this moment even increases my intensity. Photographers don't just freeze a moment in time; they also capture the feeling from any given moment. As game time approaches, you will feel this intensity. This feeling can improve your concentration and connection to the event you are about to photograph.

As game time approaches, the intensity from the fans and players rises. This intensity is yet another item you can capture. ©G. Newman Lowrance

Capturing these pregame images requires you to arrive at the event early and be ready for photo opportunities. Arriving early means that you will miss most of the traffic and have plenty of time to get your equipment and yourself prepared.

Basketball

by Andy Hayt

Played indoors in a confined space, basketball is unlike any other sport to photograph. The players run full speed up and down the court and wear only simple uniforms with no padding or helmets. Action can be continuous for several minutes, making the sport a true test of the photographer's skills. Basketball is a fast-paced game, and the obstacles of shooting within a confined space add to the challenge. Shooting basketball combines the technical difficulties of indoor arena photography with the skill needed to shoot quick action.

Loving and Learning the Game

During my professional career, I have had the pleasure of working for such newspapers as the *Arizona Republic* and the *Los Angeles Times*. I was a staff photographer for *Sports Illustrated* for 11 years and have worked for 10 years as a photographer for the National Basketball Association (NBA). I have been fortunate to cover NBA Finals games for more than 25 years, in addition to numerous NCAA Final Four championships. Along this journey, I have shot everything from Magic Johnson's rookie season to Michael Jordon's last game as a Chicago Bull. This work has allowed me to have access to many interesting characters, including the athletes, coaches, referees, and fans of the game. Because of the small squads and long seasons, basketball teams become a tight-knit family. When you are let into their world, you get to see some special moments.

Many people comment that I must have a love of playing basketball to enjoy spending so much time photographing it all these years. Truth be told, I am probably one of the least coordinated people to ever set foot on a basketball court. Throw me the ball and watch me duck. So how did I come to enjoy photographing this sport while getting the incredible opportunity to have the best seat in the house for two decades? It is really quite simple. I have always enjoyed the game, but I am more passionate about photography. Distancing myself from being a fan has allowed me to become a true observer. My love of the game has never clouded my ability to see it as it is really being played on the floor, regardless of who is winning the game. This has given me an advantage in figuring out what is going to happen in the game based on watching what is happening on the floor.

One of the first times I ever photographed basketball was for my high school yearbook. Unlike shooting outdoor sports, this presented a whole new set of problems. How was I going to stop this fast-paced game in a high school gym building? What film would work? Where should I stand, and what makes a good basketball photo? Thirty-some years later, I can say I have figured out some of how to photograph this game. The more I shoot basketball, the more amazed I am by what the talent on the floor is doing. By learning to photograph

basketball, you get an entirely different view of the game. Shooting this sport requires that you understand how the game is played, not only from a rules standpoint, but from what each player is capable of doing on the court at different times.

For a photographer, the ability to shoot basketball is not just limited to the professional game. Every night in every city and town in the U.S., some team is playing from October through March. Whether you are shooting a junior high school or pro game, the game is universally the same, with the exception of a few nuances. This provides an excellent opportunity to photograph the sport on any given day.

Telling a Story

One of the best techniques I have encountered for shooting any sport is to use a photojournalistic approach to each game or assignment. This involves telling a story with pictures. To tell a good picture story, you should start with the idea that every event has a beginning, middle, and end. Although this idea is simple in concept, you can expand it to include an establishing shot of where the event is taking place; the characters—or, in this case, the athletes involved at the start of the event; gameplay; the pivotal winning moment; the celebration of victory; and the reaction and display of emotion in defeat. Essentially, you are telling a story the same way that someone makes a movie. So how does this help you shoot a basketball game?

Sports events are dramas with both winners and losers; each outcome is decided by the way that individuals and teams react. The goal is to create the most interesting and telling sports photos from a given event. Sometimes this means that you might tell the story not just by shooting the pretty, spectacular layup or dunk. Sometimes you might shoot the defender stealing the ball with three seconds left on the clock in a tie game and making the winning basket. It is important to realize in any sport that you can shoot the individual player and how he interacts with his teammates or the game, or you can shoot the entire team within the context of the event.

Someone passed this information to me early in my career, and it gave me a way of viewing each event in a dispassionate state of mind. It allowed me to look at and analyze what was happening during the game not from the emotional viewpoint of a fan, but as a neutral party who could discern what was happening and be ready for key moments before they took place.

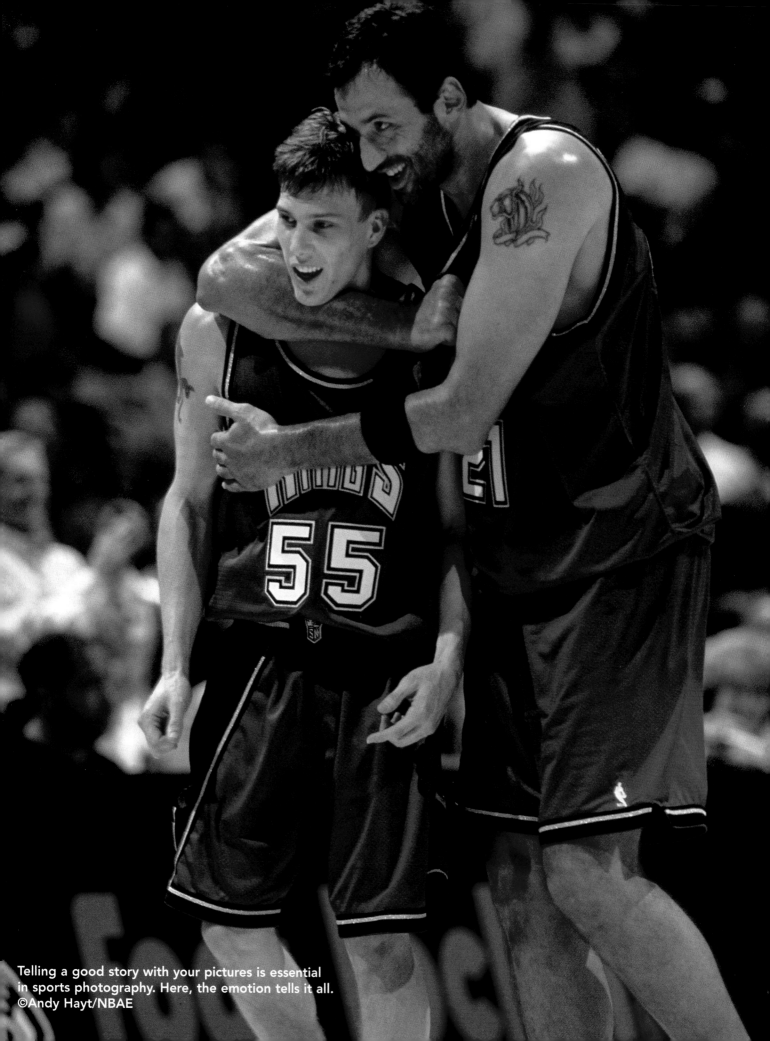

Telling a good story with your pictures is essential in sports photography. Here, the emotion tells it all.
©Andy Hayt/NBAE

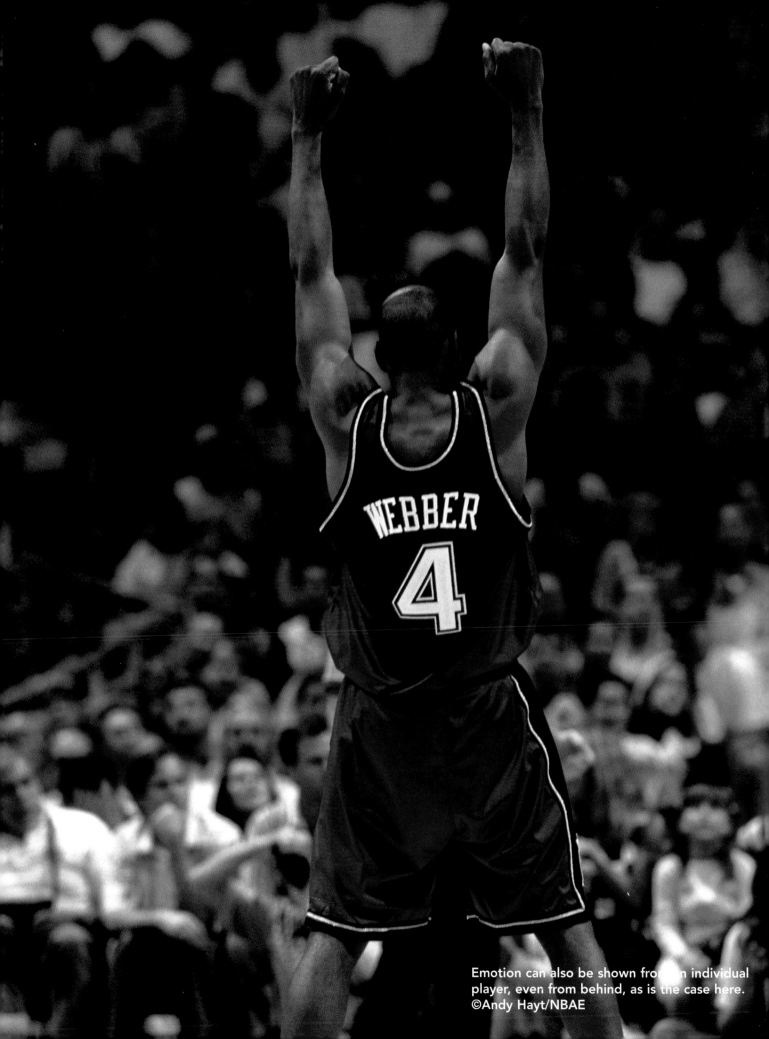

Emotion can also be shown from an individual player, even from behind, as is the case here.
©Andy Hayt/NBAE

Basketball from the Photographer's Point of View

When you are working indoors in a small, defined space, it becomes critical to realize the many different angles you can shoot from. Think of the floor as the space in which the talent will move around, and look at what each area of the floor brings to view from your camera's viewfinder. Ask yourself questions. Will this shot give me a view of the defender or the shooter? The players, the scoreboard, or the benches? Will the referees on a key play block me? Sometimes the arenas have courts that have great logos when photographed from a high viewpoint.

Location

To start photographing basketball, it is best to go to the spot just to the right side of the basket on the floor. You can find this spot by standing behind the basket and going to your right side. Sit approximately five feet off to the side of the basket standard, making sure that you leave plenty of room for a safe run-out lane for the players driving up under the basket. This gives you the angle with a "normal" or 50-mm lens on 35-mm film or digital cameras to shoot the classic layup, or in the key shots that are a high percentage. From my experience of covering the game, you can even prefocus your lens to 17 feet and then concentrate on just figuring out when to shoot the action when it comes into the basket or painted area in front of the basket. You can shoot players driving the ball and bringing the ball toward you into the corner of the floor off to your right side.

I strongly suggest going to this spot first, simply because you begin to understand the speed and movement of how a player jumps with the ball. Shooting this action at its peak requires you to time when the movement is at the peak, when the shooter is ready to release the ball from his fingertips. It can be frustrating at first to get your timing down, but remember this: Some people have been doing this for decades and still cannot hit the peak moment every time. The best thing to do is relax and wait for the action to come to you.

I do not keep my eye up to the camera during the whole game. I take my eyes off the camera and watch and wait for things to start to happen. This keeps my eyes fresh and sharp when they are up to the camera. Think of how difficult it is to concentrate intensely on one single thought for several minutes. Now, how do you think you are able to do this using your eyes for extended periods of time while concentrating on a fast-moving subject? It is not going to happen, so the best thing to do is relax and shoot only when necessary. Save your eyes for when activity is near you. Take timeouts and think about what you are seeing. Is the star player having a great game, or is the defense or a specific player shutting him down?

After you have shot from this position for several games and can judge the speed and action of the player, take a step back and analyze your results. From

every photo that I have taken in my career, I can find information that tells me how to do it better the next time. The improvement can involve framing, ugly backgrounds, missed focus, and late or early action.

Analyzing the Pros

Now that the game has sparked your curiosity, it helps to do a little research. This is a good time to visit your local bookstore or library and start analyzing what the professionals are doing to make such spectacular photographs. Books, magazines, newspapers, and even trading cards provide a variety of great basketball photographs. Ask yourself: Where is the photographer on the floor? What lens is he shooting with? How did he get that angle, and why was he looking for that shot? The easiest way to figure this out is to get inside the photographer's head by analyzing his shots. I still spend a tremendous amount of time analyzing photographs to figure out what the photographer was seeing. This includes everything from environment to lighting to camera equipment. You will start to see certain angles that work well for certain situation. Then you can go out in the field and try shooting them yourself.

Film and Equipment

Now that you've gone out and discovered what photographic nightmares most gyms are for shooting pictures, it's time to address the technical side of working indoors. One of the essential formulas for achieving great pictures is to minimize variables that can hamper your success. First and foremost, know your equipment. This includes both your cameras and your lighting sources. You can use two types of light sources in indoor photography: either available light or electronic flash units that are commonly referred to as strobes.

Shooting with Available Light

Shooting with the available light in an arena requires the use of fast lenses that have a maximum aperture of $f/2.8$. You need to shoot high-speed color negative film of either ISO 800 or ISO 1600. If you're shooting digital, set your camera between ISO 800 and ISO 1600, depending on how bright the lighting is. It goes without saying that working at these high ISOs leaves little room for errors in focus and exposure. You are operating at the end of the spectrum for achieving quality photographs. That's why it's essential that you realize that these two variables are extremely critical in achieving success with your photographs. If you miscalculate either one, you will achieve poor results. That's why I'm always careful with metering the exposure of the available light in a building before I start shooting. Most in-camera meters are extremely accurate in reading the exposure, but it's critical to know where to take your reading.

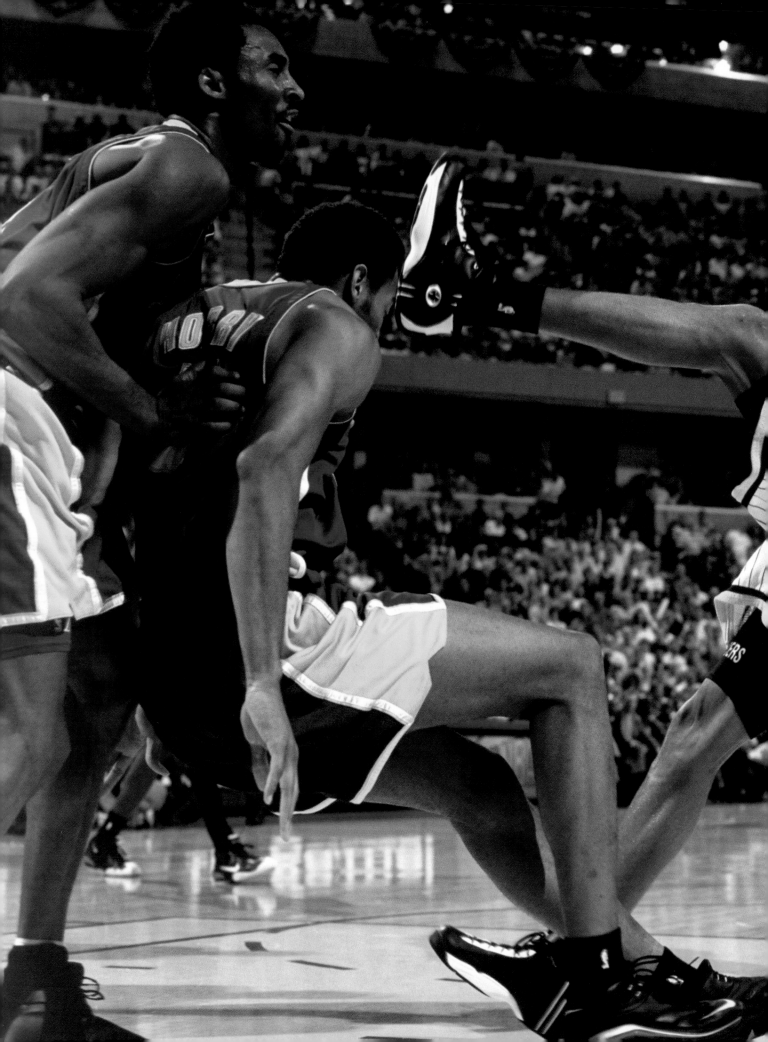

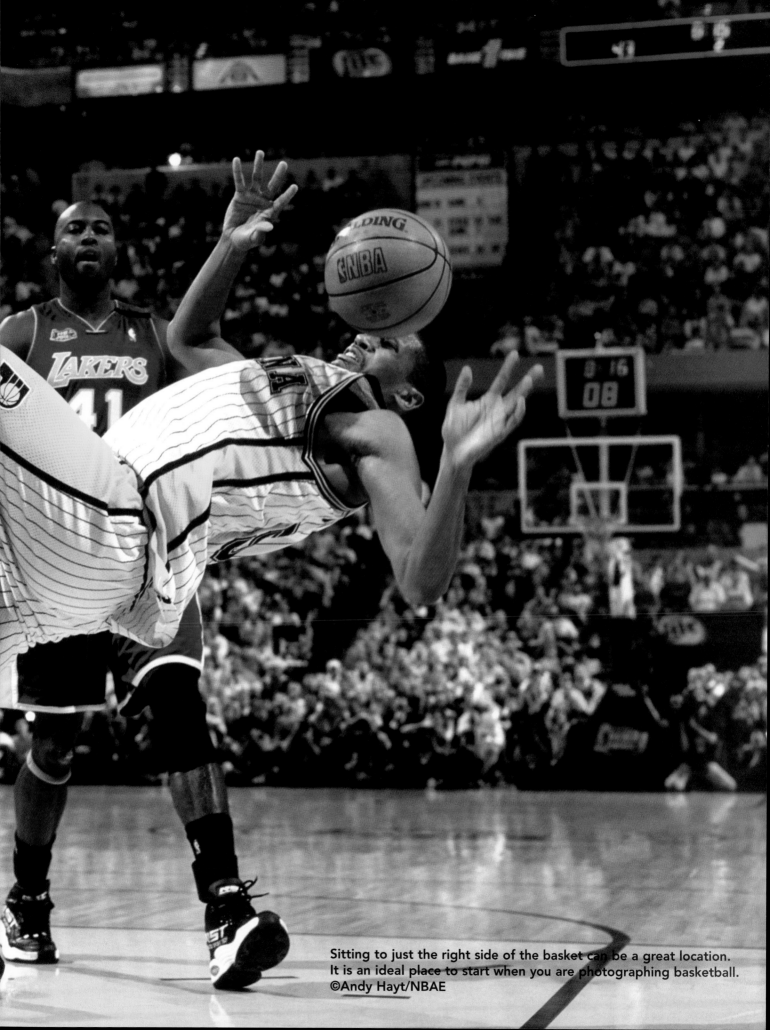

Sitting to just the right side of the basket can be a great location.
It is an ideal place to start when you are photographing basketball.
©Andy Hayt/NBAE

When photographing a sport, don't limit yourself to the game action. Great close-up or detail photography can also create great images. ©Andy Hayt/NBAE

When you view other photographers' images, try to learn from what you see. What lens were they using? From what angle were they shooting? This example of an encounter between players using a telephoto lens brings the viewer up close and personal. ©Andy Hayt/NBAE

I suggest that you find someone with a midtone, gray, tan, or midrange color shirt and have him move around the floor and meter the different spots where you will be shooting your pictures. As a rule, the bench area is one-half to one f-stop darker in exposure than the floor. If you are shooting from under the basket, the exposure is generally the same from midcourt to all the way around your half of the floor. When you shoot toward the opposite end, the exposure is usually one-half an f-stop less than where you are sitting. In most gyms, the overhead lights are focused over the floor and bleed down in intensity as they fall off into the benches and stands.

When shooting available light, I like to have a minimum shutter speed of at least 1/500 of a second to stop the action. You can sometimes stop movement at its peak at 1/250 of a second; however, it tends to blur feet, hands, or fast movement. Sometimes you can stop action at midcourt at 1/250, but it is risky at best.

I don't advocate using auto focus when you have short lenses of 50 mm or less. It is better to manually focus the lens because most short focal length auto focus lenses pick off the wrong object to focus on in the foreground or background. The short focal length lenses have a tendency not to lock in on fast-moving objects.

Strobe Lighting

When a gym is just too dark to get an exposure of at least 1/250 at f/2.8 at ISO 1600, it's time to use strobe lighting. When you're using an on-camera flash, it's best to shoot near the basket, because most on-camera strobes carry light only to about 20 feet. I suggest using ISO 200 speed film or ISO 200 in the digital format. This allows you to shoot at 1/250 of a second at around f/5.6, depending on the power of the strobe unit. Manufacturers rate strobe units by watts/second for advertising purposes. This is a measurement of electrical energy that only perceptually indicates how much light a particular unit might produce. Actual measurement of light output with a light meter that is capable of measuring flash output is the appropriate way to determine if a strobe is capable of producing a usable exposure. Generally speaking, the lower the number of watts/second, the less power in the strobe. When you're shooting with a strobe, remember that it is the duration of the flash that stops the movement, not so much your camera shutter speed. If you happen to go below 1/250 of a second, you might get a blurring or movement effect called *ghosting*. Although this can be an interesting effect, it is not desirable when you are trying to shoot a peak action shot. While working at *Sports Illustrated*, I was able to work with high-powered large strobe units mounted up in the ceiling of the arena. We turned the building into our own photo studio by placing four high-powered 2400 watt per second Speedotron strobes in the catwalk or ceiling of each

building. We placed the strobes in each corner of the catwalk just behind the baseline of the court and aimed toward the paint at each basket. Then we wired the strobes together and triggered them off a drooped electrical line from the catwalk to the floor that is tied off at the backboard standard. This allowed me to shoot slow ISO 100 speed transparency film at 1/500 or 1/250 of a second at f/4–5.6 anywhere on the floor of the arena. These types of setups are extremely time consuming and expensive to set up. All the NBA games that I shoot are on these same strobe systems. Most major arenas in the U.S. now have strobe lights permanently installed for the team photographer and visiting magazine and league photographers. Using these high-powered strobes allows the photographer to experiment with other formats than 35-mm cameras. The most popular camera to use is the Hasselblad 553 ELX for under-the-basket photos and a 300-mm f/2.8 or 400-mm f/2.8 lens on a 35-mm camera body for down-court shots. See Chapter 8, "Hockey," for a detailed description of strobe lighting.

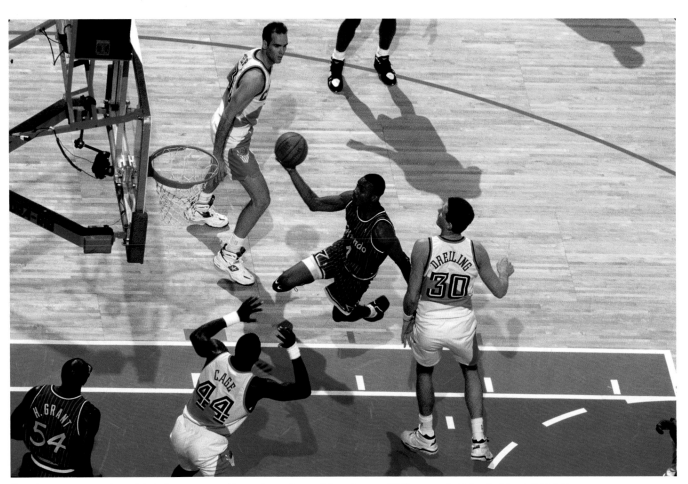

Strobes mounted up high in arenas allow shooting with a lower ISO speed. ©Andy Hayt/NBAE

Choosing a Camera

When you're choosing a camera for sports photography, be aware that the most important feature to look for is good-quality glass in the lenses. Many people ask me about one brand of equipment over another and which features are important in helping to take good photographs. With all of the new technology regarding motor drives, digital file sizes, and auto focus, the most neglected feature I hear spoken about is optical quality. If the image is not razor sharp with optimum color quality, all the other features become worthless. Consult with those who are in the field, and possibly view such Web sites as http://www.sportsshooter.com, http://www.dpreview.com/, and http://www. robgalbraith.com/bins/index.asp for resources about optics that work well at maximum apertures of f/2.8 or lower. These Web sites are also a great place to learn what the pros say about all the new equipment as it hits the market. I was fortunate to grow up using cameras that had good optics. Several times in my career, I was exposed to lesser-quality optics from off-brand camera companies. It taught me to stay away from off brands or secondary brands that were not built by the camera body manufacturer. The goal is to omit the variables that will hurt image quality and lower your success rate of in-focus and well-exposed images.

The two most popular brands that professional photographers use are Canon and Nikon. Each has distinct differences in its operating system and user friendliness. Each builds a quality digital and film camera that gives you high-quality images. I would suggest only using a camera that has an auto winder or motor drive. This is not so much for shooting bursts and sequences, but rather so that you can keep the camera up to your face without having to wind it manually. Also, the current motor drives and accessory grips have vertical shutter buttons that make holding the camera much more comfortable when you are shooting vertical photos.

Choosing Lenses

When you're choosing lenses for shooting basketball, it's best to start with a 50-mm lens. You mostly use this lens for basketball, boxing, and football. It's the best lens to use when you're first going out and shooting the game. Most photographers add a midrange zoom lens of 70–210 mm or 80–200 mm that has an aperture of f/2.8 as their next lens. This lens allows you to move around the court and shoot action at midcourt, down-court, or right in front of you. The next lenses that most photographers add are a 28–70-mm zoom, a 300-mm f/2.8, and a 16–3-mm zoom. Also, be aware that the NBA requires that photographers use soft rubber lens shades on all lenses that are utilized around the playing floor, including remote cameras. This is a good idea at any game because it protects the players from the sharp edges of metal lens shades if they run into you.

When you start adding these lenses into the mix, it is time to include a second camera body in your equipment list. This allows you to shoot toward both ends of the floor without having to constantly change lenses on a single body and miss pictures in the process. Several of the professional photographers who work shooting NCAA and NBA basketball for large publications or the leagues carry anywhere from 4 to 15 cameras to most games. Although this number of cameras might seem outrageous to someone who is starting out shooting basketball, the majority of the cameras are mounted on brackets in fixed strategic locations throughout the arena and operated as remotely fired cameras.

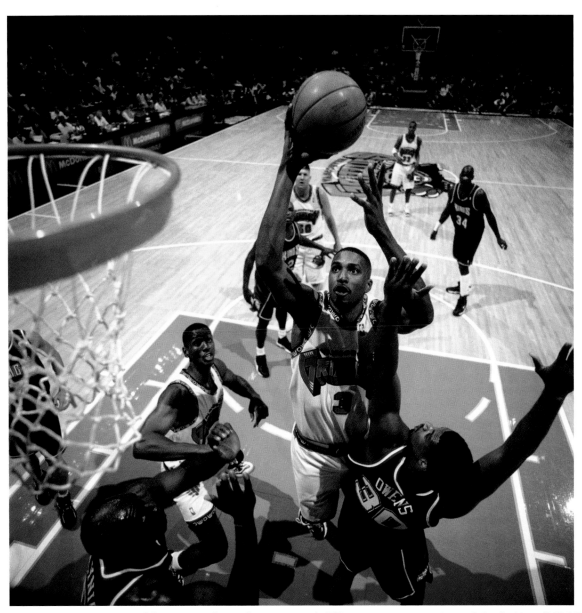

Using remotes can enable you to shoot from several different vantage points. ©Andy Hayt/NBAE

Shooting the Game

Whether you are shooting a junior high game, a high school women's game, college, or NBA basketball, all the venues have several common opportunities. The first and foremost is to tell a story. Whether the story is about a team or an individual, each one has certain parts of each game in common. However, before you can tell the story of the game, you need to be prepared both mentally and physically. That includes having all your camera gear ready for use.

Preparation

Typical preparation includes making sure all your batteries are fully charged, you have brought enough film or compact flash cards, and you have a cushion to sit on. (The court doesn't get any softer during the game.) The cushion might sound like a funny thing to bring, but look at the pros that cover the game, and you will see an interesting group of cushions and folding camping chairs. Sitting cross-legged on a wooden floor for two to three hours can cripple you. I always use a folding luggage cart to haul my gear around, and I never leave home without my seat cushion.

I usually get to a game a minimum of two or three hours before tip-off. This gives me ample time to set up my cameras, find a spot to shoot from on the floor, and measure the available or strobe light exposure. Many photographers arrive late and struggle to get ready. Almost every pro I know arrives early, sets up, and then can relax, visit with friends, watch or shoot warm-ups, visit with players, or catch moments behind the scenes. This extra time gives me a peace of mind that allows me to really think carefully about the upcoming game and how I'm going to shoot it rather than worrying about where I'm going to sit for the evening.

Behind the Scenes

One of the best opportunities in covering basketball is to shoot what goes on with the team behind the scenes. Developing a relationship with a coach and media relations staff who trust your abilities not to disrupt the game planning can provide you with access to what goes on before the players hit the floor. This access gives you a look into a private world that you normally have no access to. The private moments and intensity in these photos can sometimes be more revealing than what takes place on the floor. They set up the story of the game and can often impact the game's outcome. If you do not have this access and are developing a relationship with a team, realize that this takes both time and trust. Shoot out in the tunnels rather than the locker area when the team is ready to hit the floor. Most teams have a private huddle before they hit the floor. Try shooting it with available light or with a hand strobe without interfering in

Developing good relationships can sometimes allow you greater access to teams. ©Andy Hayt

the team's moment of togetherness. Be discreet and unobtrusive, and you will get great images. Don't make yourself bigger than what is going on with the athletes. You are there to witness and photograph and not interfere with the event. I opt to pass up shooting a moment if it disrupts a player's routine or interferes with his preparation for the game. I always tell people to imagine someone coming to their office and getting up on their desk to photograph them while they work. Most people wouldn't like that.

Before the Game

The warm-up and shoot-around period before the game is a great time to watch teams come out and loosen up. Usually, you can learn which plays a specific shooter is going to run during the game. There's a reason it's called practice, so watch the players run their plays and then see them in the game later on. I cannot tell you how many times I have watched photographers get stumped by what a specific player is going to do or where he likes to shoot from on the floor. This rule applies to almost all sports. Watch the warm-up, and see what the players and individuals like to do. It's not rocket science.

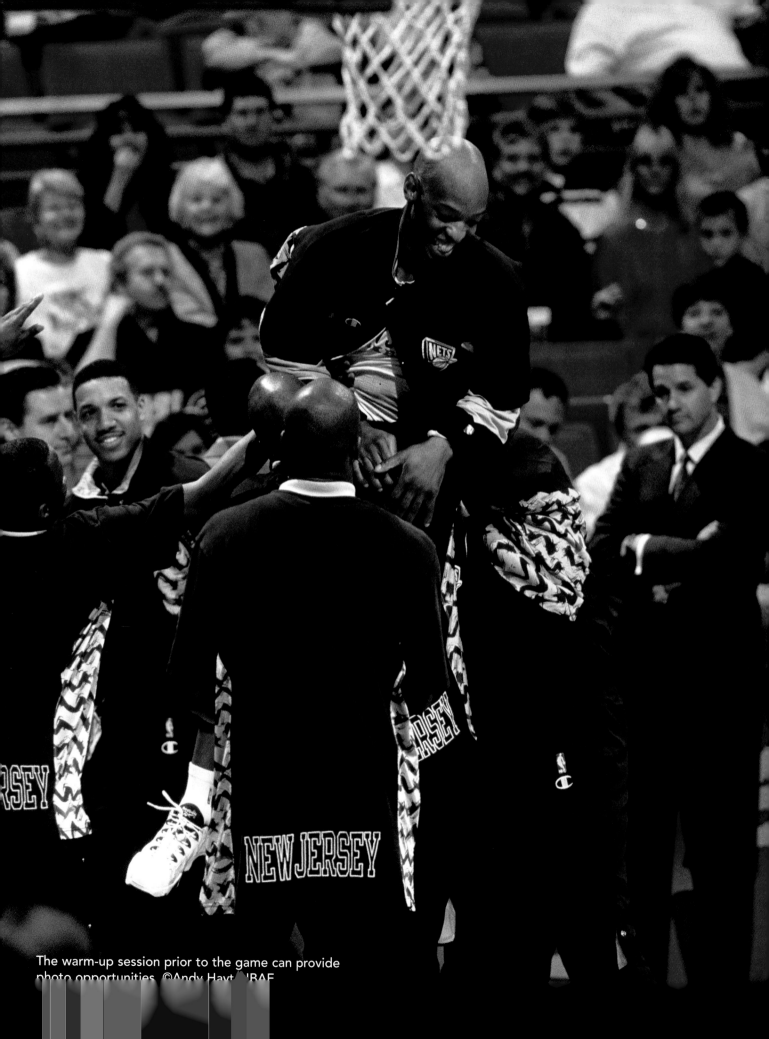

The warm-up session prior to the game can provide
photo opportunities. ©Andy Hayt/NBAE

Athletes have a tendency to naturally shoot the ball or move certain ways on the floor. They repeat their moves over and over. Michael Jordan liked to dunk to the left side more often than not. This isn't guesswork. His most spectacular plays always went from right to left. Watch and learn, and before you know it, you'll see the move right as it's about to happen. You won't be reacting after the fact.

The Basics of Journalism

First and foremost, set the scene. Show where the game is being played, and give the viewer an idea of the basics of journalism: who, what, when, where, and how. Usually, I wait until a point in the game where I can slip away to find a shot that somehow encompasses the mood of the inside of the building, showing the game in progress, the players running on the floor, or rabid fans getting behind their team. Often, one of these shots suffices to let the viewer know what is going on in the arena. This sounds basic, but shooting this picture and having it evoke emotion and also provide quality information is not always easy. Use the lighting in the arena to create mood. You can see an example of this in arenas where the stands have darker light than the floor. Using fans in silhouette in the foreground can give mood to a shot.

Always look for moments away from the action or during time-outs. Look at how players interact with the coaches and referees. An enormous amount of activity occurs during a game that can tell you more about an individual or a team than any action shot.

Ready for Action

Be ready for the tip-off, check your camera settings, and then be ready for the action when the ball is tipped. I also make sure that all my camera settings are locked or taped down so that they don't get bumped during the games, because I'm continually picking them up and putting them down. The tip-off shot is usually not that important except during a finals game. It is fairly mundane and routine. However, you can try making an interesting shot of the tip-off if you get clearance to shoot from an extremely high overhead position or a catwalk in the ceiling. This is a nice shot if you can capture every player on both teams looking up at you with the floor logo at center court. Your exposure for this shot is no different from your floor-level exposure. You usually take this shot with a 200-mm to 300-mm lens.

When the game is underway, try to shoot the peak of action, whether it is on offense or defense. Many people shoot too tight on the player and lose the wonderful relationship of how high in the air the athlete is compared to the floor. When the shooter is coming at you on the floor, the tendency is to shoot as soon as he takes the first step up off the floor. The hardest part of timing peak action is waiting to shoot right after both feet have left the floor. After many years of shooting, you get a sense of when to pull the trigger. It is all about practice, so don't expect to get it down the first few times you shoot.

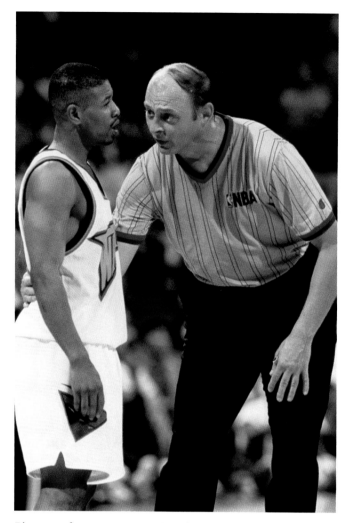

Players often interact with referees and vice versa. Be sure to capture these moments in addition to the game action. ©Andy Hayt/NBAE

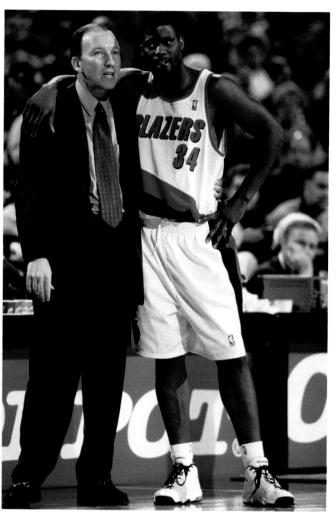

Coaches sharing a moment with players can be another important element that you can look for while shooting basketball. ©Andy Hayt/NBAE

When shooting down-court on defense plays, try to keep your focus on the defender who is facing you and not necessarily on the back of the ball handler. There is usually a point when both players hit the same plane of focus. This is when you want to look for your shot. Watch the player's hands, and be ready for them to go up to the basket for the shot or the block. The shot can look spectacular if you have two big men, fully extended, going up against each other. The same can be said for guards going for a steal or forwards who are trying to block an inside pass. Most of the shots toward the opposite end of the court look best taken with a 300-mm lens.

By moving off court and shooting from the grandstands, you can come up with some interesting angles. Try shooting from the side in line with the baseline at basket height. An aperture setting of f/2.8 with a 70–200-mm zoom lens creates good isolation on the shooter by throwing the background out of focus.

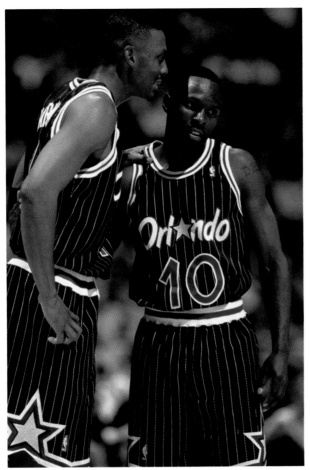

Moments between players away from the action
or during time-outs can warrant great interaction.
©Andy Hayt/NBAE

This can be particularly effective if you have a team that plays in the paint. It looks great with almost all the players on the floor. Note, however, that shooting the same way every game becomes both static and visually boring. Mix it up, use different lenses, and try different angles and shooting positions.

When you're shooting the game, don't neglect the bench, both from a close angle during time-outs and with longer lenses during the game. Just remember that photography is not allowed behind the bench during an NBA game. Floor security moves you away from that area if you attempt to shoot there. If you are shooting in a less restrictive league, make sure that you have the permission of the team or the league to shoot around the bench, especially during time-outs. Also ensure that floor security knows it is okay for you to be there. Watch for reactions from coaches and key players. Unfortunately, the bench-warmers have a tendency to jump up and down, but don't pass up a good shot just because the player doesn't start. This helps build the feel and emotion during the game.

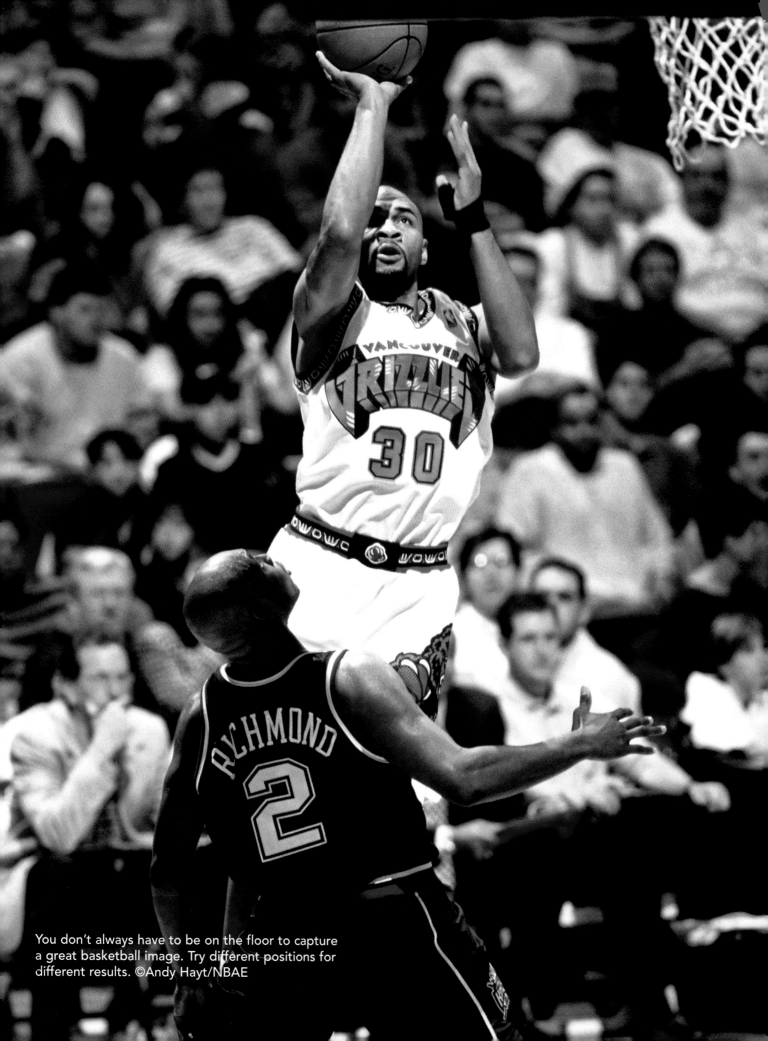

You don't always have to be on the floor to capture a great basketball image. Try different positions for different results. ©Andy Hayt/NBAE

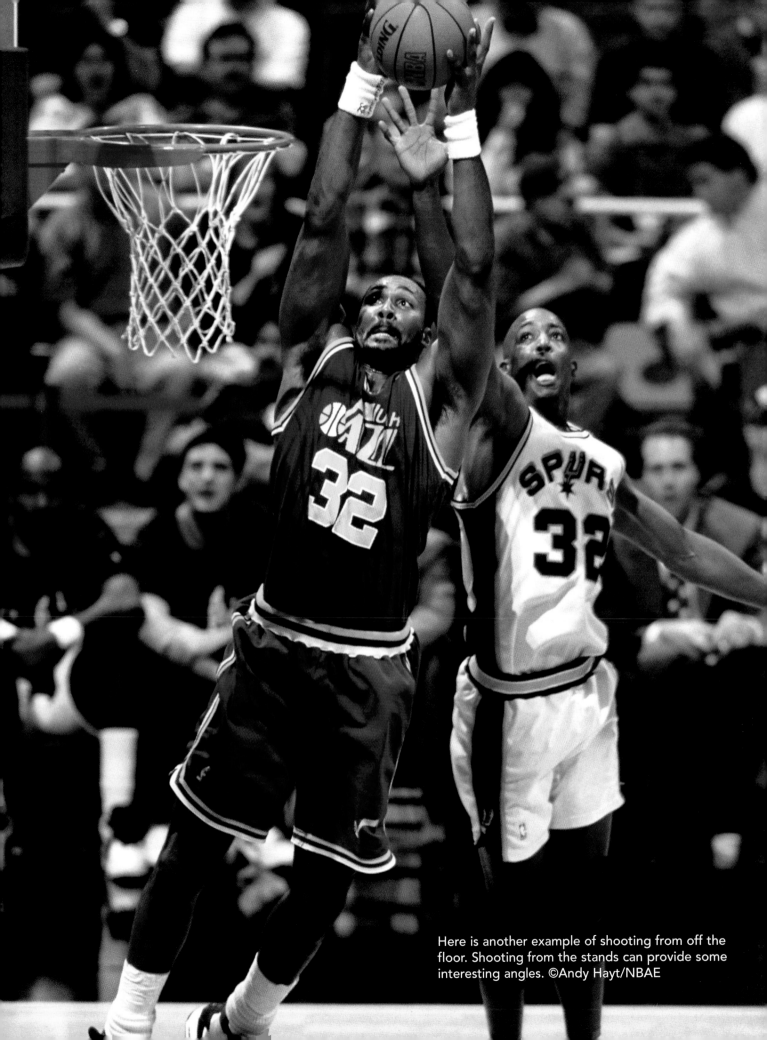

Here is another example of shooting from off the floor. Shooting from the stands can provide some interesting angles. ©Andy Hayt/NBAE

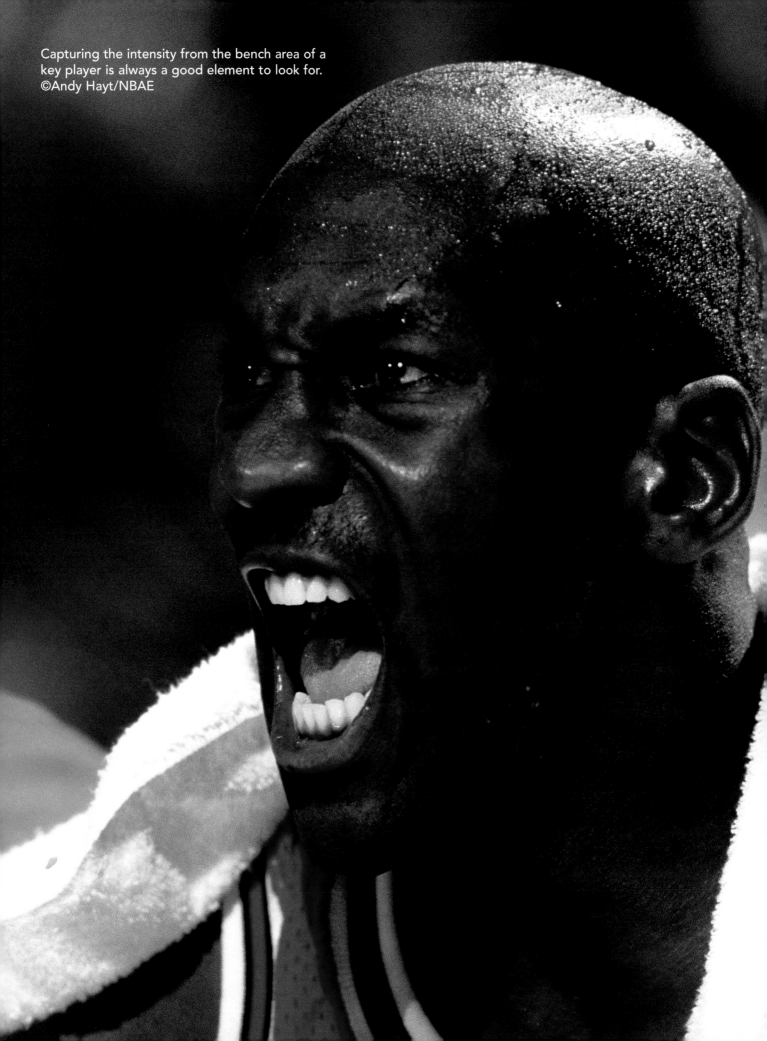

Capturing the intensity from the bench area of a key player is always a good element to look for.
©Andy Hayt/NBAE

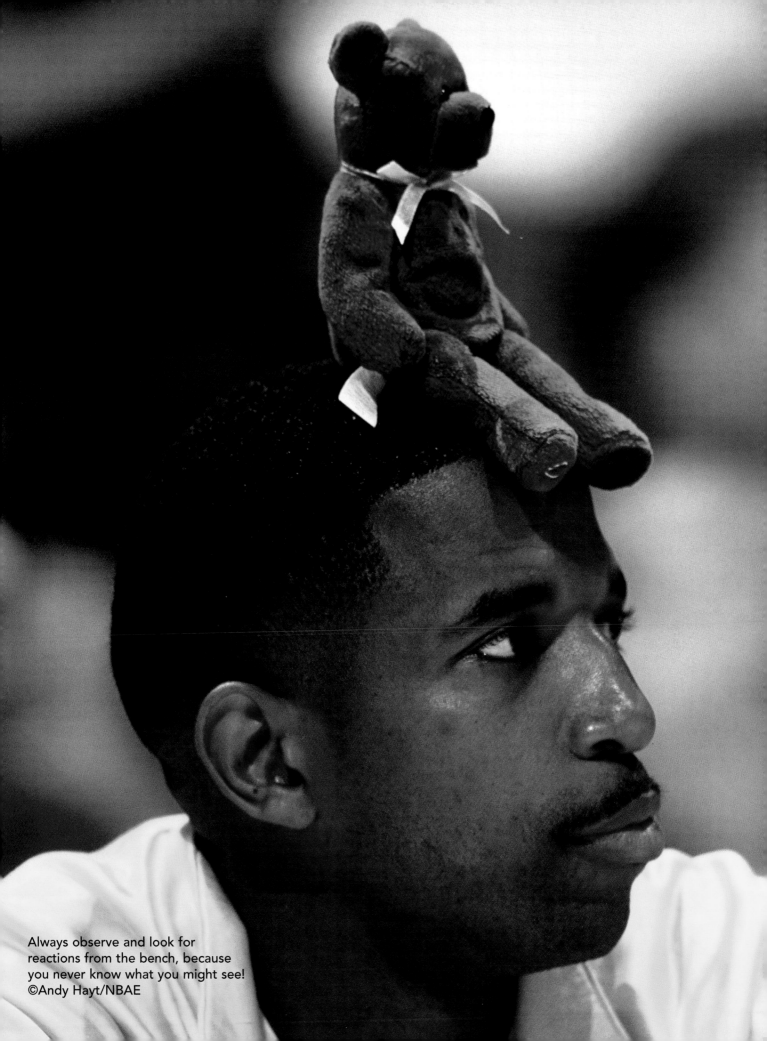

Always observe and look for
reactions from the bench, because
you never know what you might see!
©Andy Hayt/NBAE

When you're covering an assignment in which you have to shoot just one individual, it's easier to shoot the entire game as you normally would as it takes place on the floor. When you focus on just one individual during the entire time, you don't get into the flow of the game, and you usually freeze up when your player touches the ball. Allow yourself to shoot great shots regardless of who it is. That strategy gives you a mental boost to be hitting shots consistently rather than just waiting and getting frustrated when you don't react quickly.

Remotes for Basketball

At this time, I would like to add a thought for people who are interested in covering a game with cameras in a fixed, mounted position. These cameras are referred to as remotes. Setting up remotes requires safety cables, black gaffer's tape, a magic arm attached to a photo-clamp, and a remote trigger radio or hard-wire trigger. You can secure cameras to the basket stanchions, the arms of the backboard, guard rails in the stands, or overhead catwalks. The most important thing to remember when doing any of these setups is safety first. Never mount a camera where it can fall and hit someone. Always use proper safety cables to secure remote cameras. Doing so not only protects the fans and players, but it also prevents a camera from taking a long fall if a clamp loosens from vibration during the game. It's better to have a game delayed to remove a loose camera than to deal with an injured fan or player. You might find yourself in court with a hefty lawsuit or worse, so be careful in your setups and camera placement. Also, make sure that you have the approval to place a camera anytime it is within the field of play of the game so that an uninformed referee or coach doesn't ask you to remove it. Finally, inform public relations staff of remote camera placement so that you have their approval and they acknowledge the use of these cameras. Make sure your remotes are not going to fall and hurt someone, interfere with the game, or block the view of a fan.

The Final Minutes

After you have gotten into the final minutes of the game, it is important to look for the game-winning shot if it is a close game. Most pro and college arenas have a scoreboard behind each basket. If the winning shot happens to occur at the opposite end of the floor, shoot loose with an 85-mm lens and get the winning shot and then all the players on the floor with the shot clock and final score showing in one frame. If the winning basket is in front of you, don't shoot so tight that you throw the crowd out of focus. Allow the crowd to react and help define the moment. Be ready for bedlam if it is a close game or an upset.

Reaction shots can be extremely powerful at the end of a game. You can rush the floor and shoot the winning team celebrating or look for the dejection shot of the losing squad. I personally prefer to shoot these moments from an angle several rows up in the stands where I don't become part of the activities on the

floor. I get cleaner and different angles than what I get by just shooting with a wide lens on the floor. However, please experiment and try any of these.

After the game ends, watch for players reacting with family, friends, or teammates. This can be an opportune time to shoot the team in a celebratory moment in the locker room. Again, shoot the moment, but don't hinder the participants or infuse your presence into the team's moment of triumph or defeat.

Shooting moments after the game can also provide you with some great images.
©Andy Hayt/NBAE

After your have shot the game and all that it encompasses, take the time to edit your images and learn from your mistakes. Rarely do we learn from success, other than how to repeat the same moment again. Our mistakes hold the key to improvement in technique and content. You can usually pick out several ways to improve your images, which you can use the next time you hit the floor.

Hockey

by Jonathan Hayt

TKACHUK

CHAPTER
8

Combine the grace of basketball, the hard hits of football, the endurance of soccer, and the skill of tennis, and you have the game of ice hockey. Played on indoor ice rinks and covering approximately 3.5 times the surface area of a basketball court, hockey is a skill game that has continuous action interrupted by big hits and sudden moments of glory. It is one of the most difficult games to shoot but also one of the most enjoyable. Become a good hockey shooter, and all of your other sports photography will only get better.

Where It All Began

I spent the first part of my photography career in the early 1980s as a staff lighting assistant for *Sports Illustrated,* covering indoor sporting events and location shoots for almost nine years. I usually worked on two or three assignments per week, involving almost nonstop travel with huge amounts of lighting equipment and related gear. I had a firsthand opportunity to learn the ins and outs of almost every arena in North America while covering basketball, hockey, indoor track meets, and pretty much any sport that can be played under a roof. Combine this with working with every great sports photographer who graced the pages of *Sports Illustrated,* and I got the greatest paid education anyone could ask for.

I stepped out of the assistant's role in the late 1980s and took up sports photography full time. My hands-on education served me well because I was prepared to shoot sports that most photographers have no clue how to approach. The trading card companies and other licensees were just starting to gain some real momentum, and the National Hockey League (NHL) was preparing for a big expansion in the not-too-distant future. Having lit and covered numerous NHL games—regular season through the Stanley Cup Finals—I decided to create a niche for myself that few photographers had successfully achieved. I was fortunate that the NHL was getting ready to expand into Florida where I was living in the early 1990s. I approached the newly formed Tampa Bay Lightning Hockey Club with a proposal to become their team photographer. I was able to convince them that I had the skill to shoot the game and could do it with a well-designed arena strobe lighting setup that would give them the best quality images available on the film of the day.

I started shooting hockey before the advent of auto-focus telephoto lenses and today's digital cameras. It took a lot of skill and concentration to continuously frame and follow-focus on players who were moving many times faster than an athlete can run. Also, peak game action shots always look best with the puck in the picture, so you have a lot of elements to capture in a fraction of second. Because of the slow recycle time (approximately 3–4 seconds) of arena strobes, timing is everything. There is no using the camera motor drive on strobes, and the action doesn't wait for you. Every frame counts.

A nice opener shot is the first face-off at center ice at the beginning of the game. Shot with a wide-angle lens, it captures the graphics in the ice and the anticipation of the start of the game. ©Jonathan Hayt

The advent of the affordable high-quality digital camera has changed the world of the nonstrobe shooter while lessening the production costs and delivery time of the strobe shooters. I was pretty excited to get one of the first Nikon D1s in 1999, and I took it to a hockey game the next day. I already had some experience with the Kodak hybrid cameras of the previous few years and knew enough about Photoshop and digital imaging to realize that the world of photography had just taken a giant step forward. The best part of the D1 was that it was new to everyone, so there quickly developed a network of photographers who were analyzing and sharing their knowledge in a way that never occurred within the film world. It was learning by experimentation and use. The first time out, I realized I had a lot to learn about this new camera, even though it produced good-quality digital files right out of the box. It handled and worked like a film camera, didn't weigh a ton, and after it was properly set up, gave a great-looking digital file up to ISO 800.

Early on, the digital gurus of the day, such as the folks at http://www.camerabits. com, came up with Photoshop plug-ins to help eliminate high ISO digital noise. They also created a user-friendly digital photo browser that is still a standard of the industry. Adobe Photoshop version 4.0 was the standard digital

175

imaging software at the time, so all digital imaging was based around this version and the capabilities of the computers of the day. My greatest surprise was that the D1 had an unlimited shutter synchronization speed with my arena strobes. The new CCD sensor chip of the Nikon D1 eliminated the use of the original film camera's shutter, so there was no longer a sync issue. I discovered that I could stop peak action with both a high shutter speed in the camera and a short flash duration on my strobes. Further experimentation showed that I could even use slow flash duration or underpowered strobe lighting setups with great results. My images gained a sharpness that only comes with high shutter speeds to freeze game action. There was definitely a limit to all of this as color balance started to shift toward a blue colorcast above 1/1000 of a second shutter speed. I normally shot at 1/640 of a second with the original D1 camera. Also, the lowest ISO setting on the camera was ISO 200, so I immediately decreased the power settings on my arena strobes by one-third to gain a quicker recycling time and a shorter flash duration. The only major limiting factor at this point was the small 7.5-MB file size from the camera. I ended up using Genuine Fractals software (http://www.lizardtech.com/) to resize my images to fit output needs. This added to my workload but made digital photography completely acceptable to my clients.

The latest digital cameras have somewhat reduced this shutter speed advantage with the new CMOS sensor chips because they require a conventional shutter. That means we are now back to the original highest shutter sync speed of 1/250 of a second. Motion and ghosting are returning to indoor strobe-lit photography so that it is now critical to have strobe light systems that produce an exposure that completely overwhelms the available arena light and maintains a short flash duration. The tradeoff is that the new cameras have greatly improved image and color quality and produce a much larger digital file size.

Shooting Hockey

I am focusing on shooting hockey as a photographer who consistently uses arena strobes, which I discuss in detail toward the end of this chapter, to achieve the highest image quality. The skills, equipment, and shooting positions don't differ much between shooting on strobes and shooting available light. Good timing just becomes more important when using strobes. As I said earlier, shooting available light allows you to shoot sequences and respond whenever the moment arises. The incredible quality of the newest digital cameras' high ISO files and the internal ability to set up custom gray/white balancing for superb color have gone a long way toward leveling the field for shooting available light versus strobes.

The biggest advantage of strobes is that you achieve better light quality and more saturated color quality at the camera's best low ISO settings. Also, the ice acts as a big reflector and really kicks the strobe light up into the players' faces and bodies for an evenly lit image. You have to be a much better photographer with strobes because you must choose your moments. Compare this to the photographer next to you, who is shooting a motor driven multi-image sequence using the available light, and you will see an advantage in quantity but not quality. Hockey is filled with great moments, but they happen quickly. You need to shoot a lot and get used to the fast pace of the game.

The next section discusses the many different photo positions. It includes shots made from all of the different shooting angles as samples of the types of images that can be made at each one. Most of these photos work well for editorial use because of their horizontal composition and multiple players content. I have shot the majority of my games for clients who want isolated shots of individual players, so I have included examples of typical shots that will sell well for trading cards and photo prints. Each photo position that I discuss offers a unique look for these types of photos, so don't worry if center ice isn't available to you.

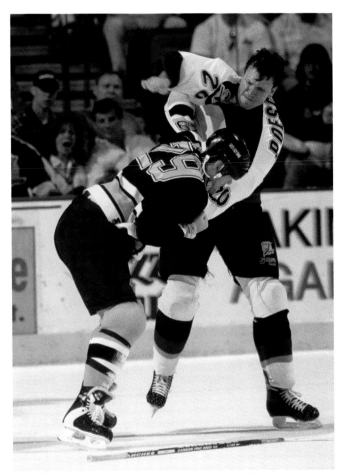

Fights are one of the highlights of hockey that make some of the most exciting photos in sports. They are one of the hardest aspects of hockey to shoot because the peak moments happen so quickly. Just remember that the NHL doesn't allow its licensees to use fight photos, so they are for editorial use only. ©Jonathan Hayt

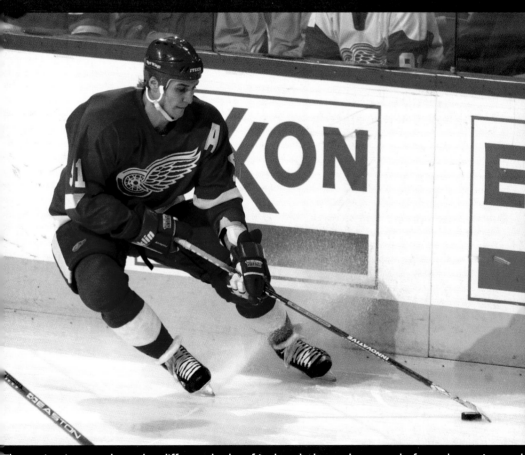

These six pictures show the different looks of isolated player shots made from the on-ice and elevated photo positions.

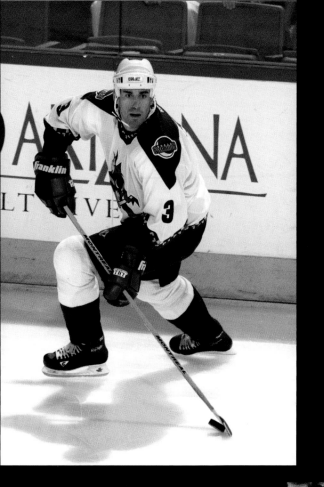
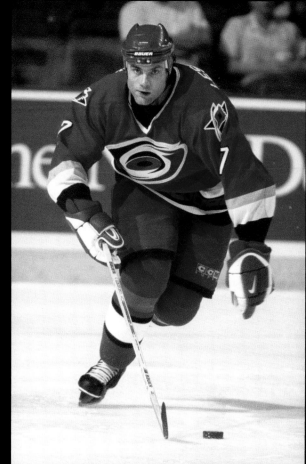
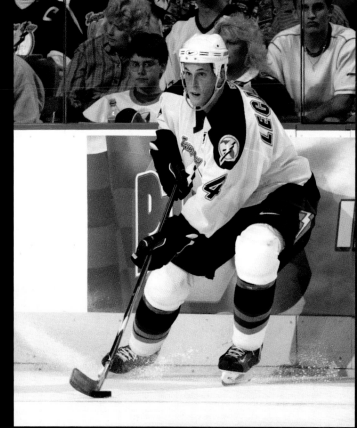

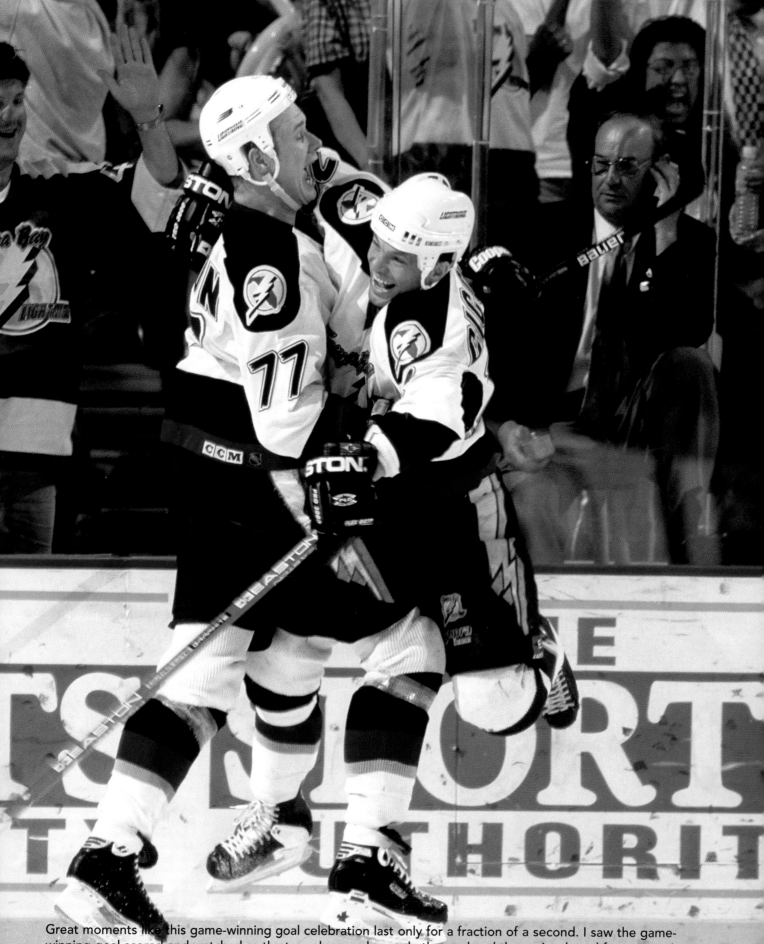

Great moments like this game-winning goal celebration last only for a fraction of a second. I saw the game-winning goal scored and watched as the two players who made the goal and the assist skated from opposite sides of the rink toward each other. All I had was one frame to make this photo, so timing is everything when you shoot on strobes. ©Jonathan Hayt

Look for the great moments of hockey, such as goal celebrations. They occur quickly and always seem to be in a place on the ice that you can't see. Keep alert for the big moments. ©Jonathan Hayt

Small moments, such as the players dashing out of the penalty box at the end of their penalty, also make good photos. ©Jonathan Hayt

Pick Your Spot but Ask Politely

Every hockey rink has its own characteristics regarding photo locations and lighting. I have shot in rinks all over the world and have found that there is no predictable way to shoot in all arenas. If you are as fortunate as I was to have a team that truly cared about the photographer and wanted the best possible photos like the Lightning did, you end up being involved in the design and placement of prime photo locations during the planning and construction of a new or existing arena. The Lightning team moved to three different buildings while I worked for them, and they always provided me with the best possible photo locations that they could fit into the building. My biggest challenge was to diplomatically educate everyone involved at this level as to this necessity. I made sure that everyone knew how it would benefit the team both internally and externally, while accommodating the media and licensees who needed good photo access on a nightly basis. The media relations staff already appreciated the photographer's role and gave me free reign to deal with the allocation of photo positions on a nightly basis, where I also acted as the liaison between the building event staff, security, and the team. Making friends with the arena staff and the team can have a dramatic effect on how much access photographers can have to good photo spots on a nightly basis.

Ice-level shots show the drama of the game and bring you right into the action. ©Jonathan Hayt

Unlike other sports' photo positions, most hockey photo positions are located in areas that are not a controlled part of the game field or court. You often end up standing in entry areas in the stands, on platforms in front of fans or next to television cameras, and at ice-level holes in the dasher board glass that put you right in the middle of the most expensive seats in the house. It is imperative that photographers comport themselves well and are respectful of fans and security personnel. Fans often get caught up in the passion of the moment and can be pretty ruthless when they feel that their view of the game is being infringed upon. I made sure that the team informed all the arena event staff that I was the go-to person regarding photographer issues so that it kept problems away from the team. This buffer was critical for maintaining a pleasant working environment for all of us on game night.

I always check in with team media relations staff and team photographers when I enter a new or away arena, and I ask about the local rules and get specific permission to shoot in designated photo locations. Even at the college or amateur level, there are appropriate places to work from, and the same level of respect needs to apply. Remember: Most hockey rinks have limited prime shooting spots, and there is almost always a hierarchy of who gets to use them.

The corner holes are a great place to shoot action around the net. Just remember that you are sitting with fans who have paid for the best seats in the house. ©Jonathan Hayt

I always ask the team photographer for his permission and help in obtaining access to the spots that I like to shoot from. I also realize that I am probably going to have to move to different locations in the building during the evening because most teams rotate photo positions in an effort to accommodate deadline shooters, such as the local newspapers and wire services. The pecking order that you think exists in other sports really applies in hockey. The locals who cover every game and are the media mainstay of the team usually get first choice of shooting spots in the first period. At Tampa Bay, I always made it my policy to give up the best spots to these photographers during the game's first period, because I knew they would be gone to their darkrooms until the middle of the second or beginning of the third periods. I never felt that a team photographer should be the most important shooter because I covered every game every night from start to finish, and I rarely faced any sort of deadline for the use of my photos. When I visited other arenas, I was usually working for a magazine or licensee. I asked for the best location and was happy to take what I was offered.

As I mentioned earlier, the clients whom I work for wanted strobe-lit material even when I began shooting digital. I designed and installed two sets of full-coverage arena strobe lights in the buildings that the Tampa Bay Lightning occupied. I kept one set for my own use and rented a second set to accredited photographers working for clients who wanted strobe images. I did this so that the catwalks where the lights were installed did not become an open door for every photographer who visited Tampa. The big concern was for safety, and I set a careful standard for securing and covering all my lights and regulating who used them. The two local newspapers also were allowed to install permanent sets of lights under my supervision. They were only allowed to use their lights for the benefit of their respective paper and were not allowed to share or rent them without specific permission of the team. This protected both the team and the fans. All other photographers were credentialed to shoot from designated and approved photo positions using the building's available light.

The Best Seat in the House

My all-time favorite shooting spot in hockey and sports in general is at ice level at center ice between the team benches. When the Lightning moved to their newly built arena, the St. Pete Times Forum in downtown Tampa, Florida, they provided me with a nine-foot open area along the dasher boards between the two team benches. This center ice spot had protective glass that ran behind the benches between the fans and the players in addition to glass on both ends between the players and the photographers. There was no glass between the photographers and the ice rink. You can't get much closer to a game than this. I was able to get a good selection of hockey helmets from the team equipment manager, and I required that all photographers wear them when shooting at center ice. Many shooters bought their own helmets so they could custom-fit them.

As photographers, we were rarely hit by flying pucks. However, the players often checked into this center ice area, and many player fights took place here involving players being shoved over the wall into our little world. The key to survival was to always shoot with both eyes open, follow the puck, and keep a good look out for players checking and making hits behind a play. Another really important part of shooting here was getting to know the crews of referees who covered the games. They typically set up right in front of this spot and went out of their way not to block the photographers.

I would shoot the entire game from the center ice location whenever possible because I produced some of my best game action and individual player shots there. It takes a long time to get used to shooting through player traffic here because you see a compressed view of the game with all of the players concentrating on the puck in front of the goal or between you and the goal.

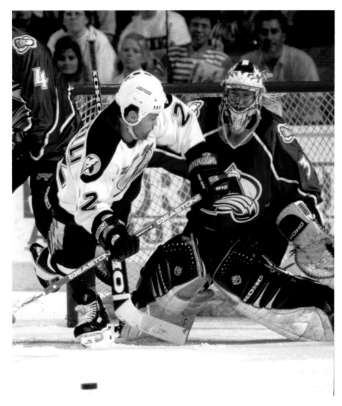

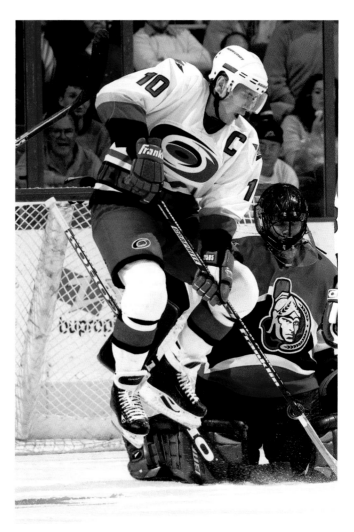

Shooting from center ice gives a view of action in front of the net. ©Jonathan Hayt

Hard hits and fights are some of the hazards of shooting at center ice, so keep your eyes open. ©Jonathan Hayt

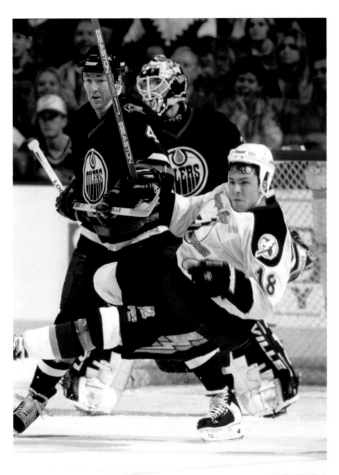
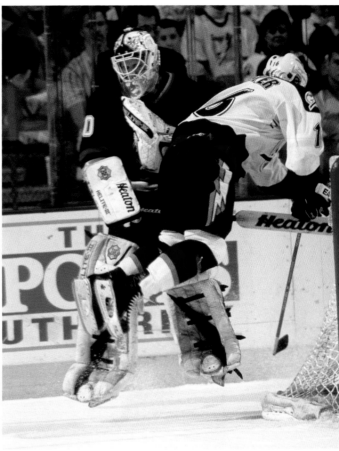

Hard hits by the players in front of the net compress nicely from the center ice photo position. ©Jonathan Hayt

You also have to contend with player line changes during play, where the players leaving and returning to the bench area can block your view. The bench area is also a great place to shoot players stretching during the pregame skate. The best part of this position is that you get to hear and observe the most intimate moments of play during the game.

You also have a good angle for shooting through the glass into the team benches, but you must be respectful of players and staff who might wave you off as a distraction to the game. I once had a television cameraperson ejected from center ice during a game because he became involved in a verbal altercation with a star player who waved him off after a particularly bad play. The player was in a bad mood, and the cameraperson was aggressive in doing his job. The player complained to his coach and the referees. They stopped play and made the cameraperson leave the center ice area. This involved his climbing through the Tampa Bay Lightning's bench full of players with his TV camera and gear while 15,000 fans jeered at him. Remember that these spots are a privilege and must be treated respectfully. Don't get bigger than the game you are covering.

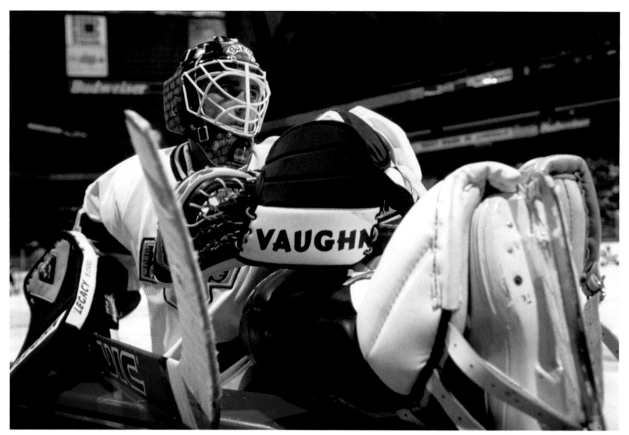

From the bench area, you can shoot photos of players stretching and loosening up during the pregame warm-ups. ©Jonathan Hayt

Even though I previously stated that I would always shoot as much of the game as possible from center ice, I also made sure to shoot from as many different angles as possible so that I could create variety in the look of my images. Too much of the same angle, no matter how good it is, gets stale after more than 40 home games. I had the team order and install panels of glass that had small rectangular holes cast in them along the dasher boards in spots that didn't interfere with fan seating and gave good angles on the play of the game. Most NHL rinks have switched to safety glass from plastic Lexan or Plexiglas. The older-style plastic panels are great for photographers because it is easy to cut holes for shooting spots, and the arena ice crew can usually do the work in house. The new safety glass requires that the manufacturer cast the holes in the glass, so it takes some careful planning and cajoling to get them made correctly. The NHL has issued strict standards for hole sizing and placement and has been instrumental in getting teams to install an adequate number of on-ice holes so that teams can accommodate more photographers. The holes are usually placed near the blue line and at the red lines at the four corners of the rink. They give a great shot of goal action and hits behind the net. Just remember that you are limited to shooting only one end of the ice, and your range of motion is quite limited. Also, be prepared to sit in a folded-up position. You might want to bring a small stool or equipment case to sit on.

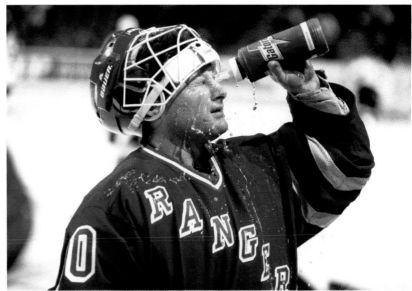

Center ice gives great access to shots in the bench area, but you have to be respectful of the players. ©Jonathan Hayt

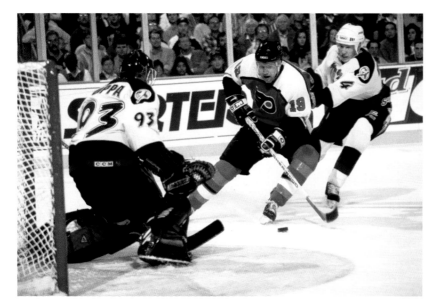

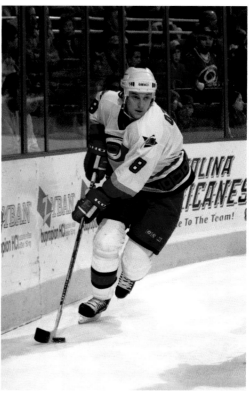

The holes cut in the glass at ice level give a view of the goal area and behind the net that you can't see anywhere else. You don't get to shoot as much, but the photos show an intimate angle of the game. ©Jonathan Hayt

The next area to shoot from is along the arena concourses or in designated elevated positions. In Tampa, the rule was that you could stand in any of the arena concourse entrances as long as you didn't impede the fans and ushers. This opened many easy-to-reach spots where you can shoot with a telephoto lens, usually a 400-mm f/2.8, and cover the entire ice with almost no obstructions. This area is a great place to learn to shoot. It allows you to achieve both high-quality and high-quantity photos. Most news photographers choose this location because they can arrive late from other assignments and walk right up and cover the entire game. Shots-on-goal and regular gameplay look good from this angle, and it is a good place to learn the rhythm of the game. I also like this angle if I am on the opposite side of the rink from the team benches so that I can shoot the coaches interacting with players and capture celebration shots when a goal is scored.

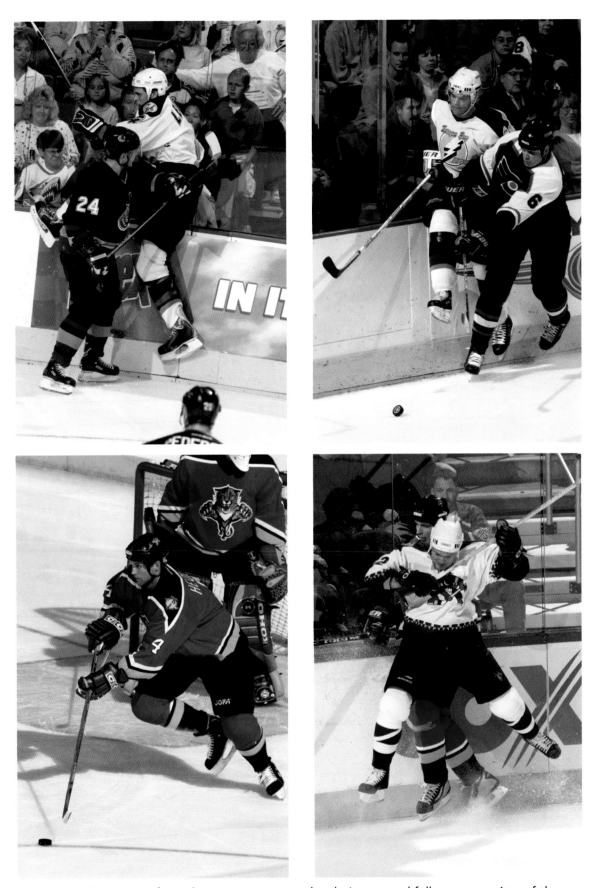

The elevated positions from the arena concourse level give a good full-coverage view of the game action. ©Jonathan Hayt

I have often added a teleconverter, usually a 1.4X, to a long lens and shot tightly on individual players in the bench area as they hang over the dasher boards waiting for a shift change. I also go down lower into the stands when there isn't a big crowd and shoot a lower view of the benches that looks more like the ice level. Also, photo positions were designated at the ends of the elevated television camera locations above center ice. They were a favorite of the news photographers because they offered easy access and good coverage. I found that making friends with the television camera crews often got me access to sitting or standing on their center ice shooting locations as long as I didn't move around and cause vibration in their cameras.

It never hurts to ask permission to wander the building looking for unique angles. One of my favorite spots is in Nashville, where the concourse is open at both ends of the rink at the top of the lower seating bowl. I found a similar but lower spot in an old arena in Buffalo where I could shoot players coming straight up the ice along with the hard hits along the boards near the blue line.

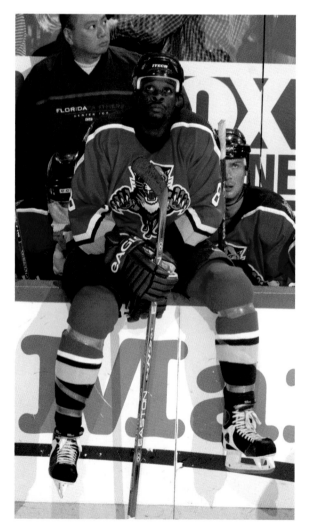

Team bench shots look great from across the ice at a low angle from the stands. ©Jonathan Hayt

I wouldn't spend all night there, but a half period can turn up some interesting photos. Be aware that the NHL now requires netting to be hung around the back ends of the rink along the high dasher board glass, so a lot of spots have disappeared. I also made friends with the off-ice officials and received permission to kneel next to the goal judge's box and shoot with a wide-angle lens pressed up against the glass. This behind-the-goal shot makes a good close-up of shots against the goalie and a nice overview of the arena from one end of the rink. Remember that every game has a winner and a loser, and there is almost always a good photo opportunity of the winning goalie being congratulated by his team at the end of the game.

Many photographers don't have access to NHL hockey and shoot only minor league, college, and amateur games. The angles are basically the same, with the added benefits of fewer rules and players and teams that are much less restrictive with photographers. I have shot in many small buildings that have seating only on one side of the rink—usually opposite the team benches. I either get permission from the teams to stand inside the bench area behind the players or just behind the bench at center ice on a six- or eight-foot A-frame folding ladder. These ladders lock in the middle and are often available with a locking platform in the middle to stand on. The ladder gets you above the players while maintaining the on-ice look of your photos. At this level of play, many teams don't care if you stand on a small stepladder behind the bench or in with the players. Just stay out of the way and leave everyone alone. I try to be as invisible as possible and rarely am I even noticed. Usually a good elevated spot is available to shoot from opposite the team benches in the smaller rinks. This allows coverage of both ends of the ice along with the bench area. I have also found that most small rinks still use plastic glass panels around the rink. If you shoot there regularly, many facilities are willing to cut one or two holes in the glass where there are no fans behind you or where the fans don't have access. It never hurts to ask because most rinks have extra panels and good workshops on the premises.

Lenses and Cameras

Now that you have an idea of where to shoot in the arena, the next issue is what lenses are best to really shoot the sport. Hockey is a sport in which both horizontal and vertical photos work equally well and can be shot from the same positions with a variety of lenses. I will follow the previously mentioned photo locations because they tend to dictate the equipment I bring to a game.

The center ice and bench position is a great spot for both horizontal and vertical action shots. I like to shoot individual player shots with the equivalent of a 400-mm lens as a vertical image. Remember that I am relating this to both film and digital. A digital camera with a 300-mm f/2.8 lens gives you a focal length of between 390 mm and 450 mm at f/2.8, depending on whether you use

Canon (1.3 times the original focal length) or Nikon (1.5 times the original focal length); therefore, you are a bit loose with one and a little tighter with the other. The larger file sizes of current digital cameras give you plenty of crop room, so shoot with a lens that you can easily hold in your hand or use on a monopod. I always carried a 300-mm f/4.0 and a 400- or a 300-mm f/2.8 for this position. A 70–200-mm f/2.8 zoom lens with a 1.4X teleconverter also works well in tight quarters. I also throw a wide-angle zoom lens in my waist pack so that I can make a quick switch for the shots within the team bench areas. I usually don't keep an extra camera around my neck because I am working in close quarters with one or two other photographers and a television cameraperson who is also there to shoot the players and coaches in the bench area. It is annoying to be bumping into someone else's camera every time you move. Also, never leave camera gear in the shelf area that is created by the dasher board structure between you and the ice. The same goes for drinks. I have seen many unwary photographers watch their expensive lenses and sodas launch into the back of the photo well when players hit the dasher boards. Remember that the dasher boards are designed to flex when the players hit them.

The game almost always ends with the winners congratulating their goalie. ©Jonathan Hayt

I prefer to use a 70–200-mm f/2.8 zoom lens with a 1.4X teleconverter to shoot horizontal action through the ice-level holes in the glass because I can zoom and track the action across a much wider area of the ice. I am using strobes, so I have the advantage of being able to shoot above the f/4.0 aperture that this setup gives. A straight 70–200-mm f/2.8 zoom lens still gives a good focal range when used with a digital camera on available light. The corner spots and blue line holes are best shot with this setup. Also, it never hurts to have a wide-angle lens on a second body for the occasional shot when the players are right in front of you, especially during fights or face-offs.

If you are shooting in a rink that has no holes in the glass and you decide to shoot through the glass, be aware of possible reflections that your body and camera can create. I always try to wear a dark shirt to reduce my reflection and add a flexible rubber lens shade on the camera. You might need to take black gaffers tape and make an expanded lens shade to get completely rid of reflections. Always keep a short roll of black gaffers tape in your bag or waist pack. Shooting through the glass limits you on camera swing because you get a lot of distortion as you angle into 1/2-inch thick glass. Also, bring a towel along and make sure that the glass is clean inside and out way before the players take to the ice. I often talk to the ice crew and ask them to run the towel over my area during the intermissions while they are clearing out the ice buildup along the boards. Get used to a lot of lost images resulting from glass distortion and colorcast that come with shooting through the glass. Also, remember that the glass moves during play, so don't daydream with your lens up against the glass. I have seen many shooters getting eyebrows stitched up after a good hit, including myself.

This shot was through the glass at the America West Arena in Phoenix, Arizona. No holes were cut in the glass at ice level.
©Jonathan Hayt

The elevated shooting positions almost always require a minimum of a 300-mm f/2.8 lens for horizontals and a 400-mm f/2.8 lens for verticals. I often add my 1.4X teleconverter to my 400-mm lens for tight individual vertical shots. Bring your wide-angle lens along because the first puck drop at center ice each period makes a good graphic shot when you include the logos and lines in the ice with all of the players staged for the game to begin. Remember that you have an advantage with the focal length extension of a digital camera; a 300-mm lens can often replace a 400-mm lens.

Remote Cameras

Hockey has several good remote camera locations, but they are not as useful as they are in basketball. The first issue is that nothing can be in the field of play because it will be destroyed, and you will be told to remove it. The only really great on-ice remote is the goal camera placed inside the net at a low angle. Placement is critical; it can't be too high up, or it will block the goal judge's view of the goal line. I usually place mine around four to six inches above the ice and then check with the goal judge to make sure it is okay. Goal cameras at the NHL level need to be approved by the league, teams, on-ice officials, and goaltenders. Don't think about just showing up and clamping a remote onto the rear upright post without going through all the right channels. The NHL has specific guidelines for the construction of a protective box for the camera. Once built, the box must be sent to the NHL for final approval.

I have constructed many goal remote cases out of 1/2-inch thick Lexan plastic. I've designed them so that the box meets the minimum dimensions of the camera, a wide-angle lens (16 mm for film or equivalent for digital), and the remote radio triggers for both the camera and the strobes. I make mine so that I can easily unscrew the front face and replace it if it's scratched. Then I attach it to the four sides of the box. After that, I install the camera and radios in the front box and use a bolt through the bottom of the box to secure everything through the threaded tripod mount hole in the camera base. I make sure the lens is 1–2 mm behind the front faceplate so that no shock is transmitted to it if hit. I then attach the front case with camera and radios to the back cover with quick release fasteners so that I can service the camera during intermissions. The back cover has a ball head attached to a photo clamp with extra securing screws to keep the cover attached to the ball headplate that is then bolted to the clamp. There is a fair amount of weight in this assembly, so it all needs to be bolted together so that it can't turn or rotate. I normally clamp the backing plate to the rear upright standard of the goal net and estimate the angle that I want the camera to point to. After that, I place the digital camera flat against the plate to mimic the angle and fire off a frame. I can quickly see how the photo is composed and make adjustments. I then set the plane of focus at the goal line. You can do this easily if you just hold the camera at the plane of

the goal line and focus back on the remote camera box, because you can't get your head behind the camera in the net. I use this trick of prefocusing a camera from the place I want to shoot toward back to the camera mounting area of the remote when I know that I won't be able to easily look through the camera to focus it after it is installed. I also make sure that all of the camera settings are locked down or taped in place after everything is set.

The other good remote spot is from the overhead catwalks. I have tried many different positions up there, and I like the direct downward shot over the goal in addition to off angles slightly to the side and behind the net. These spots usually require a medium telephoto zoom such as a 70–200 mm or a fixed 300 mm f/4.0. They work best if they aren't too tight of a shot because the players in the goal area and just to the edge often add drama to the goalie's save or loss. A nice start-of-the-season shot is the center ice face-off from straight overhead. Just don't forget to safety everything and then safety it again. I always had a policy of checking all remote cameras that other shooters set up in my arena so that no accidents could occur. Also, never enter a catwalk or overhead area with objects in your shirt or pants pockets. A dropped tool or pen can do a lot of damage when dropped from 100 feet up.

I took these overhead remote shots from the arena catwalks. They make good graphic images. ©Jonathan Hayt

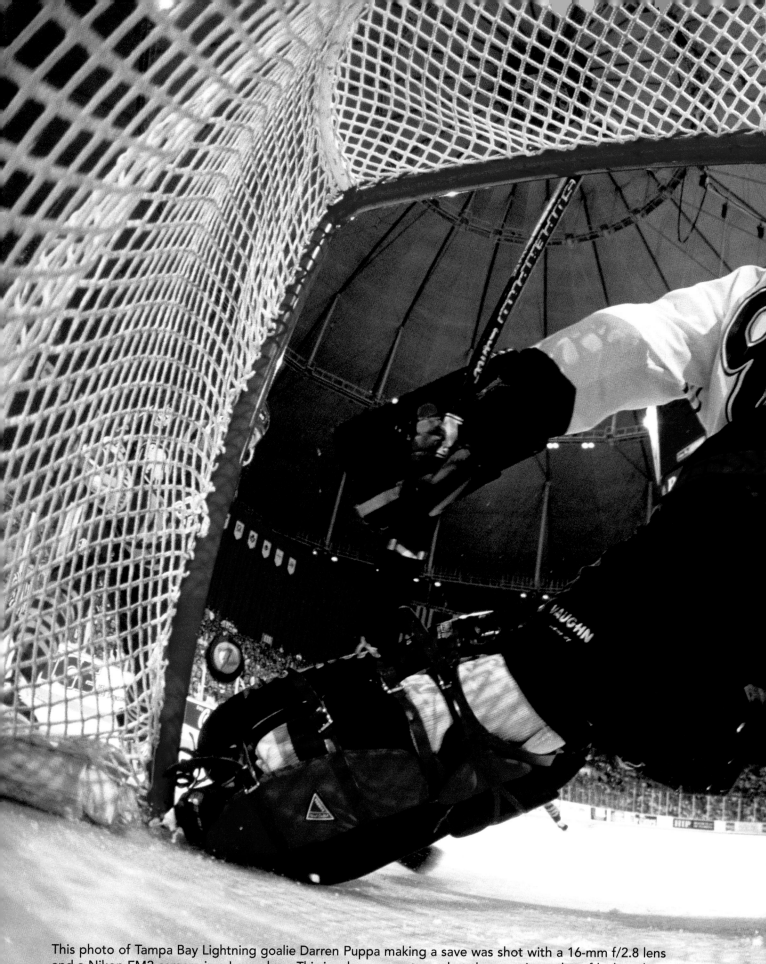

This photo of Tampa Bay Lightning goalie Darren Puppa making a save was shot with a 16-mm f/2.8 lens and a Nikon FM2 camera in a Lexan box. This is a low percentage shot that requires a lot of luck and some good timing. ©Jonathan Hayt

A Word on Indoors Flash (Strobe) Photography

Arena flash photography, or what is commonly called *strobe photography*, is mentioned throughout this book, so here is a short primer on the subject. Shooting indoors presents a separate set of issues regarding lighting. Most photographers will probably shoot indoors using the available light that is built into the buildings where they take their photos. This is simple to deal with. The only requirements are to shoot using proper exposure and correct white balancing for good color quality. The second choice requires more work but enhances the quality of your images. It involves the installation and use of arena-mounted electronic flash units, commonly called *strobes*. If you shoot in the same building on a regular basis and want to improve the quality of your images, a set of strobes allows you to shoot at a low ISO rating and gain exceptional color quality.

Almost all NBA and NHL arenas have up to four sets of strobes already installed in the catwalks. They are triggered through the use of remote radios or hard-wire lines that have been run down to the respective photo positions. These strobe setups are reserved for the team and league photographers, local newspapers, and accredited visiting photographers. Don't expect to gain access to these systems if you are not shooting for a client or company that has been given permission to shoot on strobes and the proper arrangements with the strobe's owners, teams, and leagues have been made. These systems that are installed in the big pro arenas usually consist of four lights for a basketball system per photographer and six or eight lights for a hockey system. The goal for a shooting exposure is between f/4 and f/5.6 at 100 ASA at 1/250 (or higher if the camera allows) of a second shutter speed with an even lighting exposure across the entire court or rink. Usually one photographer shoots on one set of lights, although sometimes shooters share a set when there is a high demand. This is easy in hockey, when shooters can shoot at opposite ends of the ice rink and cover action only at their own ends. Basketball is tougher because this often limits photographers to shooting on strobes at their respective ends of the court and shooting the available light down court.

Strobe units are commonly rated by watts/second for advertising purposes by their manufacturers. This is a measurement of electrical energy that is often misused and only perceptually indicates how much light a particular unit might produce. Actual measurement of light output with a light meter that is capable of measuring flash output exposure is the appropriate way to determine if a strobe is capable of producing a usable exposure. Generally, the high output strobes for arena use are rated at 2400 watts/second, and most photographers take this as gospel that this is all they need to worry about.

However, several other factors must be considered when looking into a set of strobes, such as the actual measured light output using the appropriate reflector, flash duration, recycle time, and amperage draw on the available electrical service in a building. This is where things start to get tricky because many manufacturers make great performance claims with absolutely no data to back them up. I have been amazed at how these manufacturers do little or no field-testing, yet they all seem to produce equipment that they think has been optimized for the job. I have spent numerous hours testing various reflectors and their focusing to realize that many of the manufacturers can greatly improve on their equipment's performance.

Let's talk about lighting setups and what really works. Placement of strobe units in a building is paramount to achieving good light quality. In basketball arenas, especially the pro buildings, the ceilings usually have catwalks that are approximately 100 feet above the floor and give access to the arena's house and stage lighting. They parallel the sides of the court and allow you to place lights above the four corners of the court, where they are focused between the net and the free-throw line on the court in front of the baskets. The goal is to place the catwalk-mounted lights on your end of the court so that they don't create backboard shadows by being too far behind the net, depending on your floor shooting position. You need to set the down-court lights so that you get good mid- and down-court light with the light that you shoot up into but not set so far forward that it causes flare when you shoot under your own basket. If you see the light flaring in your photos, move the light further down the catwalk away from you until it disappears. Some arenas don't have locations that allow this sort of placement, so you have to block off the light with a black flag to eliminate this problem.

Then you need to wire the lights together so that they fire at the same instant. Most photographers use 18/2 SPT-1 wire, which is simply lamp cord wire, and plastic quick connectors. Remember that the trigger voltage is extremely low, so you don't need heavy gauge wire unless you are leaving this as a long-term permanent installation. Use a color that isn't the same as other sets in the catwalk so that you can figure out where your wires are run. It is also important to check on the trigger voltage of your particular strobes because many older units are not low voltage, and the trigger voltage is additive as you connect lights. This can do real harm to the sensitive electronic of a digital camera, so be aware that this problem exists. You probably need to drop a line from your trigger system to the basketball court unless you are using a high-quality remote radio. Make sure you use a dark color wire for all drop lines because a light color shows as a big line across your down-court photos.

The only remote radios that work properly are the Pocket Wizards, which are distributed by the Mamiya America Corporation. They have been well developed and sync properly with most cameras. Make sure you check with other strobe shooters in the building so that you don't shoot on the same radio channels. If you can afford it, you can also place a Pocket Wizard receiver on each strobe unit and avoid the sync wiring altogether, especially in a situation that is only temporary or if you are in a hurry to set up.

Hockey rinks require more lights because they are 3.6 times larger in surface area than basketball courts. A typical NBA basketball court measures 94 feet by 50 feet, and an NHL rink measures 200 feet by 85 feet. One advantage with an ice rink is that overhead lighting is hitting a big, white reflective surface, so you gain extra exposure with your strobes. Typically, it is better to light most hockey rinks with six lights. You can use four on your primary side and two as backlights. You can also determine which side to front light by knowing where your main shooting spots will be. If you are shooting from the bench area or on the bench side of the ice, you can place four lights behind and above your location. You can also shoot with eight lights in hockey if you can afford them. The advantage to using four lights on each side of the rink is that your lighting becomes very even, and you can shoot from almost anywhere in the arena with a consistent exposure. Most shooters almost exclusively shoot with a radio trigger in hockey because they know that they will probably change photo positions several times during the game.

After you set up your lights and establish your metered exposure, you can shoot single frames of the game. You must allow your lights to recycle fully between shots. Many of the larger units put out a lot of power but also have 3–4 second recycle times, so you must learn to make every shot count. You need to experiment with different reflectors and their exact focusing in relation to the placement of the flash tubes in your lamp heads. I have a simple way to test this by mounting a single light on a stand and moving a distance that approximates the mounting point above the floor where you are going to use your lights. I then have an assistant hold my selection of reflectors up to the light while I fire it and check my light meter readings. The assistant moves the reflector in and out along the length of the flash tube until I see where the maximum light reading is achieved. I am usually amazed at how far off the standard position of the reflector is compared to where the most light is gained. I then make a tin sleeve that I rivet onto an accessory collar that places the reflector at the right distance from the flash tube. Many of the lighting manufacturers make well-focused lights for different distances, so try them all before you decide to light an arena. As a rule, most wide shallow reflectors focus light better at long distances, whereas smaller, deeper reflectors spread better at short

distances. The lesson here is that you can often pick up one or two f-stops of exposure and use a less powerful light unit to achieve good lighting. The other big plus occurs when you already have a big 2400 w/s per unit light, and you can dial down the power settings to get a much shorter recycle time while maintaining a good exposure. This also shortens your strobe's flash duration because a lower burst of power goes through a flash tube more quickly.

Flash duration is an important part of indoor shooting on strobes because your goal is to have a lighting set that overpowers the available house lights by at least 2.5–3 f-stops in exposure. You don't want to let the ambient light become part of your exposure because that affects your ability to freeze the action. Remember that almost all your digital and film cameras synchronize at 1/250 of a second with externally triggered flashes. If you are within several f-stops of the arena lights, you pick up this tailing of light as ghosting in your photos because it bleeds into the exposure. Moving your strobe exposure away from the ambient light exposure reduces this effect on your image. This in turn allows the *flash duration*, the length of time that the flash actually lasts, to create your shutter speed. Most strobes have a real flash duration of less than 1/500 of a second, and many are below 1/1000 of a second. This gives a nice crisp shot that really freezes the action, so keep this in mind. Also, when you set up in an arena, find out how many separate electrical circuits are available and whether they can handle your strobes. I know many photographers who have had to spend money at various arenas to get adequate electrical service installed for strobe usage.

The Bigger Picture

Hockey photography is a real challenge because you are confronted with a hard-to-follow game involving a small black object being chased up and down a large sheet of ice. It is important to shoot at the highest shutter speed that the conditions allow and learn to concentrate because events happen quickly. The game is full of great action shots of players mixing it up while chasing the puck, hard-hitting checks into the boards, and great celebration shots when a goal is scored. I also look for the emotion on the bench and the concentration and great moves of the goaltenders.

On a player level, hockey is a game in which the pros are generally friendly and approachable. The nonprofessional level is great for access, and it is not difficult to develop a good rapport with the coaches, trainers, and players. I generally stay away from the locker rooms pregame because players have rituals and don't like to be disturbed. I only ask for locker room access at specific

times and choose my moments carefully. The pregame preparation often provides opportunities to shoot players taping and shaping their sticks, working on equipment in the hallways near the locker rooms, and just hanging around and greeting their friends on the opposing teams. Hockey players represent an international group; players from various countries like to visit with each other, so you can often get a nice shot of star players from places outside the U.S. enjoying each other's company. The Canadian and international players who are playing for the U.S. teams are always looking for friends to talk about home with.

I also try to shoot photos of players off-ice whenever possible because there is little facial recognition in pro hockey. Goalie masks and helmets cover up the players, and their bulky uniforms and padding don't give you much of an idea of what the players really look like. I always emphasized this with the team staff, so they would push for off-ice photos with players because it gives the fans a different and more personal view of their favorite stars. Hockey has some great personalities that are rarely revealed during a game. I have had great fun shooting players in candid situations. The players come from all over the world and are usually willing to show you the more interesting sides of their personal lives. I always try to shoot them on team outings such as golf tournaments and public appearances. The teams also require their players to perform community service, which often makes for great photos of them out of uniform.

Take advantage of the fact that most hockey players love the game and grew up in places that are different from where they play professionally. After you have built a rapport and have earned the players' trust, they are more likely to give you access to their lives than other professional athletes. The nonprofessional players rarely see good action photos of themselves, so this can be a great way to gain good shooting access for event photography and college-level play. Just keep your eyes open and pay attention, and you can learn to shoot some of the best action shots in sports photography.

Off-ice photo shoots give you a chance to show players' characters without all the pads. These shots were from team calendars and golf outings. ©Jonathan Hayt

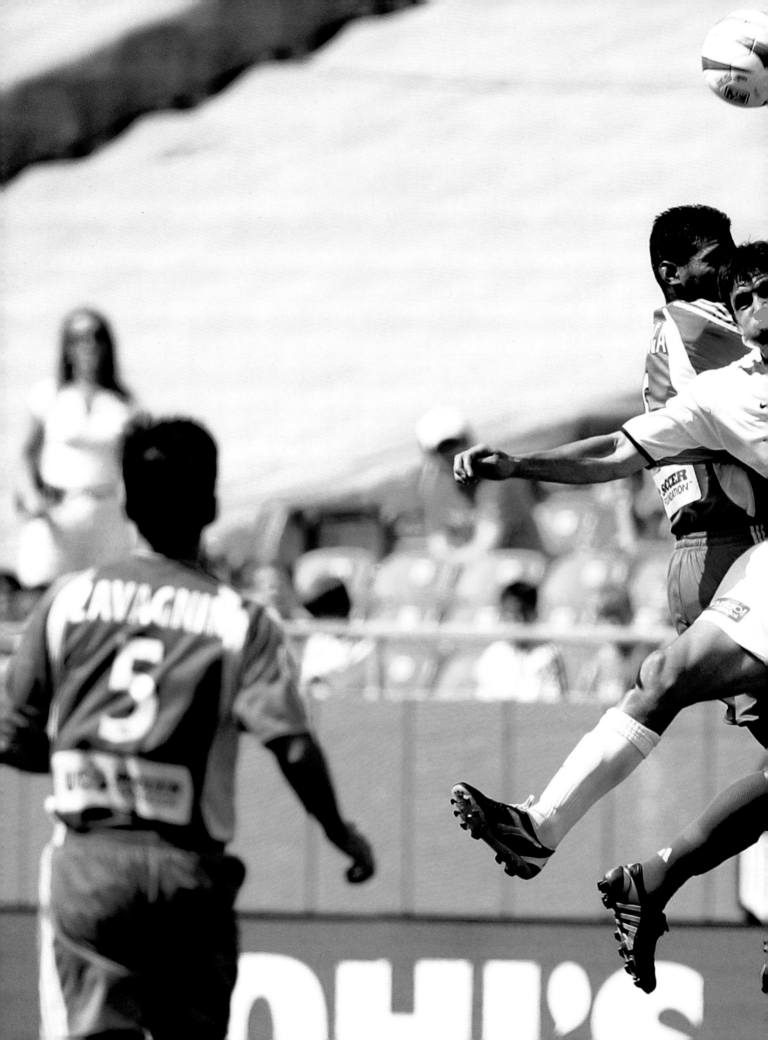

Soccer

CHAPTER

9

Photographing soccer is similar in many ways to football because you primarily use long lenses and have a wide-open field where the action takes place. For the most part, soccer isn't too difficult to photograph. Because soccer players don't wear any type of headgear, you're even afforded opportunities to obtain facial expressions. In addition, most professional-level soccer events in the United States are played outdoors in the cities where NFL stadiums are located. Because of these similarities, you will use similar shutter speeds and aperture settings that you would for football. The action in soccer, however, is extremely different from football.

Positioning

Because soccer is considered a continuous action sport, you will find yourself with plenty of opportunities to capture some intense moments during a game, albeit with some restrictions in terms of positioning. The locations in which to photograph professional-level and even college-level soccer events are some-what restricted on the players' bench side. Players from both teams are usually stationed on one side of the field right beside each other at the middle of the field. Unless you are a league or team photographer, your positioning options are usually designated at the opposite side of the players' bench or behind one of the goals. In addition, because the players' bench is usually on the "home" side of the stadium, you are frequently shooting from the backlit side of the field if you are shooting a day game and want to be positioned around midfield. This isn't a drawback, however, because you usually have plenty of space to shoot from this side of the field. Just be sure to compensate for this situation, sometimes up to two f-stops in your exposure. Of course, this is another good reason to have a light meter to correctly measure your exposures because shooting in a backlit situation requires this sort of exposure compensation. You will definitely want to set your exposures manually because the auto exposure features on most cameras do not give an accurate and consistent image exposure.

Regardless of your vantage point, you definitely need a long lens—at least a 300 mm if you are shooting digitally. Because most digital cameras come with an added multiple focal length to your lens, your 300-mm lens might be a 390-mm or 450-mm lens, depending on the brand of camera you are using. It works to your advantage to get closer to the action. Of course, you can use a 1.4X tele-converter to get even closer, but I would stay away from the 2X teleconverters, which entail losing two stops on your exposures and might lead to some softer images. If you decide you want to use a 2X converter, just be sure to purchase one that is made by your camera manufacturer and suited specifically for your camera, because off brands are not as sharp.

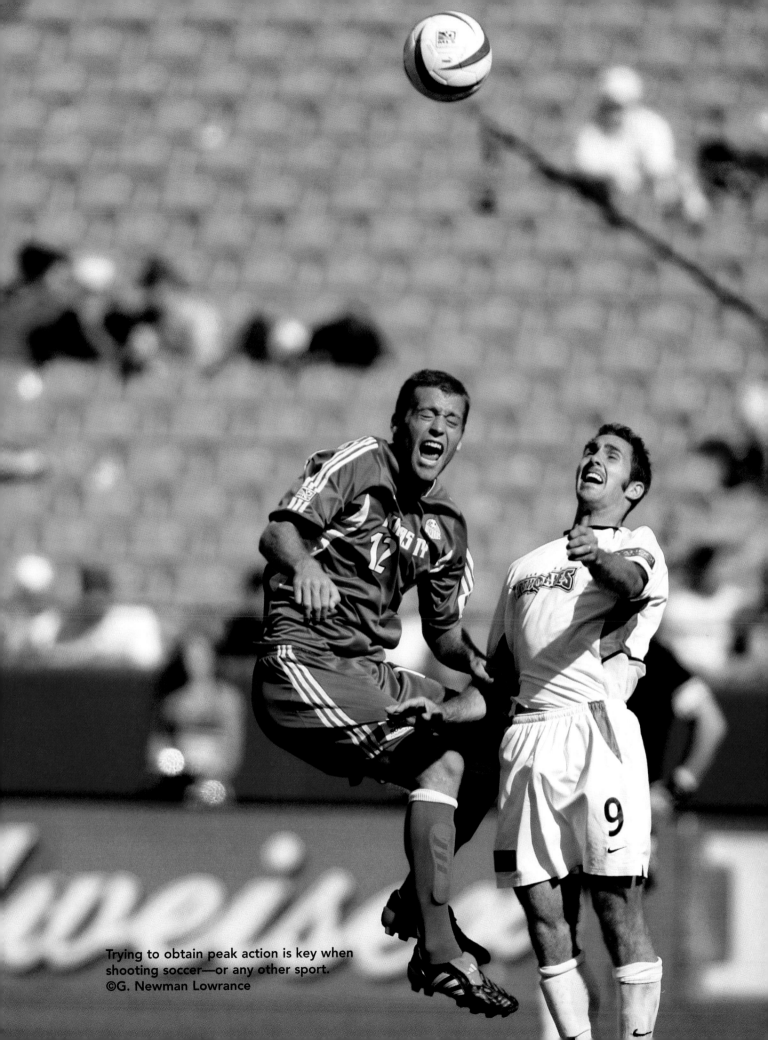

Trying to obtain peak action is key when shooting soccer—or any other sport.
©G. Newman Lowrance

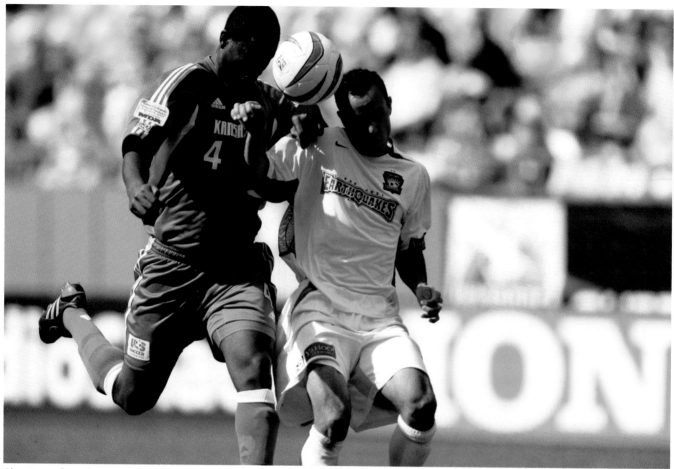

Shooting from the midfield area can provide you with many opportunities during a game. ©G. Newman Lowrance

Also, on hot days, heat waves can cause a tremendous amount of distortion when you're using long telephoto lenses, so be aware that a 2X converter can add to this problem. From these sideline locations around midfield, you can follow most of the action as teams play for positioning to set up scoring situations. Because soccer is unlike most sports in terms of goals, or points scored, much of the action is played in the center of the field. For this reason, I find the sideline positioning to be the best vantage point. Follow the ball, because that is where most of the action occurs. For professional soccer events, it is always good to capture the players as they battle for the ball after a kick or throw from the goalie. Usually two or more players close on the ball and set up for an attempted head-butt. These shots occur quite frequently at the professional level, so look for them and shoot freely.

From this sideline location, you can shoot most images horizontally to capture direct contact between the teams. As players try to maintain control of the ball, be prepared for defenders trying to seize control. The exception to this rule of general action shooting is when you are photographing just one team or one

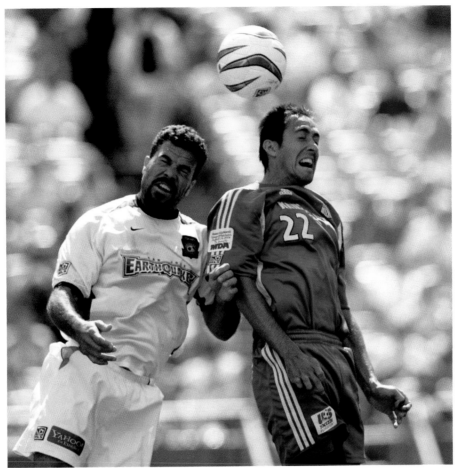

Follow the ball after the goalie has kicked it. In many cases, you will have images like this to capture. ©G. Newman Lowrance

player. In these instances, your job is perhaps easier, because you are concentrating on certain situations rather than trying to capture everything that moves. You will start to realize how often the action moves from one side of the field to the other, in contrast to football, where you constantly most move up and down the field to follow the action. Provided that you have a long enough lens, you can shoot both sides of the field and capture everything from dribbling to throw-ins, traps, corner kicks, and even goalie saves. Of course, you might also consider carrying a second camera body with a zoom lens, such as a 70–200 mm, when the action gets close to you.

Another option is to take a position at one end of the field on either side of the goal. This vantage point allows you to capture a player perhaps dribbling toward you and the goal in front of you. In this case, you might find yourself using your zoom lens more often, as the team gets closer for an opportunity to score. You can then keep the player who is attempting to score and possibly the goalie in your viewfinder. If you are using your telephoto lens, you probably want a vertical isolated shot of the player dribbling and then kicking the ball.

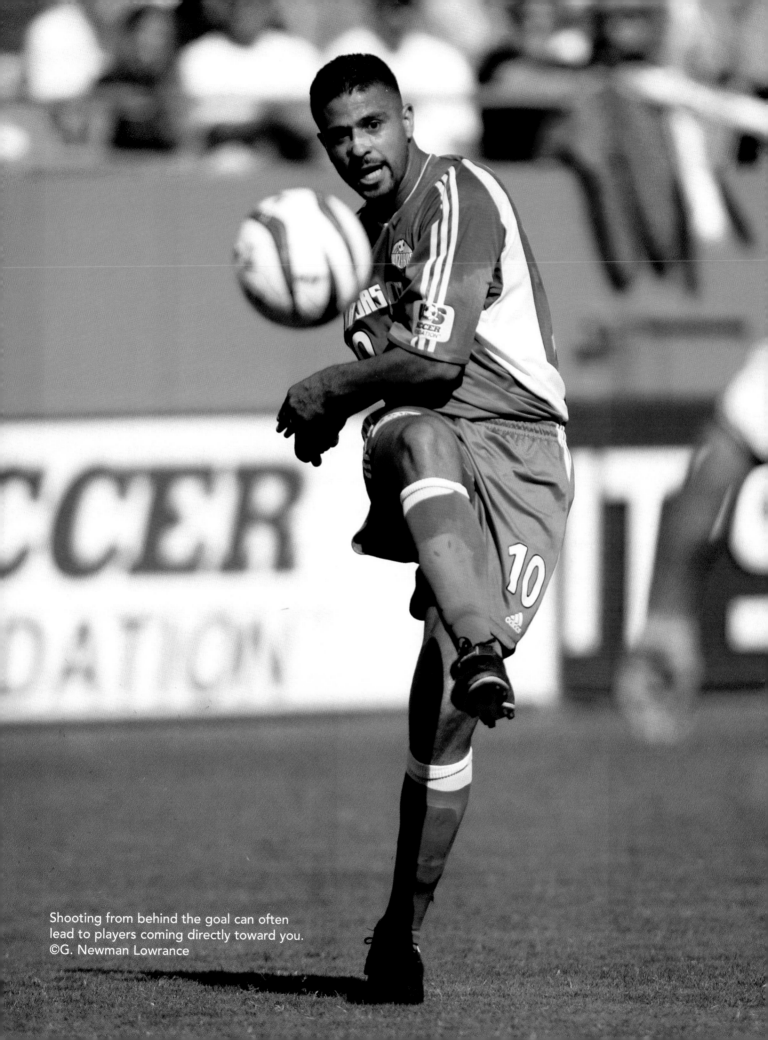

Shooting from behind the goal can often
lead to players coming directly toward you.
©G. Newman Lowrance

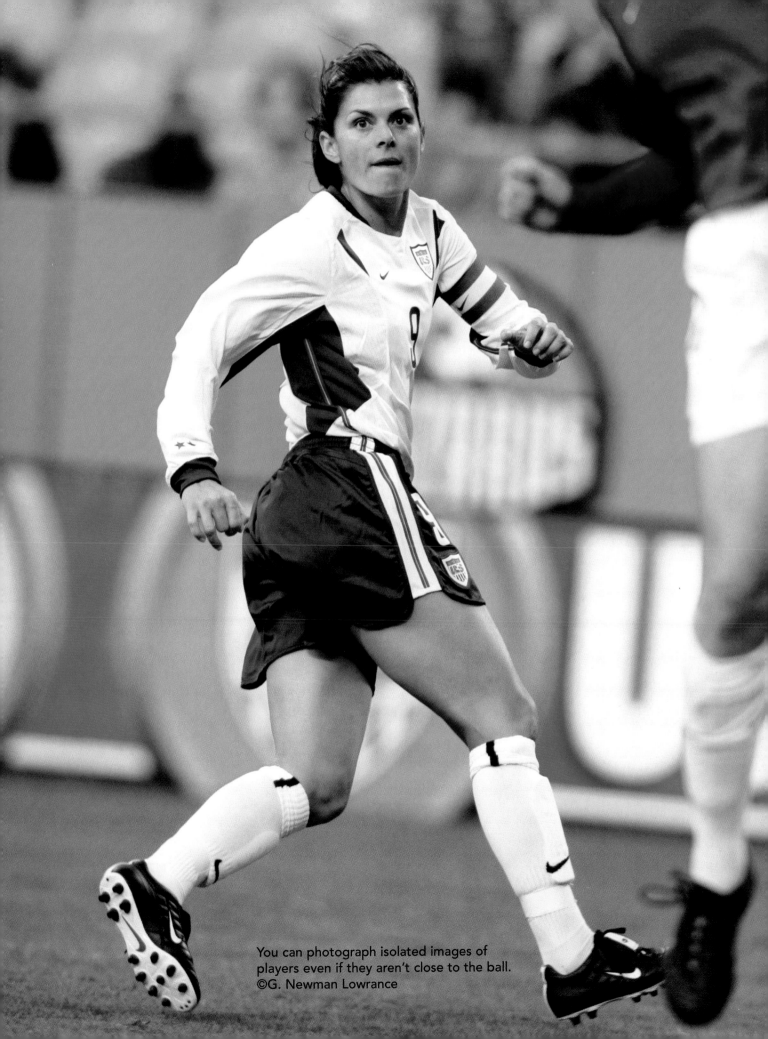

You can photograph isolated images of
players even if they aren't close to the ball.
©G. Newman Lowrance

You have several photo opportunities from this position, but the disadvantage is when the action goes to the far side of the field toward the other goal. You might then be 100 yards or so from the action and will have to wait for the teams to come back to your side. Don't forget that an international-size soccer field is 120 yards long by 80 yards wide, so you are covering a big field of play. In addition, remember that you don't always need to photograph a player dribbling or being close to the ball. You can always shoot isolated images of players without the ball as they move closer to the action.

Youth Soccer

Shooting youth soccer is much easier than shooting professional soccer. First, you probably have unlimited access to roam practically anywhere you want to be around the perimeter of the field. Second, you don't need to worry about obtaining a credential, because children's sports are easily accessible to everyone. Third, the field is smaller, and you can get by with a shorter telephoto lens or maybe even a long zoom lens to capture the action. Despite the differences in shooting youth soccer versus professional soccer, you can apply the same positioning methods as described for the professional-level games. However, because the players are smaller and slower, capturing good shots is much easier. The level of youth sports also allows for some great sideline shooting of the coaches or parents as they cheer on their respective teams. In addition, watch for some separate, isolated shots of the players during time-outs or stoppages in play, because these types of images capture moments that a parent treasures. Take both vertical and horizontal images so that you have several options when choosing your best images after the event.

Of course, shooting youth soccer might also lead to some evening events. In that case, your lighting situation is likely to be marginal at best. When photographing night games, you need a lens with an f/2.8 maximum aperture opening to allow you to use the fastest shutter speed. Because the youth level isn't as fast, you can probably get away with a shutter speed as low as 1/250 of a second, depending on the level of play, but use the fastest shutter speed that the lighting allows so that you have a better chance of freezing the action. Once again, I advocate shooting all moving sports at a shutter speed of at least 1/500 of a second if you want to minimize subject movement. The current high-end digital cameras have greatly reduced digital noise at the ISO 800 through ISO 1600 settings, so try to keep shutter speeds high. Movement in a photo is far worse than a little bit of noise that you can easily remove in Photoshop.

Shooting youth soccer is much easier than shooting professional soccer because it usually gives you unlimited access. ©G. Newman Lowrance

Always look for shots during time-outs and stoppages in play because they can lead to some nice isolated images. ©G. Newman Lowrance

Although soccer on the professional level doesn't have the same status as other professional sports, the popularity at the youth level increases every year. Most leagues have a photographer already in place to shoot the team and individual photos, but you can find great opportunity in showing up and taking action shots at these youth events. Few leagues at this level have anyone shooting action shots. Children tend to express their emotions unconditionally during a game, so be on the lookout for shots that capture joy, sadness, and even anger.

Watching for images that display emotion is a key element in sports photography, regardless of the sport.
©G. Newman Lowrance

Remember that emotion is a major element of what makes an image worthwhile. Shooting all of these elements is a great way to break into sports photography, meet new people, and advance to bigger and better things in your shooting adventures.

Tennis

CHAPTER

10

If you are just beginning your adventures in sports photography, tennis is a good place to start. That's partly because you will be covering only two players unless, of course, you are shooting a doubles match. Another reason is the general way in which tennis is played. You know from which location the player is going to serve the ball and where the receiving player is standing. You also know the general areas in which the players will move due to the court size.

Tennis is a good sport for training your eye to follow the player's pursuit of the ball as he vollies to another during the match. Because the basic area of play is relatively small compared to other outdoor sporting events, the area in which the players will often be positioned is somewhat predictable. As a result, you can easily track an individual player as he moves around the court in his attempts to hit the ball back to the opposing player. Players have different styles of play. Some are aggressive and attack the net, whereas others play back from the net and try to win the point with volley play. Although you might not know the players' style of play initially, you should become aware of how they play as the match goes on. These individual movements are unique and present the challenge in capturing good tennis images.

Tennis is a great sport for training your eyes to follow the action. ©G. Newman Lowrance

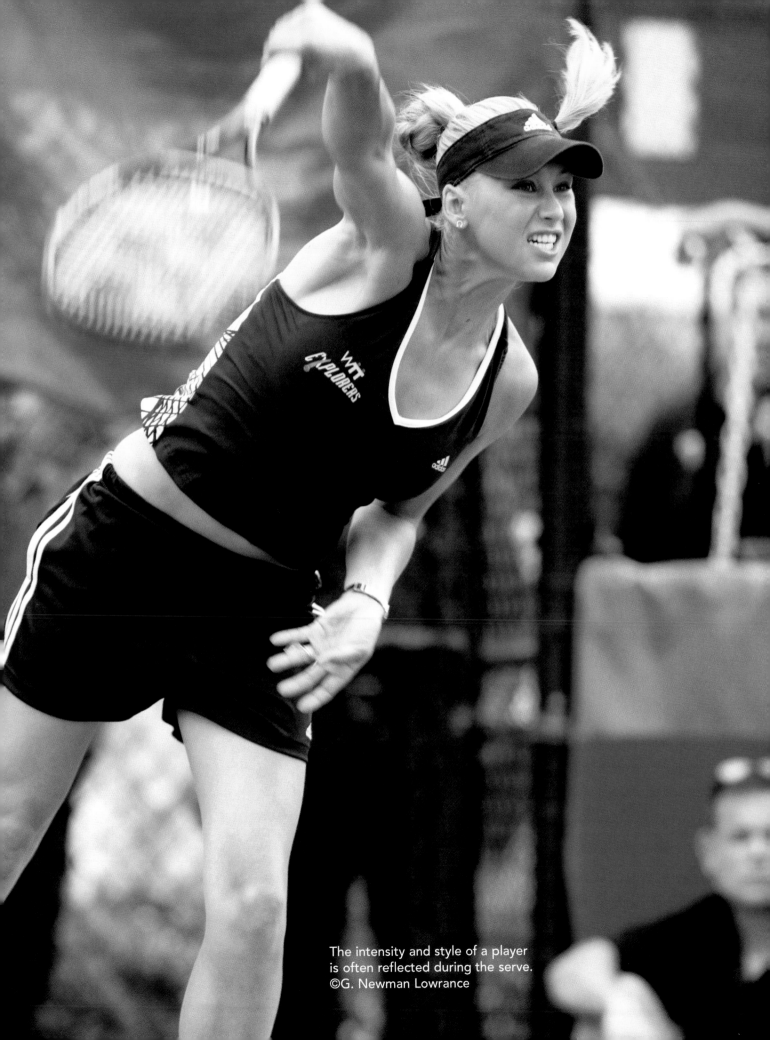

The intensity and style of a player
is often reflected during the serve.
©G. Newman Lowrance

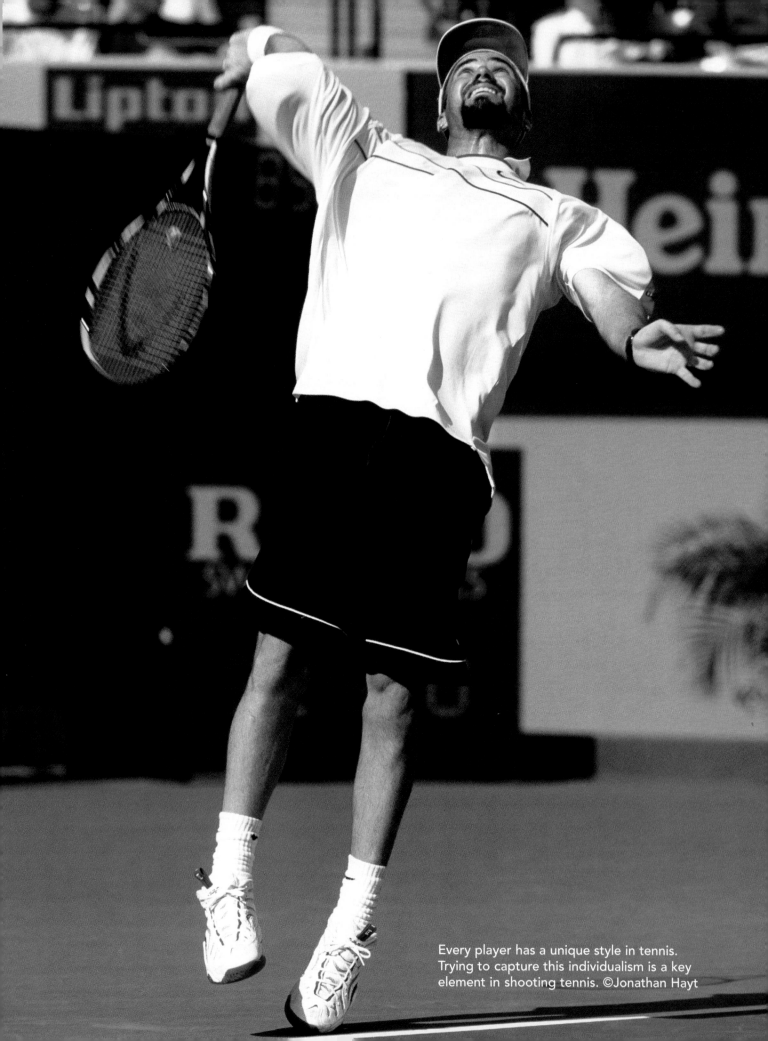

Every player has a unique style in tennis. Trying to capture this individualism is a key element in shooting tennis. ©Jonathan Hayt

Positioning

At most professional tennis matches, photographers are positioned together at center court opposite the players' bench or along the ends of the court behind one of the players looking toward the net. Generally, the best position to capture both players is at the center court position. Regardless of which player you want to concentrate on, he is often right in front of your lens during the match. From here, you can focus on one player as he serves, reacts to his opponent's return, and then roves to the ball and hits his subsequent shot. This also allows you to shoot with the same camera lens in both directions. You can photograph a player as he ranges back and forth or up and back around the court. Many players display great emotion as they try to range to the ball. This is also a good location to obtain bench shots because the players are directly opposite of you. The resting periods within the match are good opportunities to get some isolated shots as the player prepares for the remainder of the match. As you are focusing on these types of images, watch for a player's body language. He might be upset at his performance and talk to himself, or he might pump himself up to get going. Perhaps he's noticeably exhausted. Whatever the situation might be, getting an image of this kind of moment can define how you portray the final outcome of victory or defeat.

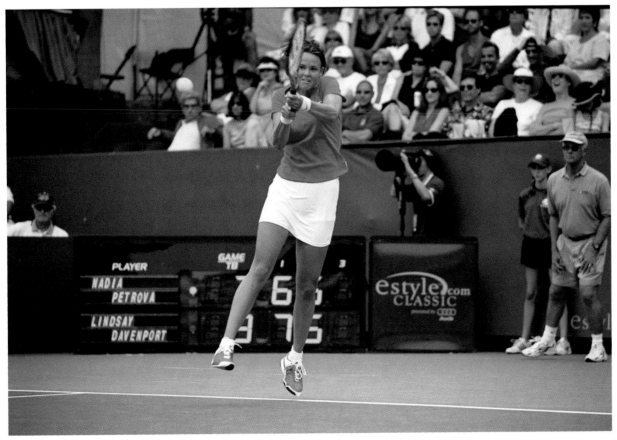

You can also shoot horizontal images with a zoom lens, such as a 70–200 mm. Notice the other photographer in the backcourt shooting from behind the net. ©G. Newman Lowrance

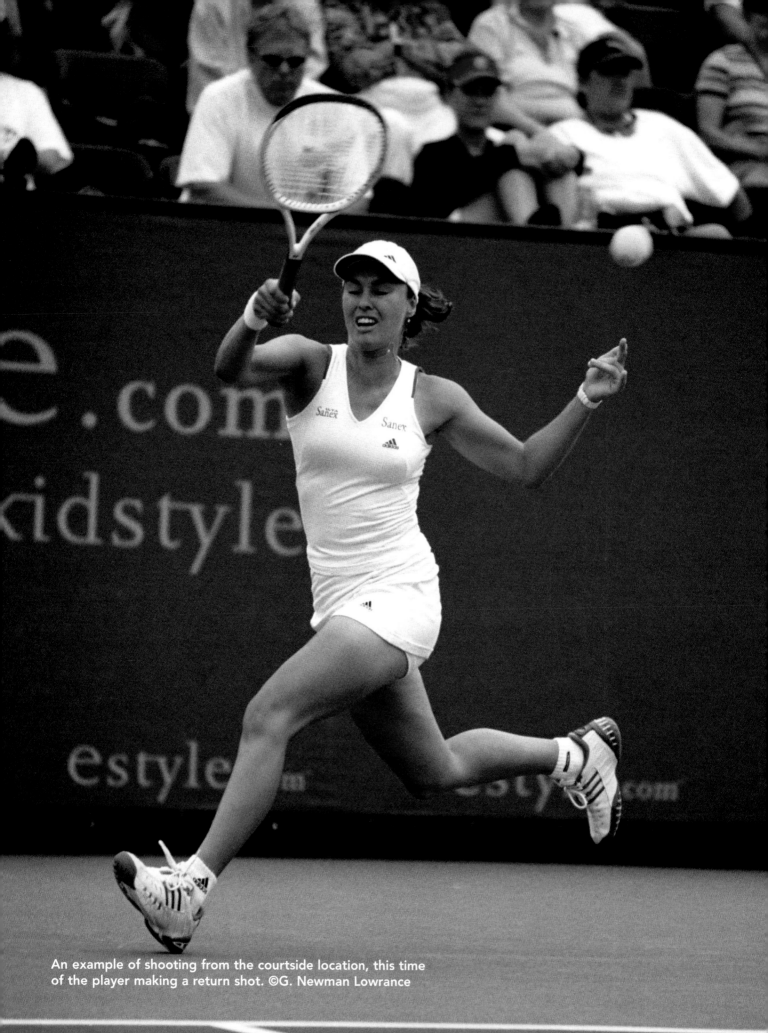

An example of shooting from the courtside location, this time of the player making a return shot. ©G. Newman Lowrance

You can photograph many other nuances of individual styles. Often, the player who is getting ready to receive a serve practically dances on his tiptoes or moves with his feet to prepare for the serve location. Similarly, you might find players holding their rackets a certain way as they set up. In addition, the player who is making the serve often takes a final look at his opponent's defensive position before launching the ball. These individual styles can provide various looks for you as a photographer.

Photographing from behind the net provides a completely different perspective. In this position, the player on the far side of the net faces you directly, and you can shoot some great action showing both players. If you are shooting horizontal images with a zoom lens such as a 70–200 mm, both players are often in your viewfinder, and you can capture some great shots that show the positioning and angles that occur. You can also shoot with a long lens and wait for a player to attack the net. Hopefully you can capture a great "kill" shot or a nice return shot.

For bigger events, you might even consider an overhead location. If the stands surrounding the courts give you this option, by all means use it to your advantage. You can try many different lenses from this vantage point. Take a few shots with a wide-angle lens to show the overall surroundings, which a corporation might like to have for a brochure. Alternatively, you can shoot isolated images from here with a long lens, albeit from a different angle. You can even use a tripod and attempt some long exposures for a different approach. In a nutshell, the more images you have from various vantage points, the more choices and strength your images have. This is true regardless of the sport you are shooting. Try moving around from all the locations to get several different vantage points as you cover each player. You will find yourself with several different looks that might be appealing to a client for the player you are photographing.

Lighting and Exposures

Generally, professional tennis is played outdoors during ideal weather situations, so lighting shouldn't be a problem. If the lighting is such that one player is front lit and the other is backlit, you obviously need to compensate your exposures accordingly. If you are shooting manual exposures and find it difficult to adjust, you can always shoot one player while he is on one side and then wait until the players change sides to get the other player in the same light. Usually, this isn't a hindrance.

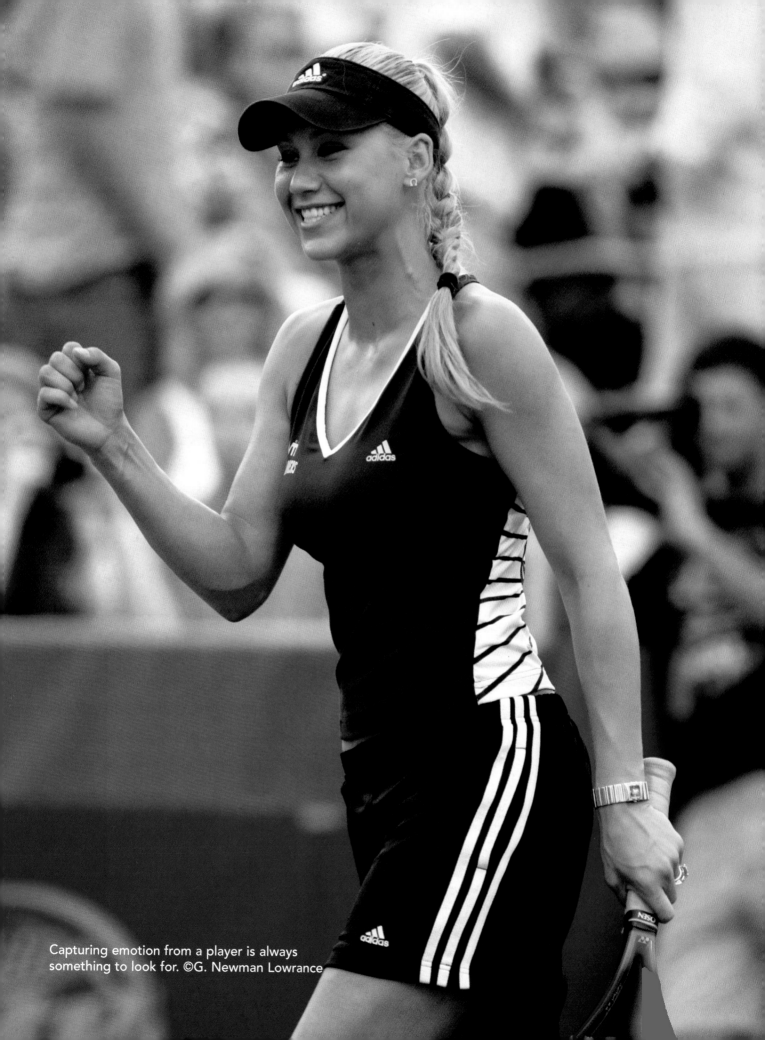

Capturing emotion from a player is always
something to look for. ©G. Newman Lowrance

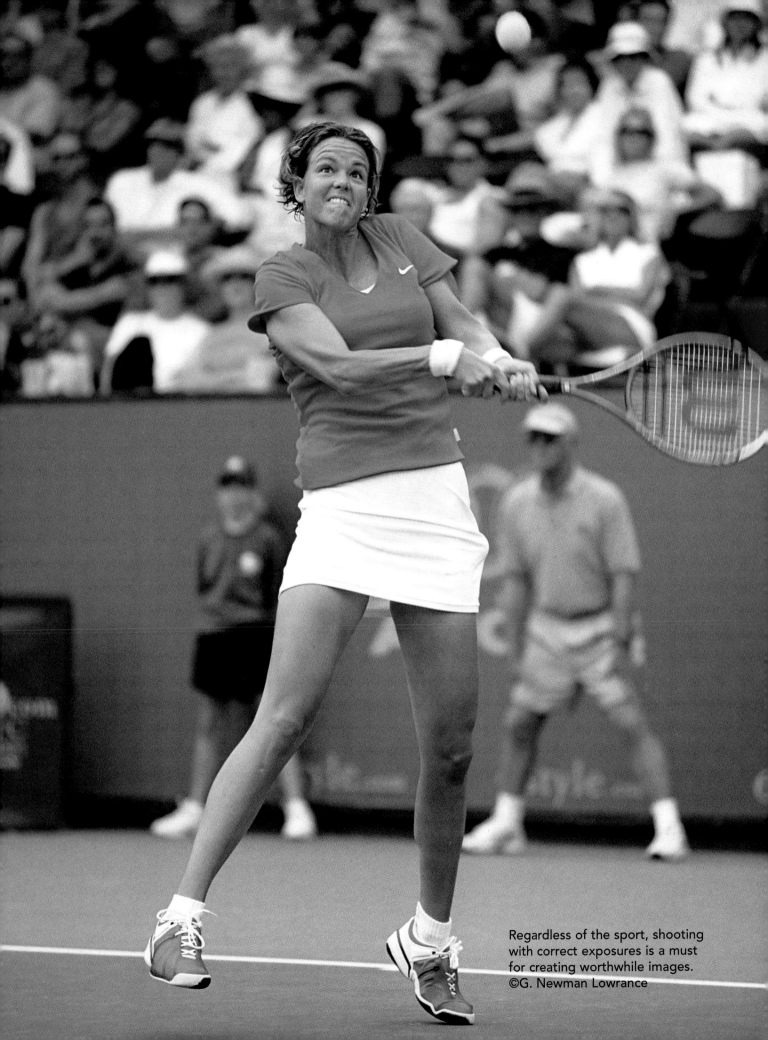

Regardless of the sport, shooting with correct exposures is a must for creating worthwhile images.
©G. Newman Lowrance

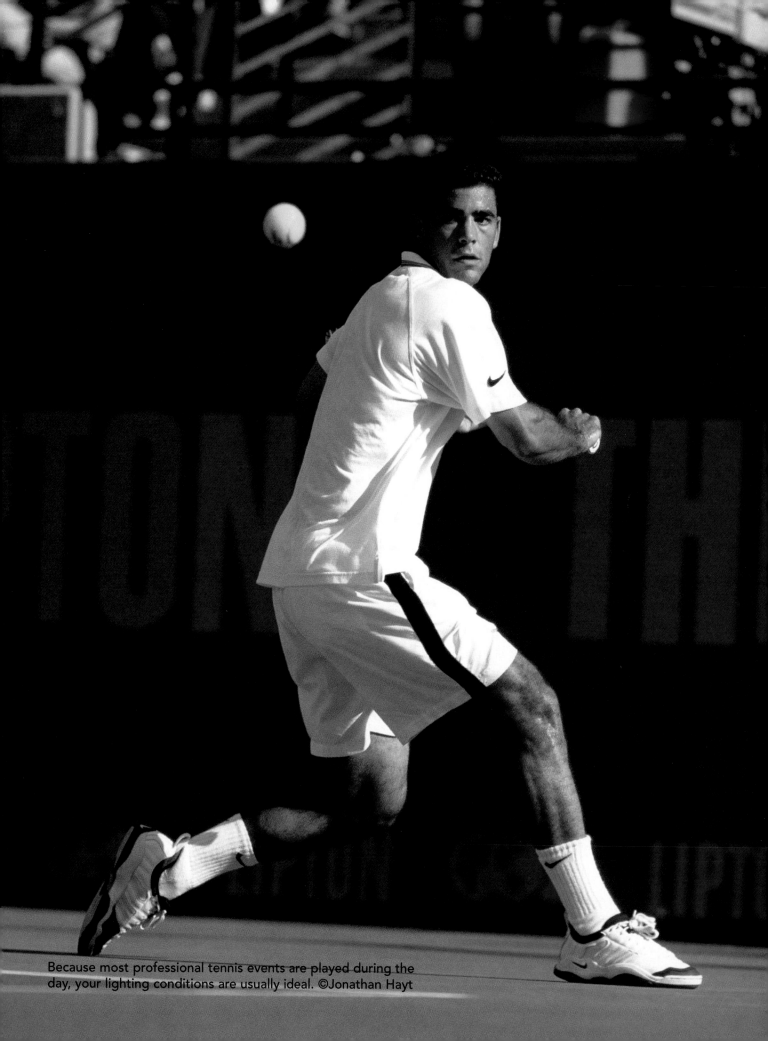

Because most professional tennis events are played during the day, your lighting conditions are usually ideal. ©Jonathan Hayt

At night or indoors, you will probably find yourself shooting at extremely high ISO settings such as ISO 1250 or ISO 1600. Remember that the new digital cameras allow you to accurately set ISO settings in smaller 1/3 increments, so take advantage of using the lowest ISO that will get the job done and still allow for a high enough shutter speed to stop the action. Because you will be shooting available lighting, you won't have control over the lighting except for what your camera can provide. In these cases, like other sports, choose a high enough ISO and shutter speed to stop the action sufficiently. Although these settings might be different, depending on what level you are shooting, I would recommend that you shoot with the highest shutter speed allowable to freeze the action. In tennis, the ball is the object traveling with the most speed, so I wouldn't worry so much about freezing it in flight. However, you should at least minimize the blur effect on the players. For amateur levels, you might try to use a minimum of 1/250 of a second with an f/2.8 opening, but experiment with the speed of the players you are covering. I've spent many Friday evenings shooting high school football games, where the lighting is usually at its worst. I had to learn where the best lighting was on the field and where it was practically nonexistent. Learning the different aspects of available lighting is a helpful although sometimes painful element in sports photography. These types of experiences are wonderful for learning and will assist you in dealing with similar situations at other events down the road.

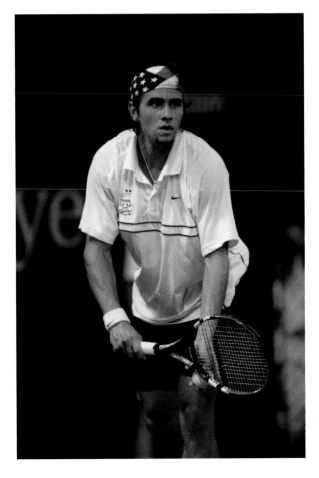

When shooting tennis, focus on the player's concentration, not the ball.
©G. Newman Lowrance

Public Courts

Of course, it is much easier to photograph tennis at schools or public courts, where access is typically unlimited, and you have free reign to move around as you want. In these situations, use your access to your advantage, and capture everything that you can. I would recommend, however, that you inform the players of your intentions. Most players at the amateur level are not accustomed to having their photographs taken, and some might feel uncomfortable. Others might love the attention and play harder, even showing more emotion than under normal circumstances. Regardless, most people love to get coverage, and it could lead to some sales and good experience for you. This is a great time to experiment with different shutter speeds, apertures, and ISO settings that will increase your knowledge as you progress to higher and faster levels of play.

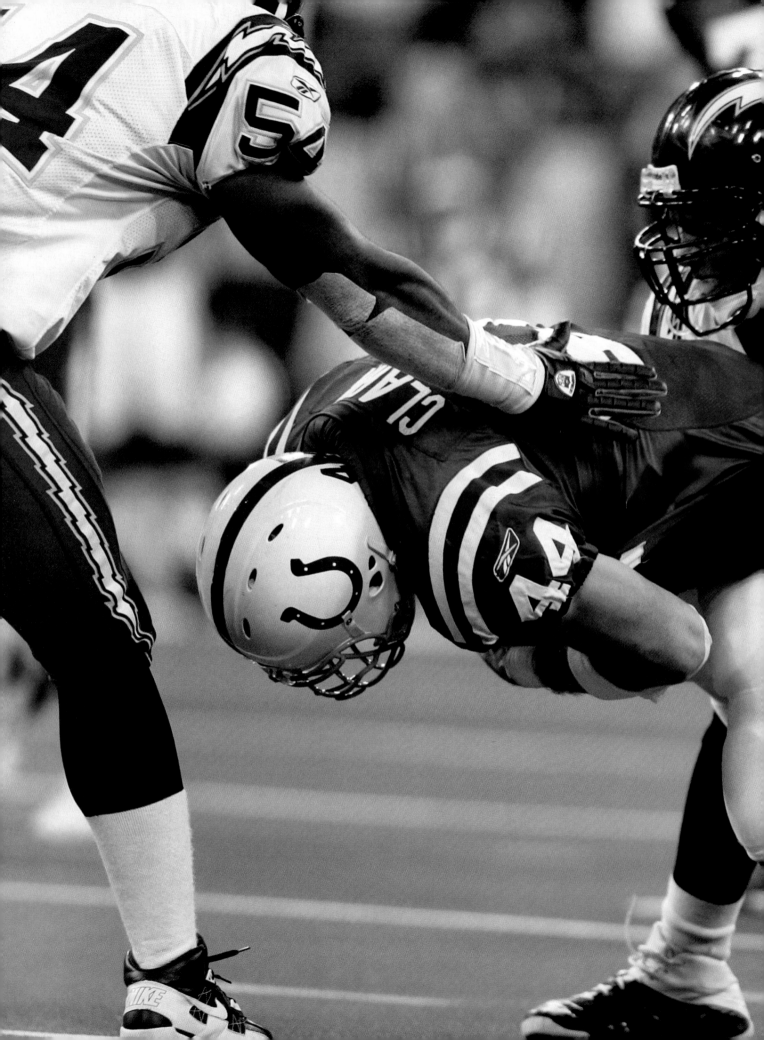

Glossary

©G. Newman Lowrance

This glossary takes into account many definitions and terms attributed to the world of digital photography. The following links were used to compile the bulk of this glossary. You can use them to obtain further information about any of the terms:

- http://wwwca.kodak.com/CA/en/consumer/guideToBetterPictures/glossary.jhtml

- http://www.nikonians.org/html/resources/photography-glossary.html#A

- http://www.digitalexposure.ca/sub1.html

- http://www.canon.co.uk/For_Home/Product_Finder/Cameras/Digital/digicam_glossary.asp?ComponentID=29381&SourcePageID=26181

acutance—The power to resolve detail in the transition of edges. *See also* sharpness.

AE (auto exposure)—A mode in the camera that adjusts the shutter speed, the aperture, or both by using the built-in light meter. These definitions are defined as follows: Programmed AE (P mode), where the camera sets both aperture and shutter speed; Aperture Priority AE (A mode), when the user sets the aperture and the camera finds the most appropriate shutter speed; and Shutter Priority AE (S mode), when the speed of the shutter is set by the user and the aperture by the camera.

AF (auto-focus)—When applied to a lens, AF allows the lens to focus automatically on an object within its focusing sensors. When AF is attached to an auto camera body, you don't need to use the aperture ring in auto modes. When applied to a camera, AF means that it is equipped with auto-focus capability and an auto-focus lens.

ambient light—The available natural (sun-lit) light in a scene.

American Standards Association—*See* ASA.

angle of view—The portion of a scene that is covered by a lens or viewfinder. This is determined by the focal length of a lens and film format.

aperture—The lens opening through which light passes to expose the film. The size of aperture is either fixed or adjustable. Aperture size is usually calibrated in f-numbers—the higher the number, the smaller the amount of light that passes to make the exposure.

aperture priority—Aperture Priority Auto Exposure (A mode). A mode of automatic exposure in which the photographer selects the aperture and the camera sets the shutter speed. This is the most used mode because it is the appropriate one for accurate depth of field control.

ASA (American Standards Association)—Used in conjunction with a number, such as ASA 200, to refer to film "speed" or light sensitivity. The higher the number, the more sensitive the film is to light, allowing for faster shutter speeds or smaller f-stops. ASA has been replaced by ISO, but the scale remains the same. *See also* ISO (International Organization for Standardization).

auto-focus—*See* AF (auto-focus).

automatic exposure—A mode of camera operation in which the camera adjusts the shutter speed, the aperture, or both to produce the correct exposure.

automatic white balance (AWB)—Digital cameras come with an automatic white balance meter that essentially tells the camera which intensity of the color white is in the picture. The rest of the colors in the spectrum are adjusted accordingly to make the image look as natural as possible.

available light—Existing light surrounding a subject. It can be natural or artificial, but the photographer does not add it, as with strobes or flash photography.

AWB—*See* automatic white balance.

backlighting—Light coming from behind the photo subject. Backlighting can cause underexposure of the main subject with auto exposure systems, lending itself to the use of fill-flash or spot metering.

barrel distortion—*See* distortion.

bellows—A flexible, light-tight, and usually accordion-folded device mounted on cameras that allows the lens to move toward or away from the film plane for greater magnification than with the lens alone. It is usually employed for close-up or macro work.

bit—A bit, which stands for *binary digit*, is the smallest unit of digital information. Eight bits equal one byte. Digital images are often described by the number of bits that represent each pixel. That is, a 1-bit image is monochrome; an 8-bit image supports 256 colors or gray scales; and a 24- or 32-bit image supports true color.

blur—Also known as ghosting. This effect is caused by an excessive movement of the camera, a zoom lens, or the subject. Blur is often intentional in creative photography to convey the feeling of motion. Blur or ghosting can also be the result of slow shutter speed or slow flash duration in flash photography.

brightness—(1) The balance of light and dark scenes in an image. (2) The amount of light that is reflected by a surface. (3) The intensity or quantity of light emitted from a light source. (4) The condition or quality of luminance from a color.

buffer—Temporary memory area that stores data before it is written into a permanent area. In digital cameras, buffer refers to the memory where images are stored before they are written to the memory card.

built-in meter—A reflected-light exposure meter built into a camera so that light readings can be made directly from the camera position.

camera—A picture-taking device usually consisting of a light-tight box or container, a film cartridge or memory card (image) holder, a shutter to allow a measured quantity of light, and a lens to focus the image.

cartridge—A light-proof film container, made of metal or plastic, that permits a roll of 35-mm film to be loaded into a camera in the light. It is often called a magazine or cassette.

cassette—See *cartridge*.

CCD (charged coupled device)—A semiconductor device that is often used as an optical sensor. It stores charge and transfers it sequentially to an amplifier and detector used in digital cameras to capture an image.

charged coupled device—*See* CCD.

chrome—A trade term for color transparency film.

close-up—A larger-than-normal image that is formed by focusing the subject closer than normal to the lens with the use of supplementary lenses, extension tubes, or bellows.

CMOS (complementary metal-oxide semiconductor)—A method of constructing transistors that produces microchips that run with relatively low power consumption. This type of image sensor chip is replacing the CCD. *See also* CCD (charged coupled device).

CMYK—Acronym for cyan (process blue), magenta (process red), yellow, and black, the primary colors of ink used to create color prints from typical printers. CMYK is not to be confused with the primary colors of light, which are red, green, and blue (RGB).

collimation—The precise alignment of lens optics in relation to the film or image plane of a camera body. This term describes the parallelism of a camera body lens mount to the film plane.

color—The property of objects (or light sources) described in terms of a person's perception of red, blue, green, or other shades and lightness (or brightness) and saturation.

color balance—(1) The ability of media to reproduce accurately the colors of a scene. Color films are balanced for use with specific light sources. (2) The reproduction of colors in a color print, alterable during printing or post-processing.

color cast—A slight trace of one color in all the colors in an image.

color reversal—*See* positive.

color temperature—Measured in Kelvin (K) degrees, the temperature at which a blackbody emits radiant energy that is competent to evoke a color the same as that evoked by radiant energy from a given source (as a lamp). Photographers need to understand how light changes and film records it so that they can filter it to fit the film in use. Average noon daylight has a color temperature of 5500 K. A common tungsten house light bulb has a color temperature of 2800 K. Tungsten studio lamps measure 3200 K, and photo lamps or photofloods measure 3400 K.

CompactFlash card—Trademark name for one type of digital camera's reusable memory card on which images taken by the camera are stored. It is available in a wide range of storage capacity and recording speeds.

continuous servo auto focus (AF)—An especially useful AF mode when you are focus tracking fast-moving subjects. Using this mode, you can release the shutter at any time, even if the picture is not in focus. As long as the shutter is activated while half depressed, this mode keeps a subject in focus and makes calculations to the subject's positioning at the moment of firing. The setting is typically stated as AF mode "C" on cameras.

continuous tone—Describes an image containing a range of tones from black through many intermediate shades of gray to white.

contrast—The apparent difference in darkness or density between one tone and another. Contrast also refers to the gradual shade difference between black and white. Fewer gray values are described as "high contrast." Many shades of gray are considered low contrast.

convergence—The phenomenon in which lines that are parallel in a subject, such as the vertical lines of houses or buildings, appear nonparallel in a photo.

copyright—A form of protection provided by the laws of the United States (title 17, U.S. Code) and other countries to the authors of "original works of authorship," including literary, dramatic, musical, artistic, and certain other intellectual works. This protection is available to both published and unpublished works. Section 106 of the 1976 U.S. Copyright Act generally gives the owner of copyright the exclusive right to do and to authorize others to reproduce, distribute, perform the work, or display it. These laws are similar in all countries. Copyright is also considered a legal right of creative artists or publishers to control the use and reproduction of their original works.

crop—To trim the edges or enlarge a portion of an image to improve the composition.

curves—A function in Adobe Photoshop that allows a change of the tonal range of a digitized image. It permits anything from simple modifications in shadows, highlights, and midtones to complicated adjustments at any point within a 256-color (from 0 to 255) tonal range of the entire image or precise modifications to the individual color channels of an image.

darkroom—A light-tight room where photographs are developed or printed. In this room, a photographer is able to handle light-sensitive materials without causing unwanted exposure.

daylight—Ambient light with a color temperature of 5500 K. Average daylight, combined with the reflected light from the sky, produces natural ambient light.

depth of field—The area between the nearest and farthest points from the camera that are acceptably sharp in the focused image. This can also be identified as the zone of acceptable sharpness in front of and behind the subject, on which the lens is focused. Depth of field varies according to lens focal length, aperture, shooting distance, and many other factors.

depth of focus—The small range of error within which a sufficient sharp image is produced when a lens is focused.

diaphragm—The mechanism controlling the brightness of light that passes through a lens. An iris diaphragm has overlapping metal leaves whose central opening can be adjusted to a larger or smaller size. *See also* aperture.

digital—A device or system that uses binary information that can be stored and processed. This binary information has two states, where 0 is on and 1 is off. These states are translated into data called bits. *See also* bits.

digital camera—A camera that captures an image through the lens on an electronic image sensor, a CCD, or a CMOS chip. The image is then temporarily transferred to a memory buffer and stored onto a FlashCard for eventual download and manipulation on a computer.

digital noise—*See* noise.

digitization—To store and process the transformation of analog data to digital data.

DIN—Stands for *Deutsches Institut für Normung,* the German Institute for Standardization that was founded in 1917. It's a numerical rating used in Europe that describes the sensitivity of a light-sensitive material to light. The DIN rating increases by 3 as the sensitivity of the light-sensitive material doubles.

distortion—The effect of straight lines not being rendered perfectly straight in an image. Two types of distortion exist: barrel and pincushion.

dots per inch—*See* DPI.

download—The process of transferring computer data from one location to another, such as digital images from the camera's memory card onto a computer, from a computer to a memory device such as a CD-ROM, or files from the Internet onto a computer.

DPI (dots per inch)—As applicable to the resolution of a printer, the number of dots it can print per inch. The higher the number, the higher the resolution. Inaccurately, this term is also applied to scanners and digital cameras instead of PPI (pixels per inch), as if a dot were equivalent to a pixel.

electronic flash—*See* flash.

existing light—Available light. Covers all natural lighting from moonlight to sunshine. Photographically speaking, existing light is the light that is already present on the scene or project, or scenes that are artificially illuminated after dark.

exposure—The amount of light that reaches film or the combination of f-stop and shutter speed that controls the amount of light reaching the light-sensitive material. In addition, this term describes an exposed piece of film. *See also* f-stop numbers; shutter speed.

exposure compensation—Often referred to as EV compensation by deliberately changing the exposure settings recommended by a light meter to obtain a different exposure to fit a personal preference, create special effects, or meet special requirements.

exposure meter—An instrument that measures the amount of light falling on a subject (incident-light meter) or emitted or reflected by a subject (reflected-light meter), allowing aperture and shutter speed settings to be computed. This is commonly called a light meter. Many light meters are also capable of metering flash or strobe exposures.

extension tubes—Provides additional extension to make the lens focus at closer distances and produce higher magnification. Extension tubes are usually manufactured with metal tubes. They have a rear-lens mount at one end and a camera-body mount at the other end.

factor—A number that tells how many times the exposure must be increased to compensate for loss of light (for example, because of use of a filter or converter).

fast film—A film that has high sensitivity to light, needing less light to obtain a proper exposure. Fast film is recommended for action and low-light photography. This term is normally applied to films that have ISO 400 and higher.

fast lens—A lens that has a maximum wide aperture and low f-number, allowing it to gather more light than a slow lens, which has a narrower open maximum aperture, such as f/3.5, f/4, and smaller.

file format—A common computer-related term to describe programs or data file types such as JPEG, PSD, TIFF, PDF, PICT, or EPS.

film—A photosensitive material that is used in a camera to record an image. Film is made from a thin, transparent base coated on a flexible acetate or plastic base covered with light-sensitive chemicals.

film speed—The relative sensitivity of a film to light. Several rating systems are available: ISO/ASA (the most common in the United States and Great Britain), DIN (common in Europe), and others. Film speed ratings increase as the sensitivity of the film increases. ISO is the contemporary term.

filter—(1) A piece of colored glass, plastic, or other material that selectively absorbs some of the wavelengths of light passing through it. (2) To use such a filter to modify the wavelengths of light reaching a light-sensitive material.

fisheye lens—A lens that has an extremely wide angle of view (as much as 180°) and considerable barrel distortion.

fixed focal length—A nonzoom camera lens that has an unchangeable focal length.

flash—An artificial light source, such as a flashbulb. Flash is often called strobe or electronic flash.

flash duration—The duration of a flash burst from an electronic flash or strobe light.

flash card—A removable memory device that is capable of storing the image data after the system is turned off.

flash range—The distance range within which an artificial light is capable of rendering well-illuminated subjects for proper exposure. The range is a function of both the maximum and minimum flash output capability of the unit and the aperture selected, whether automatically or manually. Flash range is also affected by the ISO speed in use.

flash sync (synchronization)—The shutter speed that corresponds to the proper timing of the flash. If the flash sync is too fast, the shutter won't be open for the duration of the flash. If it's too short, the subject movement might cause blur.

f-number—A scale that expresses the relative area of the aperture of a lens, which is the result of dividing the focal length of the lens by the effective aperture of the lens opening (the apparent size of the diaphragm seen from the front of the lens). The f-number, or f-stop, increases by the multiple of the square root of 2, or 1.4142, from 1.0, 1.4, 2.8, 4, 5.6, 8, 11, and so on, allowing each setting to pass half the light of the aperture below and twice the light of the aperture above in the scale.

focal length—The distance from the lens to the focal plane when the lens is focused on infinity. Generally for 35-mm format, lenses that have a focal length of approximately 50 mm are called normal or standard. Lenses that have a focal length of approximately 35 mm or less are called wide-angle. Finally, lenses that have a focal length of more than approximately 90 mm are called telephoto lenses.

focus—To move the lens or position it in a way enabling light rays to converge so that you can record a sharp image on the film.

focus mode—For contemporary professional digital cameras, three basic types of focus modes exist: Single servo AF (S), Continuous servo AF (C), and Manual AF (M).

focus priority—A camera mode in which the shutter cannot be released until the subject is in focus, as when using Single servo AF (S).

focus tracking—An advanced feature whereby a camera's microprocessor analyzes a moving subject's speed by anticipating the position of the subject at the exact moment of exposure, and drives the lens to that position based on the information.

foreground—The area between the camera and the subject.

format—The size of the camera or the size of the film. Camera sizes come in APS, 35 mm, medium, and large format. Film formats come in APS, 35 mm, 645, 6×6, 6×7, 6×9, 4×5, 5×7, 8×10, and so on.

freeze focus—A feature by which the shutter is automatically actuated when the subject reaches the preset focus point. *See also* preset focus.

frontlighting—Light shining on the side of the subject who is facing the camera.

f-stop—*See* f-number.

f-stop numbers—A number that equals the focal length of a lens divided by the diameter of the aperture at a given stop. The larger the number, the smaller the opening of the lens; the smaller the number, the larger the opening of the lens.

FTP (File Transport Protocol)—A protocol that allows users to copy files between their local system and any system they can reach on a network or on the Internet.

ghosting—*See* blur.

grain—The granular appearance of an image. Grain becomes more pronounced when you're using faster film speeds and when you enlarge an image.

gray scale—An image made up of varying tones of black and white but no color. Grayscale is synonymous with black and white. The gray-level system divides the gray scale into 256 sections, with black at 0 and white at 255.

grip—A worker who moves the camera around while a film or television show is being made. Grip is a common term for a photo assistant in the photography industry who possesses knowledge of cameras and lighting.

highlights—The brightest or whitest parts of an image.

histogram—A graph defining the contrast and dynamic range of an image.

hue—Color or gradation of color. Hue also refers to the attribute of colors that permits them to be classified as red, yellow, green, blue, or an intermediate between any contiguous pair of these colors.

image—A scene that is represented by a two-dimensional medium.

image editor—Allows adjustments to an image to improve its appearance using computer software. With image-editing software, you can darken or lighten a photo; rotate it; adjust its contrast, colors, hue, and saturation; crop out extraneous detail; remove red eye; and more. Adobe Photoshop is the professional image-editing standard.

image resolution—The number of pixels in a digital photo.

incident light—Light as measured as it falls on a subject or surface, instead of light being reflected from a surface.

infinity—The farthest position on the distance scale of a lens. In relation to camera focus, this refers to the horizon.

International Organization for Standardization—*See* ISO.

ISO—The letters actually stand for International Standards Organization, which also refers to a film's sensitivity to light, or more commonly, its speed. The term is pronounced by the individual letters: I-S-O. It is not considered an acronym, but a word derived from the Greek *isos*, meaning equal. The early term was ASA, which stood for American Standards Association.

Joint Photographic Experts Group—*See* JPEG.

JPEG (Joint Photographic Experts Group—A digital image file format standard in which the size of the file is reduced by compression. A JPEG image file name carries the extension JPG. JPEG compression is loosy, which means that it loses some image information as opposed to other formats, such as TIFF. A high-quality JPEG file loses less than a low-quality JPEG file.

K (Kelvin)—Thermodynamic temperature scale measurement. In photography, it is a numerical description of the color temperature of light at different wavelengths. In 1933, the International Committee of Weights and Measures adopted the temperature at which water, ice, and water vapor coexist in equilibrium as a fixed point, the triple point of water; its value was set as 273.16. The unit of temperature on this scale is called the Kelvin, after William Thompson Lord Kelvin, and its symbol is K (no degree symbol used).

LCD (liquid crystal display)—An information display method. Usually used for external displays on cameras, speedlights, or other electronic devices, such as flat-screen computer monitors.

lens—A piece or several pieces of optical glass shaped to control and focus a subject's light.

lens flare—The soft effect that is visible in a picture as a result of stray light that passes through the lens but is not focused to form the primary image. You can control flare by using optical coating, light baffles, low reflection surfaces, or a lens hood.

lens hood/shade—A lens addition, ring, or tube in front of the lens that minimizes lens flare.

lens speed—The maximum aperture of a lens. A lens that has a wide aperture (such as f/1.4) is called fast because it transmits more light than a slow lens (such as f/5.6).

light box—A device for viewing film. This box uses sunlight-balanced fluorescent tubes and is covered with glass or a plastic surface on which film negatives and positives are placed for viewing.

light meter—*See* exposure meter.

liquid crystal display—*See* LCD.

loupe—A small magnifying glass for viewing slides, negatives, and contact sheets. 8X to 10X are common loupes.

magazine—*See* cartridge.

magnification—The size of an image relative to that of the subject, as expressed in a ratio.

manual camera—A camera that lacks autofocus capability. You can use AF lenses on manual cameras, but you need to focus them by hand.

manual mode—Mode on the camera when the automatic capabilities are disabled. Used for complete control when a camera user wants to manually set both the aperture and shutter speed settings.

MB—*See* megabyte.

media—Material that data or images are captured to and stored upon. Items such as CompactFlash cards and CDs are referred to as common storage media used with digital photography.

megabyte (MB)—A measurement of data storage that equals 1024 kilobytes (KB).

megapixel—One million pixels.

meter—Any measuring device. In photography, it is commonly referred to as a light meter, although it could also refer to a color meter.

mode—Type of exposure method used by a camera. Common modes include Manual mode (M), Aperture Priority mode (A), picture mode, and flash mode.

monochromatic—Tending toward one color. A monochromatic image is one displaying only black-and-white or grayscale information.

monopod—Single-legged camera support. A monopod is a good substitution for handholding telephoto lenses while allowing mobility.

motor drive—A device for automatically winding and rewinding the film in a camera. Most contemporary professional cameras have motor drives built in. Another term for motor drive is motor winder or speed winder.

motor winder—*See* motor drive.

negative film—A photographic film that has been exposed to light and processed in a way that the image is reversed; the shadows are light and the highlights are dark.

noise—Also known as digital noise, this is the random colored pixels that appear in dark or shadow areas when the light levels are below the camera's CCD sensitivity range.

normal lens—A lens where the focal length is approximately equal to the diagonal of the film size that it's being used for. This is also representative of the same angle of view and perspective of the human eye. In 35-mm format, the normal lens is approximately 50 mm; in medium format, it's approximately 90 mm; and in 4[ts]5 format, it's approximately 200 mm.

overexposure—Light-sensitive material that has been exposed with too much light to obtain a properly exposed image.

panning—The act of following a moving subject as you release the shutter that allows the object to remain sharp and the background to be blurred.

perspective—The apparent size and depth of objects within an image.

photography—From the Greek *Photos* and *Graphos*, photography is light writing or writing with light. It's the mix of art, craft, and science for the creation of images on a light-sensitive surface.

PICT—A Macintosh graphic imaging file format using a PCT extension. PICT can contain object-oriented and bitmapped graphics.

pixel—Short for *picture el*ement. This refers to any of the small, discrete elements that together constitute an image (as on a computer CRT or television screen), or any of the detecting elements of a charge-coupled device used as an optical sensor in a digital camera.

positive—Any image that has tones corresponding to those of the subject matter. Positive also refers to a slide, transparency, or color reversal film.

PPI (pixels per square inch)—A measurement regarding image quality. The greater the number, the better the image quality.

preset focus—To focus at a predetermined distance when shooting a moving subject as it goes by the focus point. This technique is employed with both manual lenses and when locking focus with auto lenses in anticipation of fast-moving subjects. *See also* freeze focus.

primary colors—Red, yellow, and blue, the three colors that make white light when they're combined.

prime lens—A lens that has a single, fixed focal length; not a zoom lens.

processing—In photography, a chemical process in which an undeveloped photographic image is converted to a stable visible image.

pulling—Overexposing and underdeveloping film to effectively reduce its speed or ISO. *See also* pushing.

pushing—Underexposing and overdeveloping film to effectively increase its speed or ISO. *See also* pulling.

RAW—The data from a digital camera as it comes directly off the CCD, with no in-camera processing performed.

recycle time—The time that it takes for an electronic flash, strobe, or battery pack to recharge so that it can power a flash burst.

red, green, and blue—*See* RGB.

relative aperture—Diameter of the aperture divided by the focal length of the lens. This is expressed numerically as an f-stop.

release-priority AF—A camera mode option in which the shutter can be released at any time, whether the subject is in focus or not. This is used in fast-moving situations where you don't want to lose any of the action due to shutter release delay.

resolution—The ability to reproduce small details in a photograph. Resolving power measures lens performance using line pairs per millimeter (1/mm) and indicates how many black pairs of lines placed at equal intervals within 1 mm can be resolved by a lens. This is also known as resolving power.

resolving power—*See* resolution.

retouching—Altering a finished print, digital image, or piece of film to cover up unwanted spots, marks, or elements.

RGB (red, green, and blue)—The three colors to which the human visual system, digital cameras, and many other devices are sensitive; the colors that are used in displays and input devices. These colors represent the additive color model, where 0% of each component yields black, and 100% of each component yields white.

sharpness—The amount of detail that you can perceive in an image, or its focus and contrast. It's the combination of resolution (which is typically measured in terms of the number of distinguishable line pairs per millimeter) and acutance.

shutter—Blades, a curtain, plate, or some other mechanical device in a camera that controls the time that light is permitted to reach the film.

shutter priority—A camera automatic exposure mode that allows a photographer to choose the shutter speed while an electronic processor in the camera adjusts the aperture for best exposure.

shutter speed—The amount of time that the shutter stays open. The shutter speed controls the amount of time that light is allowed to expose the image on the film or sensor.

single lens reflex (SLR) camera—A camera in which the image formed by the lens is reflected by a mirror onto a ground-glass screen for viewing purposes. With this camera, you can view the scene through the same lens that takes the picture.

single-servo auto focus (AF)—When the subject comes into focus, the focus operation stops and stays locked as long as the shutter release button is lightly depressed. Single-servo AF mode is commonly used when shooting stationary objects.

skylight filter—Filter that removes more UV light (and therefore excessive blue) than a UV filter, adding a slight warming tone in two grades—1A and 1B—where B is the warmer one.

slave—A light-sensitive trigger device that synchronizes strobes or flashes without an electronic synch cord.

slide—*See* positive.

slow lens—A lens that has a small aperture (such as f/8), which allows you to use a slower shutter speed than when using a fast lens.

speed winder—*See* motor drive.

strobe—A high-intensity flashing beam of light produced by charging a capacitor to a high voltage and then discharging it as a high-intensity flash of light in a tube.

Tagged Image File Format—*See* TIFF.

teleconverter—A device, consisting of optical glass, that increases the effective focal length of a lens. Mounted between the camera and the lens, a teleconverter typically is available in two different sizes: 1.4X and 2.0X. A 1.4X teleconverter increases focal length by 1.4 times, whereas a 2.0X teleconverter increases focal length by 2.0 times. The aperture of the lens is increased by the same amount as the focal length. For example, a 2.0X teleconverter increases the focal length of a 300-mm lens to 600 mm; however, if the aperture of the lens is f/2.8, it is automatically decreased to f/5.6.

telephoto lens—A lens that has a focal length that is longer than the diagonal of the film format being used. A telephoto lens makes a subject appear larger on film than does a normal lens at the same camera-to-subject distance. It has a narrower field of view than a normal lens does.

through the lens—*See* TTL.

thumbnail—A small version of a digitized image. Image browsers and image editors commonly like to display thumbnails of several photos at a time. In Windows XP's My Pictures, you can view thumbnails of photos in both the thumbnails and filmstrip view modes. Camera Bits' image browser, Photo Mechanic, displays all images as thumbnails that you can then enlarge for better viewing.

TIFF (Tagged Image File Format)—An uncompressed no-loss image format.

tone—The strength of grays between black-and-white values in an image.

transparency—*See* positive.

TTL (through the lens)—Automatic flash output control, which uses a light sensor to measure the flash intensity and is read through the lens as reflected by the subject. The result is the flash turning off at the correct exposure.

underexposure—Allowing too little light to reach a photo-sensitive material. The result is a thin or light image with negative material and a dark or dense image with reversal material, such as slide film.

variable focus lens or variable focal length lens—A zoom lens that has a focal length capable of varying from 28 to 100 mm, from landscapes to portraits.

white balance—The technical method for digital cameras to adapt to the color temperature of the dominant light source in a scene. It's the way in which a digital camera compensates and determines the different colors that are being emitted by the source of light.

wide-angle lens—A lens that has a focal length that is less than the diagonal of the film format it's being used with. This lens has a shorter focal length and a wider field of view than a normal lens.

zoom lens—A lens that has an adjustable focal length (70–200 mm), which allows for a closer or farther view of a subject. It changes the magnification, not the perspective.

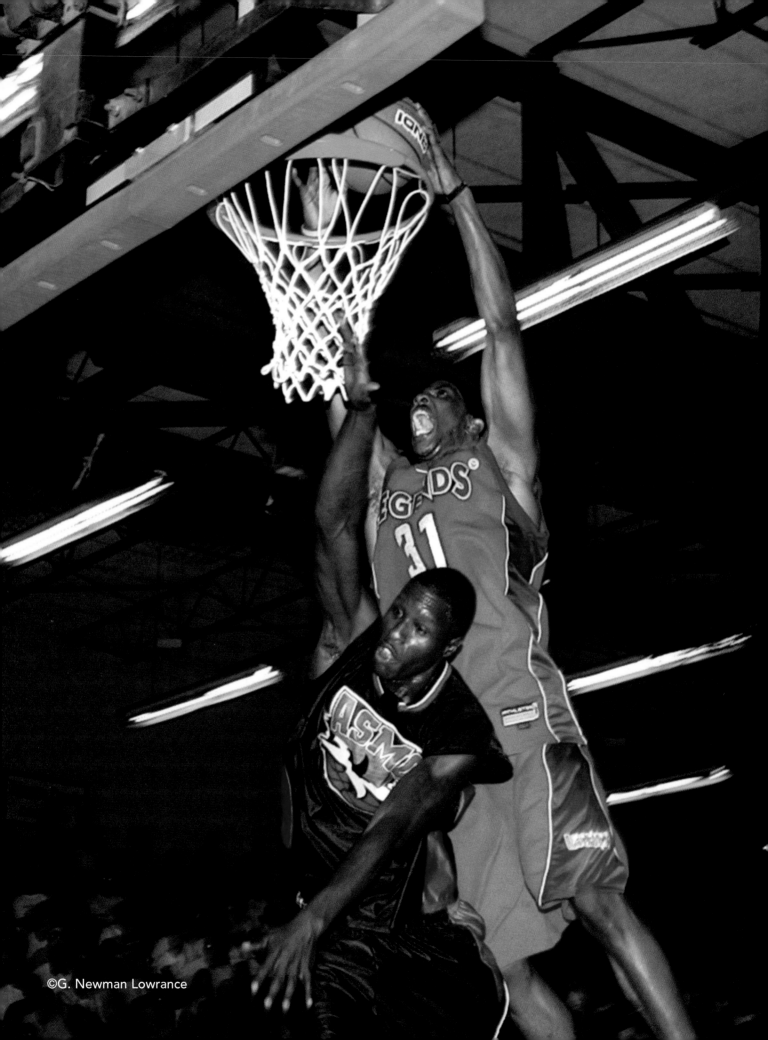

Index